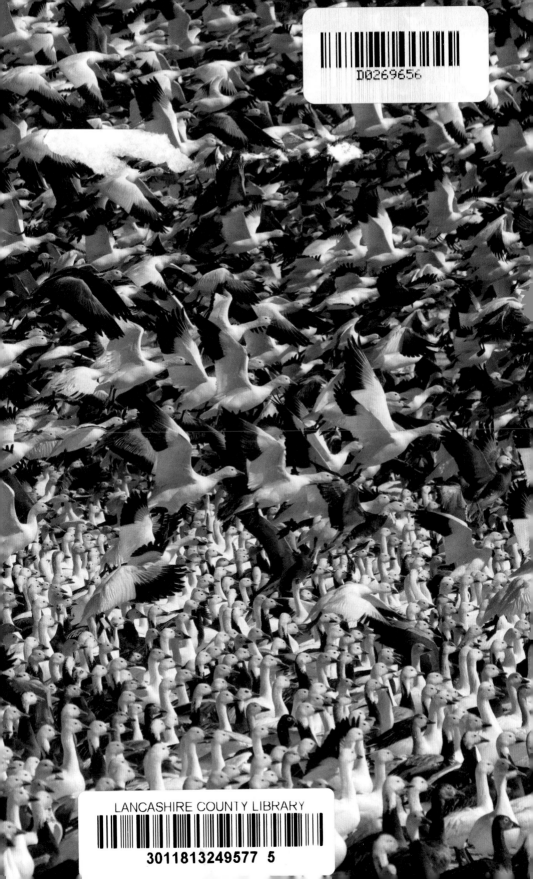

THE
SHARK
AND THE
ALBATROSS

THE
SHARK
AND THE
ALBATROSS

Travels with a Camera to the Ends of the Earth

JOHN AITCHISON

P

PROFILE BOOKS

First published in Great Britain in 2015 by
PROFILE BOOKS LTD
3 Holford Yard
Bevin Way
London
WC1X 9HD
www.profilebooks.com

1 3 5 7 9 10 8 6 4 2

Typeset in Granjon by MacGuru Ltd
info@macguru.org.uk
Printed and bound in Great Britain by
Clays, St Ives plc

ISBN 978 1 78125 348 9
eISBN 978 1 78283 107 5
Export 978 1 78125 501 8

FSC
www.fsc.org
MIX
Paper from
responsible sources
FSC® C018072

This book is dedicated to my family,
and to the memory of my grandma, who taught me to notice

CONTENTS

INTRODUCTION:
THE SHARK AND
THE ALBATROSS

Cloud shadows. Water-dapple and dancing light. A strip of sand, blindingly white: an island made entirely of broken coral and shells and, at my feet, the sea. This sea, the colour of glass, stacked layer upon layer: a clear and vivid green, like the eyes of a cat. There are seven squat bushes on the island, moulded by the salt wind and decorated, like low Christmas trees, with birds called noddies. They are terns, chocolate-coloured, evenly spaced, all facing the wind: the ever-present wind. Most of the island's birds are black-footed albatrosses: big, dark brown, with pale faces and, well, you can guess the colour of their feet, but it's their wings that mark them out, that define them. Their wings are wider than I am tall.

A shower is coming. As the sky darkens, the sea turns to turquoise milk. A strong gust sweeps across the island and the albatrosses respond, opening their wings. All of them. Hundreds of them, yearning to fly. They live for this wind. They are all young birds, just a few months old. The boldest lift a metre into the air on the gust and teeter there, trailing their feet. It's their first taste of flight. They will spend most of their lives in the air: the ones that live to leave the island.

This is part of French Frigate Shoals, four days away from Honolulu in Hawaii, and I'm seeing it from a tiny platform, thirty metres offshore. The waves are just a metre below me, with another three to the seabed. It's a bit precarious but perfect for filming the young albatrosses as they are gradually drawn to the sea.

At sunrise I sit beside one of them on the beach, just an arm's reach

away. She takes little notice – just one peck at my shoe – before turning back to the water. I follow her with my camera. Her dark eye fills the viewfinder. I can see the waves reflected there, the beach and a man, silhouetted, crouching by his tripod under the bright circle of the sun. It is humbling to be trusted by her as she opens her wings to the wind. In two weeks she and every other albatross on this island will have left, or died in the attempt. I shift focus and frame a view of the albatross's feet: black triangles on the sand. The shadow of her head falls exactly between them, completing the image of the bird. A wave curls in and hides her feet, but the shadow of her upper half remains on the froth until the wave retreats and restores her. The shadow of a frigate bird streams across her back, across my face and on across the bright sand. I am often drawn to filming shadows. I like the way they hint at reality without being the thing itself, as photographs do, or films. I like the way they are made, by light and matter touching. Later my own shadow does that, when it falls across another's eye.

From my filming platform I scan continuously. Looking out. Looking down. The water surface is fascinating. Impressions of the seabed filter up through its restless lens: sand ripples, like fingerprints, compress and stretch, while webs of light dance to the wave-rhythm and from every wavelet and every curve comes the image of the sun, a million, million times. This camera could slow the motion down for me to study it, to probe the optics of the sea, but I don't even try because I don't want to break the spell. Instead I watch and revel in the beauty of this dancing light; but within this enigmatic sea there are other shadows moving: large ones, sometimes larger than me, and that's why I stand here, day after day. I am looking for shadows, but they are shape-shifters: green turtles splinter and re-form, to surface with a monk seal's whiskery face. Others shimmer but stay put and become rocks or coral heads. Some shadows are longer and darker and more sinuous. More dangerous.

Another gust hits the beach and the albatrosses paddle the air with their wingtips. To fly from here, where their toes are wetted by the surf, would take them out over the water for the first time. If they knew what was waiting for them I wonder how many would choose to stay and starve upon the beach.

The shadow of my platform leans towards the shore, cast down through the sea and stretched out upon the sand: three boards to stand on, a handrail, the tripod, then me – and into this space, between me

and the shore, swims a fragmented shape. It is twice as long as I am tall. Beyond it I can see the albatrosses exercising: naïve, oblivious. The shape swims into my shadow. My shadow-head falls across its eye, across the sharpness of its fin and across its skin: skin striped like sun-dapple and built to hide in shifting light and shade, like its namesake, the tiger – but this tiger is a shark. Beneath my shadow it changes course. The tiger shark has seen me too.

Feeling the breeze and lifting onto tiptoe, the albatrosses are exquisitely aware of the air flowing over their wings: they sense it in their every feather-filled pore. They are almost ready now. I think it is better that they do not know. Suddenly my coming here to film these birds dying seems horrible, but if I do not record what happens I will have failed; and yet these albatrosses are young and beautiful and some are on the brink of meeting killers fit for nightmares. So can I wish that every albatross evades the sharks? I can wish it, I suppose; I know it won't make any difference, and still I must film what happens. Even if I wanted to prevent them dying I could not: sharks have to eat.

We Must not Interfere. It's our mantra, our creed as filmmakers: to document but not to touch, and sometimes that's very hard.

From the beach an albatross lifts clear and cuts its ties with the land. It heads my way and for each of us the test begins. The bird is unsteady in the air. I imagine the effort it is making, trying to stay level, trying to stay dry. It passes me, flying slowly, too slowly, and it settles on the sea. Through my lens I can see it swimming calmly. I start the camera. The bird folds its wings with an efficient, three-way bend and paddles on. I'm completely still, intent on focus, composition and the dozen other things that are my job and which make the camera work, or not. Much of this is second nature and I find I have just enough spare thinking time to be there, on the sea, with the albatross. Again I see its eye but this time the only reflection is the bright point of the sun. This young albatross is entirely alone.

The shark is shocking when it comes.

The sea erupts. A head four times wider than the bird hurls it towards the sky, its wings trailing. In this liquid world the shark is astonishingly solid, the antithesis of water, like a blade. Its eyes are blank white circles, zombie-like membranes, closed for protection as it attacks, but they mean the shark must strike blind and it doesn't see the albatross slide sideways from its enormous head, unharmed.

3

A triangular fin cuts past, inches away and far taller than the bird. The tail thrashes as the shark turns to try again. The camera runs. I haven't breathed. Another lunge and I see the shark's jaws bulging forward through its skin as it prepares to bite, but the bird is deflected sideways by its bow-wave and again the shark misses.

The albatross grasps its opportunity and runs. Literally runs, scrabbling for footholds on the water and pumping its wings. It gains the air and heads out to sea, and this time it doesn't stop. The shark makes two more frantic passes and then it's gone. Who knows how much it understands of flight? Perhaps the albatross appeared to it briefly, only to vanish again, leaving its footprints patterning the sky.

There will be others in the coming days. The sharks will wait for them and so will I, but I can be honest with myself now: I am glad at least the first one escaped.

ƒ

I filmed this drama from the albatrosses' perspective, so perhaps it was inevitable that I would sympathise with the birds, but there were divers on our team as well, filming what happened underwater. They saw things differently and, despite taking much greater risks than I did, they surfaced from every dive full of admiration. They spoke of the sharks' exquisite sense of timing and their extraordinary navigational skills, which bring them every year to that tiny speck of land just as the first birds fly. They pointed out that sharks are vital to the health of the ocean and in hushed voices they described their beauty and their shocking decline, through overfishing.

The way in which a film is shot, edited and narrated affects which animals we sympathise with and there is no doubt that many of the programme's viewers will have taken sides, as we did – but do we really have to choose between sharks and albatrosses?

Each chapter in this book is about one of the journeys I have been privileged to make in the two decades since I started filming for broadcasters such as the BBC. In these pages you will find some of the world's great wildlife spectacles and you'll meet some of the people who are usually hidden behind the scenes: people as varied and interesting as the animals themselves, and who are just as important to the filming. I have chosen these stories because each one says something about why nature

matters. I hope they also show that learning about wild animals through films can make a difference to our lives, and sometimes to theirs.

It is impossible to travel widely without seeing that many wild animals are struggling. On French Frigate Shoals, for example, we came across dead albatross chicks, choked by plastic brought to them by their parents, who had mistaken it for food. Having spent time with those albatrosses, the tiger sharks and many other animals, it is clear to me that we all face choices about how much we care, just as I did on that filming platform. These are vital choices. Ultimately, they are about how to share the planet's resources. We can make them consciously or we can drift along half asleep, but either way we are choosing now.

The most important choice is not whether we prefer predators or prey, it's whether we are on nature's side or against it: whether we want the shark *and* the albatross, or neither. This book is about that too.

Wildlife filmmaking does not always take place in tropical paradises. Most of the journeys in this book have been to the colder reaches of the planet – the Arctic and Antarctic, the Falklands and the Aleutian Islands (all for the BBC series *Frozen Planet*), as well as to China and Yellowstone National Park in the winter. I am occasionally sent to warmer parts as well: to India and even to New York City in the spring.

Two of the world's most exciting animals are the emperor penguin and the polar bear. Both live close to the poles but at opposite ends of the world and for years I had dreamed of filming them. Working on *Frozen Planet* gave me a chance to go to Svalbard, in the far north of Norway, where I joined a team trying to film polar bears hunting. I knew that living and working in the high Arctic would be very different from filming sharks and albatrosses in the tropics, but none of us had guessed how much we would struggle even to find hunting bears, let alone to film them.

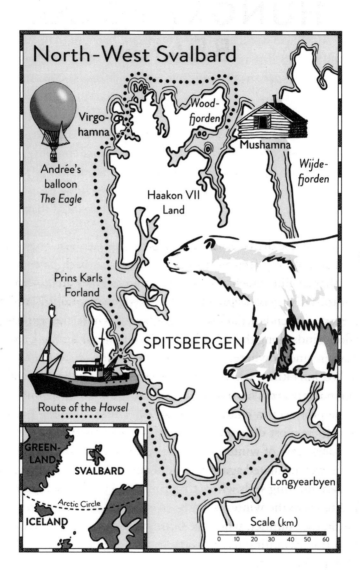

North-West Svalbard

Virgo-
hamna

Andrée's
balloon
The Eagle

Wood-
fjorden

Mushamna

*Wijde-
fjorden*

Haakon VII
Land

Prins Karls
Forland

SPITSBERGEN

Route of the *Havsel*

Longyearbyen

GREEN-
LAND

SVALBARD

Arctic Circle

ICELAND

Scale (km)

0 10 20 30 40 50 60

HUNGRY POLAR BEARS

A small ice floe drifts by, carrying eight footprints. Each one is larger than both my feet put together. The bear's back paws have left marks shaped like shoeboxes, while the front ones are rounded and pigeon-toed. Every pad shows that it walked purposefully across the ice but the last print ends in dark water. The bear was here: the bear has gone. The floe grinds along the ship's hull and spins away, the tracks pointing everywhere and nowhere, which seems to sum up perfectly our failure so far. We don't know where this bear came from or where it went, but if filming polar bears is hard it is nothing compared to being one.

The producer in charge of the shoot, Miles, is hoping to film the bears at their most difficult time of year. Surprisingly this is not during the dark days of winter, when the Arctic Ocean freezes over. Polar bears are well insulated against the cold and they roam freely across the frozen sea, hunting seals where they haul out onto the ice to rest or give birth. For them the winter is a time of opportunity. Their hardest time is now, in the summer, when the bears can either carry on looking for seals on the dwindling ice, or come ashore in places like Svalbard, to search for other food.

f

The islands of Svalbard belong to Norway and they are surprisingly busy, despite being more than 700km (about 460 miles) north of the

mainland and twice that far above the Arctic Circle. The only town, Longyearbyen, has housing for more than 2,000 people, a supermarket and even a university where, during their first week, all the students are taught to shoot. It is against the law for anyone to leave town without a gun and at the camping store you can rent rifles by the day. Longyearbyen's road signs make no bones about the reason: they are standard red and white warning triangles, but with bears in the middle. In Svalbard polar bears outnumber people.

Our ship is called the *Havsel* and we know little about her except that her name means 'ocean seal' and that on the way north from Tromsø, her crew stopped to fish for cod – they are Norwegians, after all. Miles chose her, not just because the other ship he was offered had a harpoon gun mounted on the bow, but also because the *Havsel*'s lower deck is large enough for the extraordinary amount of equipment we have brought. It is evening when we start to load the ship, passing boxes from hand to hand across the deck and down the hatch. The ship's engineer lifts the lid of one case labelled *Guns and Ammo*. It is filled with weapons and cans of 'bear spray' made from chilli peppers. He pulls out one of the cans: 'For a polar bear this would be sauce!'

As we work through the night the sun never sets, which is quite a contrast to the team's first visit to Svalbard, back in the winter. Then, even at noon, the sky was as dark as night and the temperature hovered around −20°C (−4°F), but for us that was ideal because we had come here to be taught about filming in extreme conditions. A large part of the course covered how to deal with polar bears. We were told that, almost uniquely among animals, some of them choose to hunt people. One photograph from the course has stuck in my mind. It showed the foot of a man who had been dragged from his tent by a bear. His heel had been bitten away, the gap extending more than halfway through his leg. He had saved himself only because he slept with a loaded rifle. Using the *Havsel* as a base, rather than camping, makes sense for this reason too.

We had spent that day at a firing range with an instructor from Svalbard University who, in a country where it is normal to be called Odd, had the quite un-Norwegian-sounding name of Fred. He didn't seem fazed to be teaching a group of British naturalists how to kill bears and began by explaining why it might be necessary: two teenage girls, he said, had been walking close to this range when a bear surprised them. Neither of them was armed. One ran and the bear killed her.

'If she had thrown down her mittens the bear might have stopped to sniff them. She could perhaps have bought herself a little time, but if the same thing happens to you *this* will be your first line of defence.' He showed us a wide-mouthed flare pistol. 'The sea ice often cracks and bears hear many loud noises, so flares are a better deterrent than the sound of a gun.'

To show us what he meant he fired a brilliant red firework into the sky. The flare was impressively bright against the darkness but individual bears have different characters and it seems that some are not frightened by flares. Fred described what happened when one such bear tried to break into a cabin. Someone inside opened a window and fired a flare. The ball of blazing magnesium flew past the bear's nose and bounced away along the ground. The bear chased and swallowed it, then returned to the hut as if nothing had happened.

'So we will also practise with rifles,' he said.

The targets were all photographs of bears.

'Four rounds, commence firing!'

I lined up the sights and squeezed the trigger. Bang! Pull the bolt to eject the cartridge and push it forward hard to load the next round, aim and squeeze, trying not to shut my eyes. Bang! Bolt in and out, aim, squeeze. Bang! Again. Bang! The shots echoed off unseen mountains as snowflakes settled, bright in the floodlights of the range.

The bears in the photographs stared at us as we walked towards them to inspect the bullet holes. The cameramen had all done well, perhaps because we spend so much of our time aiming long lenses, but I said I would much rather use the chilli spray if we were to meet an aggressive bear, instead of shooting it. Fred agreed that we should always try to scare bears away first, but added that with some there may not be time to choose.

'This bear was shot soon after the photograph was taken. It was just over a metre away. Your targets were set at thirty metres. How long do you think it would take a running bear to cover that distance?'

The answer was four seconds, just enough time to aim and fire four times.

'Don't wait too long to decide.' He paused by my bear, looked at the cluster of holes over its chest and said, 'Well done, dead bear.'

It was the least welcome praise I have ever received.

f

Siberian hunters may have been the first people to visit Svalbard. The first Europeans were probably Dutch explorers, led by Willem Barentsz, who came here in 1596 while searching for a North-East Passage to Asia. Barentsz reported that the fjords were packed with whales. Dutch and British ships soon came to hunt them. In time the whales were wiped out and geologists prospecting for minerals replaced the whalers. They noticed that the islands' cold rocks contained fossilised plants from much warmer climates, which even included the remains of ancient rainforests in the form of coal. They solved this puzzle later, by determining that Svalbard had moved north, carrying its fossils with it. In 1906 an American called John Munro Longyear opened the first coal mine in the town, which still bears his name. It was an uncomfortable place to work: after dodging polar bears the miners had to cut through ice as well as rock to reach the coal.

During the Second World War Longyearbyen gained the dubious distinction of being the only town to be shelled by the German battleships *Tirpitz* and *Scharnhorst*. They scattered the small Norwegian garrison and set fire to a mine. It was quite a sledgehammer to crack a nut but the attack had more to do with weather forecasting than with coal. Cold Arctic air affects the weather over much of Europe and accurate forecasts, incorporating the latest information from Svalbard, were vital to both sides for planning bombing raids, aerial landings and attacks on convoys. Under cover of the shelling the German Luftwaffe landed a team of meteorologists on an out-of-the-way island, where for some time they remained unnoticed by the returning Allies, who hurriedly rebuilt their own critically important weather station. Later there were occasional skirmishes and one unlucky weatherman was shot as he returned to his hut after photographing birds – a salutary tale for any wildlife filmmaker. By 1944, four separate groups were sending encoded weather data from Svalbard to Germany. When the war ended some of them were stranded and became the very last German troops to surrender, four months after everyone else.

Svalbard is still an important base for science, with an observatory for studying the Northern Lights and a seed bank housed in vaults dug deep into the permafrost, where plant seeds from all over the world are stored and will remain frozen even if civilisation collapses. Of the

many expeditions to have used Svalbard as a base, the most fascinating set their sights on the North Pole, starting here because, in most years, these islands are the easiest place in the high Arctic to reach and travel around by ship. When we arrived in Longyearbyen to start our search for polar bears, we found that this summer was proving rather different.

Our skipper, Bjørne, is a smiling man wearing a cardigan and an Errol Flynn moustache. He says that our plans may be affected by the unusual amount of ice around the north of Svalbard, then takes me to the bow to point out fifteen codfish dangling from the rail: 'They are drying,' he explains. 'It will take weeks.' He thumps his chest. 'This is grown-up food, not for children!'

He supervises the last piece of equipment coming aboard. It's a large aluminium boat. The *Havsel*'s winch tightens and the steel cable jumps, smoking around its drum. We all grab lines to guide the boat gently onto its wooden cradle, with an inch of deck space to spare on either side. It belongs to Jason, the ebullient Australian who is in charge of our logistics. He calls his boat the *Buster* and it has been set up to try something new. A crane mounted in the middle carries a sophisticated stabilised camera of the kind more usually found on helicopters. It has a very long lens and will be operated by a cameraman called Ted, sitting in the boat and watching a monitor screen. A third cameraman, Mateo, and I will be sharing a cabin in the *Havsel*'s stern. It's below the waterline but at least it seems nice and quiet. The last member of the team is Steinar, our Norwegian field assistant. He and I will spend most of our time together, filming with a simpler camera in the old-fashioned way, with a long lens and a tripod.

We finish loading our gear in the early hours of the morning. The only cargo left on the dock is a basin for a new kitchen, brought on the ship from Tromsø for a friend of Jason's. It seems we really are taking everything but the kitchen sink.

'So – we go!' Bjørne shouts. The mooring lines are cast off and a gap appears between the *Havsel* and the pier. It's the first small step with which all journeys begin. As we leave, Steinar points out four other ships at anchor in the fjord. Within the last week each one has

tried to sail north around the islands but they all became stuck in the pack ice and had to be rescued by an icebreaker. We are going that way too, in our search for bears.

f

Bjørne steers from a corner of the wheelhouse. From the bow I can see his face hemmed in by the radar, the echo-sounder and his radio equipment. A fulmar passes on stiff wings, like a miniature albatross, as much at home riding a wave or surfing the air displaced by the ship. As it goes by its eye meets mine.

The coast is lined with saw-toothed mountains, interspersed with glaciers. The landscape is unremittingly black and white and from time to time I glance at the *Havsel*'s painted deck, to be reminded of green. Barentsz saw these mountains when he made his first landfall. He called the largest island in Svalbard's archipelago Spitsbergen, which means 'jagged peaks' in Dutch. Jason joins me at the rail and asks how far away I think the mountains are. They seem startlingly close but I double my guess to twenty kilometres. He tells me it's more like forty: there is so little moisture in the cold air that it's gin clear. Aside from the Norse in Iceland, Barentsz was one of the first Europeans to meet a polar bear. His men shot at it, then, finding their muskets made little impression, they used a lasso to hoist it aboard their ship and when the bear became truculent they killed it with an axe. Encounters like that set the tone for human–bear relations until the 1970s.

I can think of little worse than coming here to film bears and having to shoot one instead, but it is a possibility we have to face because they are formidable animals. In Longyearbyen I studied a male bear, stuffed and standing upright in a hotel lobby. His eyes were considerably higher than my head and he had weighed five times as much as me. Dropping mittens in his path would probably not have delayed him very long. I have filmed large predators before but always with somewhere to retreat to close at hand, most often a car. Now we have left Longyearbyen there are no cars and scarcely any roads. When we meet bears we will be either in boats or on foot.

f

Bjørne beckons me inside to look at the charts. 'There are so many glaciers in these valleys that most of them don't have names,' he says. 'They are numbered alternately, like houses on a street. Even I can understand it.'

On the chart table there are some photographs showing him standing on a riverbank, surrounded by birch trees and holding an immense salmon: 'At home in Alta,' he says proudly. He lays a chart on top of them. It shows the whole Arctic Ocean with the coasts of Russia, Alaska and Canada enclosing it almost completely. There are only two places where water can enter and leave: the Bering Strait, above the Pacific Ocean, and where we are now, at the top of the Atlantic. There is only one deep-water channel, a trough in the seabed just west of Svalbard. Above it runs a current flowing all the way from the Caribbean. It brings enough warmth to fill the sea with life and it helps melt the ice, making the west side of these Arctic islands usually accessible by ship. The north coast is a different matter.

Today's sea-ice map has just arrived by email. At its heart is Svalbard, coloured grey. There is precious little open water and most of the sea is covered by blue cross-hatching, showing the varying ice density. It is an incredible jumble, reflecting how the currents swirl around the islands. Here on the west side the water flows north, but on the other coast, where the ice is thickest, it flows south and it is on this conveyor belt from the high Arctic that we are most likely to find polar bears hunting seals. To reach them we must first pass along the north coast of the main island, Spitsbergen, and that's where Bjørne says we will meet a wall of ice. He compares today's map with the one from two days ago. The north coast then was a mess of blue checks, like a ragged tablecloth, with ice pressed hard against the shore. In the same place today there are mostly blue circles indicating 'very open drift ice', according to the key. These maps are drawn from satellite pictures, so no one has been able to check how accurate they are. Bjørne peers like a schoolmaster over his half-glasses.

'It seems to be opening a little but who knows?'

On either side of us the map shows ice extending hundreds of kilometres further south. To reach most of the bears we have no choice but to go on.

In a whole day travelling, the only flat area we have passed is at a place called Virgohamna. In 1897 it became the base for an expedition to the North Pole that was extraordinary, even by Svalbard's standards. From here, on a globe, the pole seems within easy reach but, by the late nineteenth century, several expeditions had slogged north across the frozen sea, only to find they were further south at the end of the day than when they had started. The conveyor belt of ice was moving in the opposite direction faster than they could walk. It must have been soul-destroying. To a Swedish engineer called Salomon August Andrée the answer seemed obvious: he would fly there, and in style.

Andrée came to Virgohamna with a balloon which he called the *Eagle*. It had been stitched together by seamstresses in Paris from panels of varnished silk. He mixed acid with an iron compound to release hydrogen gas, which filled the balloon. Fully inflated, the *Eagle* was 20 metres (67ft) across and it made an impressive sight while Andrée's team made their final preparations. In a posed photograph, Andrée is working on a paper plan with three companions, including Knut Frænkel and Nils Strindberg, who were to fly with him. His face is impassive but one of the other men stands with his hand to his head, as if he is dismayed at the prospect of the journey. He had every right to be, because to pass over the pole, and then reach the safety of Alaska or Siberia, the *Eagle* would need to fly at least 2,000km (1,250 miles). Andrée had placed a great deal of faith in technology. He planned to hang ropes from the basket, to drag across the ice and help him steer, and he even took a remotely controlled cooking stove, which could be lowered and lit out of range of the flammable hydrogen. When the meal was ready it would be hauled up and eaten from specially made plates, bearing the expedition's initials. He seemed to have thought of everything.

The *Eagle* was photographed just after it took off, on 11 July 1897. A few figures stand silhouetted in the foreground, frozen in that moment of hope and excitement. They had no idea that for the next thirty-three years they would hear nothing more of their friends in the balloon. In the Arctic such stories of failure are alarmingly common.

f

The ship's propeller shaft passes under the floor between Mateo's bunk and mine, so our cabin sounds like the inside of a cement mixer.

Earplugs help until I lay my head on the pillow, when my teeth start to vibrate. Then we hit the ice. The *Havsel* rings like a dull bell and the floes growl along her side, less than an inch away through the hull. It is less noisy and more interesting in the wheelhouse, because we are rounding the tip of Spitsbergen and for the first time we can see the north coast ahead. The pack ice is a few kilometres away, a bright line like a frozen wave, but in front of us the water is open where, just two days ago, ice would have blocked our way.

Bjørne points out that when the ship hits a large floe the mast vibrates like a ruler twanged on a desk. He seems unconcerned and explains that his ship's hull has been strengthened and her rudder and propeller are safely enclosed in steel housings. Below the waterline the *Havsel* is shaped like an egg, so she should pop up if she is trapped between floes. He is more worried that the ice might be blown towards us, trapping us against the rocks. He climbs to the crow's nest and steers from there, squeezing his ship between the ice edge and the shore.

In the golden light of late evening flocks of little auks skim the water, black and white like the dappled mountains. Every small iceberg is fringed with them, standing upright and evenly spaced, all preening their feathers. We enter a wide fjord and the *Havsel* cleaves a mirror-calm sea as we pass our first bearded seal, hauled out on the ice. Its body is long, with a small head and a snub-nose like an otter. Its eyes are rheumy in the cold and its cheeks are pale and round, like apples, dotted with regular spots where its whiskers sprout. They are more of a moustache than a beard, but splendidly long and curled none the less. Others roll in the water, showing just their glossy backs and dark crowns. This is encouraging: if there are seals here there might also be bears.

The water is choked with icebergs but this is not low-density sea ice, one or two years old: these pieces have fallen from a glacier and Bjørne is less sanguine about hitting them. Ice becomes as hard as concrete after thousands of years of being compressed by the weight of more ice accumulating above, and it floats low in the water where it is difficult to see.

'What would happen if we ran into that piece, Steinar?' Miles asks.

'It would make a big hole in the ship.'

Bjørne brings the *Havsel* to a stop, 100 metres from the glacier. It's almost eleven at night and perfectly quiet. A long blue-white wall drops sheer into the sea, except in one place where it rests on rock. Jason says this island was barely visible three years ago: the glacier is retreating.

'Bear!' I follow Bjørne's pointing arm and see it striding along in a beautiful setting below the glacier front, where the ice is bluest and most crevassed. Against the cold tones the bear's fur is the colour of rich cream.

'It's a male,' says Steinar, at my shoulder. 'His neck is much thicker than a female's, shaped like a cone. It's impossible to fit radio collars to male bears, they just slide off.'

The bear eases himself into the sea, as though his bulk might crack the fragile margin. He swims without a ripple and pulls himself out onto a small iceberg, raising and lowering his muzzle to test the air. He is hunting. The others rush to launch the *Buster* while I keep track of the bear. Jason has filmed bears from a small boat before and he says the trick is to choose carefully: small bears are likely to be wary and they will swim away, while larger ones are often too curious or aggressive. This one is an ideal, medium-sized bear but he's already swimming quickly through a maze of icebergs and we will soon lose sight of him from the deck. The boat crew must put on immersion suits in case they fall in but they are struggling with the unfamiliar zips and Velcro. Eventually they scramble down the rope ladder, Jason starts the outboard and they're off. By now the bear is just a distant head. Steinar and I guide the boat towards him by radio.

On the distant ice we can see two dark shapes. At this range it is hard to tell whether they are seals until the bear surges from the water onto the same floe. The shapes do not move: they must just be blemishes on the ice. Perhaps he also mistook them for seals.

'When bears are hunting they can swim a long way underwater and change course if they think you are following,' Steinar says. 'They'll surface behind some ice to check where you are, just by smell. It's easy for them to lose you.'

He says that 'fjord bears', like this one, behave differently from the bears on the pack ice because their hunting grounds do not melt in the summer. Some use the same fjords for many years and they will also take nesting birds. Steiner and I are hoping to film a bear searching for eggs or chicks, when the *Havsel* drops us on the other side of the fjord tomorrow – today actually; it is already after midnight.

The boat is returning and, although the bear did not find any seals, everyone comes aboard smiling. Ted plays back his rushes and it is clear from the first shot that this is something special. The camera tracks smoothly alongside the bear as he swims. We are at his eye-level, almost in the water with him. Ice drifts through the frame, sometimes blocking him from view then sliding aside. He feels close enough to touch but the lens is so powerful and the boat so far away, that without his monitor Ted could not see the bear at all. When he climbs onto a floe, rings of light, reflected by the ripples of his swim, travel his full length, defining every curve as if the sun is scanning him. It's a promising beginning: if he had found a seal to hunt, the pictures would have been extraordinary. In the final image Ted has framed the bear with the light directly behind him, so his warm breath condenses in a golden cloud.

It is three o'clock in the morning. To celebrate filming our first polar bear we eat some of the world's most northerly bananas, then, in the silence of the fjord, we fall asleep.

f

One of the many explosive devices in the *Guns and Ammo* box is a tripwire with four spring-loaded launchers, which can be placed around a tent, allowing campers to sleep without nasty surprises. A visiting bear is supposed to displace the wire and trigger the flares but sometimes this goes wrong. On one occasion Svalbard University sent out a group of scientists, one of whom was a professor called Bjørn. It's a common name in Norway but 'bjørn' also means 'bear'. The group camped for the night and carefully set up the tripwires and flares around their tent. In the small hours Bjørn woke up needing a pee and left the tent quietly, remembering to step over the wire. On the way back he forgot and the exploding flares woke his friends, who grabbed their guns in a panic, expecting the thin walls of their tent to be shredded at any moment. All they could hear outside was the professor shouting in Norwegian: 'It's bear! It's bear!'

Steinar and I are also expecting to camp, so he takes me through the guns and ammo in order to avoid any similar mishaps. There are four signal pistols, which can fire flares, two handguns in holsters and two cans of pepper spray. We will also take a rifle.

'Take care with the spray,' he says. 'If it goes in your face you'll be really sick, in bed for two days.'

He tells me that the guns will always be loaded because it will be too late to start fumbling for ammunition if a bear appears nearby: 'In Longyearbyen there's a polar bear incident about once every ten years, but five times a year people fire bullets by mistake. Film crews worry me the most because I think one day someone will pick up a gun to pose for a photo and shoot the photographer. Guns are more dangerous than bears.'

We are going to a place called Mushamna, where there are two cabins close to a huge colony of Arctic terns. A few weeks ago a woman called Linda arrived to spend a year in one of these cabins. After talking to her on the radio Steinar has changed his mind about camping. Linda says that a large number of bears have been visiting her cabin – there were three yesterday – so Steinar is hoping we might be allowed to stay in the second cabin instead.

f

A pan of noodles is bubbling on the gas stove. It is ten at night and we have just finished making the cabin habitable. It is almost filled by the single bed we've built from wooden slats, bales of straw (intended as bedding for Linda's dogs) and our equipment cases. The tiny window is too narrow to admit more than a bear's head but the walls are flimsy and so is the door. When it's closed, bent nails stick through the wood like claws. For perhaps seventy years, summer and winter, this hut was home to a succession of fur trappers. They must have been hardy people and very familiar with bears. A hundred metres away is Linda's sturdier cabin, built more recently using driftwood logs from Russia, which wash up on the beach. Beside it there are two kennels, an outhouse and a tall A-frame.

Steinar has kindly chosen the first night-watch and once the noodles are done I'm going to turn in. He says he is happy, with a beer cooling in the stream, his cigarettes and coffee, a book and a view of the sun turning the northern sky to gold. He will wake me if a bear comes or when he can't stay awake any longer. We are doing this, not just because the hut is too small for us both to fit inside, but because Linda was right about the bears: their tracks are everywhere. Earlier we followed footprints through the snow to where one of them had slid down a slope on its belly, giving a leisurely push on one side then

the other, each time leaving the marks of five claws. Through the bin-oculars we followed the prints around the bay until they climbed an apparently sheer cliff and meandered to a halt, where the bear himself lay curled up. Young males like this one are particularly untrustworthy. Steinar says they have recently left their mothers and he describes them as spoiled, still expecting every meal to be provided: 'They are insecure and they'll have a go at anything.'

It is obvious why so many bears are coming to the cabin. Linda feeds her dogs with seal meat, which she stores high on the A-frame. Its smell must carry for miles and the bears find it irresistible. Even though it is out of reach, they watch the meat store closely and they are clever enough to exploit any lapse. Jason told us earlier about a bear that had watched him all morning as he carried seal carcasses up a ladder to a similar store. When he stopped for a rest, the bear noticed that the lad-der was still there and climbed it without hesitation. It knocked some meat down, then tried several times to descend the ladder head first, before realising it would be easier backwards. It's this flexibility that makes bears successful as well as dangerous.

As I fall asleep in the hut I'm aware that something is missing. We have not yet searched for the Arctic terns but their colonies are always noisy places and I cannot hear the cacophony of their voices. We will have to look into it in the morning.

Steinar wakes me at six. It is cold and the sky is veiled. He points out that the bear in the distance has not moved. It is lying flat on its chest, watching us. He says they sometimes make the child's mistake of hid-ing their heads but leaving their backsides showing. This one blends in so well with the snow and the stony ground that it would be easy to walk almost on top of it.

'Remember – the bear that gets you is not the one you've seen,' he tells me, and goes inside to 'start the machinery'. Within minutes the wall at my back is vibrating in time with his snores. The hut blocks the view inland, so I walk round it, checking that there are no bears in that direction. Linda's dogs are asleep outside their kennels. They should bark if a bear approaches, so I can safely look the other way.

A single Arctic tern flies over. *Sterna paradisea* is his formal name,

the paradise tern, and with good reason. He flies with slow wingbeats, exaggerating his shape and showing off his tail's gorgeous streamers, which seem as long as knitting needles. He points his blood-red bill at the ground and his black cap glistens. A female takes off and flies close behind until he lands and droops his wings, crooked at the wrist. He points his tail skyward and struts on legs that are barely more than landing gear. I've probably just watched him walk as far as he will ever need to. He weighs about as much as a hamster, but he's flown from the Antarctic to be here and three months from now he will make the same journey in reverse. The latest research shows that, in their lifetimes, some Arctic terns will fly the equivalent of three times to the moon and back. The pair take off and cross a snow patch where their shadows are banished by the rebounding light: ice-birds gleaming against the sky. But where are the rest of them? When Steinar was here at this time last year he could not leave the shore without being hit by terns defending their nests. This year there is still snow on the beach and the late spring seems to have forced most of the terns to move elsewhere.

In the Arctic, conditions change so much from one year to the next that the risk of failure is very high, for birds and for people too. Arctic terns live a long time, so they can offset occasional bumper years against several bad breeding seasons, but it is much more of a gamble if you have to stake everything on one attempt, like the balloonist Andrée, or us.

f

To keep myself awake I walk along the beach, holstered like a gun-slinger and feeling ridiculous. Steinar has left the rifle propped against the wall. I have not dared to ask him whether he has ever had to shoot a bear, in case the answer is yes.

On the sea, two red-throated divers yowl like cats and, where a ridge cuts off my view inland, a little face pops up as if it's spring-loaded. It is the colour of coffee and cream, heart-shaped with copper eyes and a black button nose. It's an Arctic fox: all nerves and curiosity. It ducks behind the ridge and reappears closer. The American writer Barry Lopez described one, 'tapping the air all over with its nose', and this fox does that now, scenting me and deciding whether to approach or flee. A pair of terns dive to peck its ears. It ignores them, searches

left and right, then crouches to paddle at something with its paws, and quickly eats one of this year's few eggs. The terns are in a frenzy, but there is little they can do on their own. A busy colony in full cry would be a different matter. The fox finishes its meal and bounds away like a hare.

It's a long time before I notice the bear and then the surprise is like a jolt. Shimmering air blends her shape into the stones, but she is definitely coming this way. Steinar leaves the hut before I can call and I am grateful to have him standing by me as I film. The bear leaves the water's edge and turns towards us. There is something fascinating about the way she lifts and places her paws, folding each one below her belly while it travels, then flicking it at the last moment to place it deftly on the ground. Around each one there's a fringe of fur, muffling the sound of her feet on the pebbles. She sticks out a dark tongue, as if she's tasting the air, coming closer all the time. Through the camera I can now fill the frame with her head. She is not looking directly at us, but I can see her eyes turning. They are small and brown. She is fifteen metres away, crossing the stream where Steinar cooled his beer, the same stream I am standing in, filming her feet scattering spray: a polar bear splashing through water, an image of the Arctic summer.

She is so close that I can see her whiskers catching the light, as the fur does on her long throat when she sniffs the air. From the corner of my eye I see Steinar braced like a policeman in the movies. He is cocking a gun. She is far inside the safe distance we were shown on the rifle range, the distance at which we were supposed to open fire to guarantee a kill, but the training course was about aggressive bears: bears that have not responded to flares, bears that are charging at us. Steinar has read her body language and he is aiming a flare pistol, not his revolver. He knows that she wants to reach the A-frame with its delicious smell of seal. She passes without a backward glance.

The dogs bark. The door of the larger cabin opens and Linda hurries out with her rifle on her back. She too is holding a flare launcher. She aims it above the A-frame and fires. There is a loud explosion and a puff of smoke against the sky. The bear scrambles wildly for a grip on the stones, sprints to the shore and swims away. It is the sixteenth time Linda has had to scare a bear away from her cabin, and now she has to coax her dogs from their kennels. They hate the bangs too.

When the bear has gone, Linda asks us to help her fish. Laying

her rifle on the beach, she wades into the water and I can see why she has been reluctant to do this on her own. It would be a compromising position to be found in by a bear. She pays out a net and fixes it to a buoy offshore. An hour later she pulls the net in and untangles a beautiful Arctic charr, a fish like a salmon but with a red belly and fins edged in white. Linda invites us to dinner.

We find her standing by the window of the kitchen-cum-living room, making fish cakes and watching three Arctic foxes chasing each other across the beach. On the snow bank in the distance is the pale smudge of the sleeping bear. This is one of several cabins owned by Svalbard's governor and loaned to people on the condition that they live as traditional a life as possible, which includes hunting for food and trapping foxes for their fur. Norway's claim to these islands is contested by Russia, and in future it may be necessary to prove that Svalbard has long been occupied by Norwegians who have lived off the land. The benefit is that a few lucky, self-reliant people like Linda can borrow a cabin in the high Arctic for a year. In the summer at least, life here is not as tough as I was expecting: she offers us wine and apologises that she has no dill, although the fish cakes are delicious without it. The winter will be a different matter.

Linda tells us that last year a man was living here with his teen-age sons when they had an accident. The boys set out on a three-day trip by dog sled, to visit a trapper in a cabin in the neighbouring fjord. Their dogs chased a bear onto thin ice and both sledges broke through: the boys found themselves swimming. They managed to climb out and searched for their emergency beacon to call for help, only to realise that they had packed it on one of the sledges. One of them had to dive back in to retrieve the beacon and by now both were in desperate need of shelter and warmth. By luck the accident had happened close to an unoccupied cabin where they had spent the previous night. They made it back inside and barely managed to start a fire with their frozen fingers. The rescue helicopter picked them up an hour or two later.

'The last thing everyone does before they leave a cabin is to lay logs in the stove and put matches beside them,' says Steinar. 'It's such a simple thing but it has saved many lives.'

To survive here for a year, Linda will need to know all these tricks and more. Her bookshelf occupies the length of one wall: medicine sits alongside polar history, dog diseases beside cookery books. She talks

about the year ahead: how the social life will soon fade and that from September until Christmas she expects no visitors. She worries that some of the bears are becoming used to her flares, while her dogs are doing the opposite, bolting inside when they see a bear, in case Linda makes more frightening bangs. She and Steinar discuss the case of a man who shot a bear to protect his dogs. Svalbard has clear rules about this: it is only legal to kill a bear if it is threatening a person's life, but the man argued that, by killing his sled dogs in winter, that's exactly what the bear was doing. With her own dogs outside the cabin and the winter approaching, these are vital concerns. As we leave to go back to our vigil, Linda says she doesn't expect to be lonely through the dark months to come. Most of all, she says, she is looking forward to having time.

It is my turn to be on watch through the night and I sit outside the hut, realising that I am beginning to grasp what it means to be a polar bear: it is normal for them to walk 100km (60 miles) between meals, or to swim twice as far in water that, even in the summer, might never reach 6°C (43°F). It is normal too for the females to fast for six months, while they give birth and suckle their cubs in dens under the snow. They can dive ten metres to the seabed, run as fast as a horse and crush a seal's skull with a single blow, then climb to the top of Svalbard's highest mountain, just to see what's there. Afterwards they might sleep for a week. No other animal on Earth can do all these things and few are so resourceful. It's clear, though, that with hardly any terns nesting, we will have to look elsewhere if we are going to film hungry polar bears hunting birds.

The night passes quietly, no bears visit and in the morning we pile our equipment cases on the shore and wait for the *Havsel* to pick us up. The sound of her engine throbs through the fog. There's the usual flurry of loading, of hurried goodbyes, and we climb into the inflatable boat. When I look back, Linda is halfway to her cabin: a small upright figure with her dogs at her side. I wonder at her resilience and that of the trappers before her, who spent their winters in the little hut with bears at the door and only their dogs to help them. I admire the quiet confidence that comes with solving your own problems, using skills acquired

through decades of experience rather than on training courses: lessons learned as much from failure as success. Most of us who have specialised as cameramen, accountants or whatever else, have lost the chance to be as self-reliant as Linda or Steinar. Our ancestors had their kinds of skills and it's our loss that most of us do not.

As the *Havsel* leaves the fjord I wonder what it will be like here in a few months' time, when the terns have flown south and it is pitch dark at noon. Then Linda's only link to the outside world will be the satellite phone she uses to collect emails. To avoid spam messages she has asked her friends to include a password in the subject line, so each email she receives will be titled 'sol': the sun.

Meanwhile, we have bears and nesting birds to find. Steinar says we are going to one of the most impressive bird colonies in the Arctic.

AN UPDATE ON SVALBARD'S BEARS

*S*valbard's polar bears come ashore from a large area of the Barents Sea, which surrounds the islands. For a century, hunters killed 300 bears here every year. Their numbers have been recovering since the hunting stopped forty years ago and there are now about 3,000 bears in the Barents Sea population, but their boom times may be coming to an end: some are noticeably thin, perhaps because they are competing with each other for food, and in the south of Svalbard, female bears have fewer surviving cubs in years with less ice. The same effect has been seen in the Beaufort Sea in Alaska. There, in 2005 (a year when the sea ice reached a record low) a fifth of the female bears could find no food and polar bears were seen hunting and eating each other for the first time. In another low-ice year, one collared bear in Alaska swam almost 700km (435 miles) in nine days, searching for ice and seals to hunt. Doing so cost her a quarter of her weight and her cub's life. As climate change melts the ice more polar bears will face these risks. Being forced to spend more time ashore is also likely to bring them into closer contact with people.

For now, many of Svalbard's bears opt to live on the sea ice all year, while fewer 'fjord bears', like the first one we filmed, stay close to the islands. Linda became very familiar with some of these during her year in the cabin at Mushamna, especially the ones attracted to her store of seal meat. It was catch 22: she needed her dogs to protect her but their food was irresistibly attractive to bears.

Her blog contains a fascinating account of her year. Early on she wrote, 'I enjoy the beauty of the changing light. I know why I am here when I see white mountains and clear sky, with stars and a glimpse of the aurora. It is nothing but beautiful,' but by mid October the sun had set for the last time

and it would not rise again until the following March. Then the first determined bears came calling in the dark. She recounts that at times there were too many for her to leave the cabin unattended.

'I made good use of the little window in the door. I got a glimpse of the back of the bear standing by the stair and was happy for a solid door! I chased him but did not dare to follow him further away.' She found relief in the full moon, which seemed incredibly bright in that snowy place.

'I keep wondering who turned the light on. The mountains are shining. It's like a fairytale landscape when the soft light gives shadows to sea cliffs covered by ice and snow.'

Just before Christmas the governor of Svalbard sent a helicopter to deliver presents: fresh fruit, mail (including a small Christmas tree) and a companion who would stay for the next month or so. There were still bears to chase away (on around 300 occasions in total) but there was also time to decorate the tree and do country dances. On Christmas Day, looking forward to the light returning, she wrote, 'For now the star on top of the tree is our sun.'

Her dogs slept outside, even at minus forty degrees, but her skidoo and everything else mechanised stopped working in the cold, so she skied to check the fox traps, towed by her ever-enthusiastic dogs. By late January the frozen landscape was incredibly quiet: even the bears had mostly gone elsewhere as the dogs' food had dwindled. At noon there was a glow in the southern sky but Linda could still see the stars overhead; then came a storm bringing more than a metre of fresh snow in an hour and almost burying her dogs in their kennels. While she was working hard to collect and melt almost a ton of snow for drinking water, the side of the store collapsed and dumped burning wood on the cabin's floor. In a wooden building with such deadly cold outside, fire is a greater threat than any number of bears. Luckily she heard the stove break and was able to put out the flames.

One morning she woke to find two polar bears mating outside her window and soon afterwards the eider ducks returned: 'The fjord is completely calm … it is like time is standing still. It might be lonely up here, but at least we have the most beautiful choir.'

She had been on her own for a month and was craving company more than she had expected: 'Sometimes when I woke up in the morning I did not want to get out of bed … In my dreams there were people, so I just wanted to sleep and have company.'

In the far north the light returns astonishingly quickly and by mid April

Linda realised it was already light at midnight. She found it hard to believe how dark it had been just a few months earlier, and 'that we had to dress up in four layers of clothes just to go out and have a pee.'

Spring came a month earlier than the year before – no wonder the Arctic terns had seemed nonplussed when Steinar and I were filming them – and by Midsummer Day the eiders and terns had started nesting. On the solstice Linda put her Christmas tree on the fire. Her time at Mushamna was coming to an end: 'My last week was full of feelings and impressions ... even chasing polar bears for the last time felt sad ... I guess a part of me will still be among the terns, eiders and floating ice.'

Since then she has had a little boy. Steinar is his godfather. As a reminder of the time she spent with the bears she has put one in her son's name: Sigbjørn. Linda is looking forward to him growing up in the high Arctic.

'I think the everlasting changes are the reason why people love Svalbard so much: fear and joy, darkness and sunlight, changing seasons, happiness and excitement. All in one.'

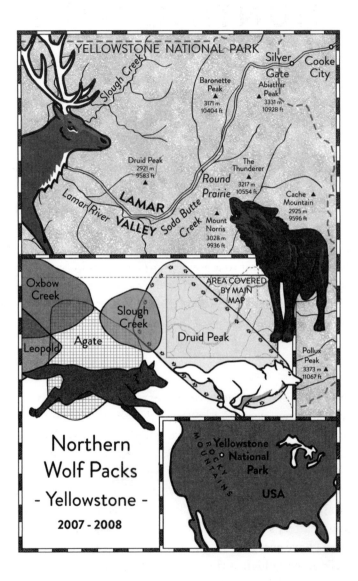

YELLOWSTONE NATIONAL PARK

Slough Creek

Silver Gate

Cooke City

Baronette Peak
3171 m
10404 ft

Abiathar Peak
3331 m
10928 ft

Druid Peak
2921 m
9583 ft

Round Prairie

The Thunderer
3217 m
10554 ft

Cache Mountain
2925 m
9596 ft

LAMAR

Lamar River

VALLEY

Soda Butte Creek

Mount Norris
3028 m
9936 ft

Oxbow Creek

Slough Creek

AREA COVERED BY MAIN MAP

Druid Peak

Agate

Leopold

Pollux Peak
3373 m
11067 ft

Northern
Wolf Packs
- Yellowstone -
2007 - 2008

ROCKY MOUNTAINS

Yellowstone
National
Park

USA

HUNTING WITH WOLVES

The difficulty of filming polar bears made me appreciate the importance of belonging to a good team, like ours in Svalbard. Teamwork proved vital on another shoot the same year, for a series about Yellowstone National Park, where I was asked to film wolves hunting elk. This is something rarely seen, let alone filmed.

f

The sun breaks the horizon of the Lamar Valley, adding little warmth. The sky has been clear all night and the air is crystalline with cold. Flowers of frost bloom on dead stems and diamonds flash on every surface. Cottonwood trees make dark shapes, cut from a sparkling field of snow. The last of the water vapour freezes into angel dust – specks of ice, glittering and spinning like mayflies. When the light strikes them they form a rainbow. The air smells of gunpowder and tasting it is like touching a battery's terminals with my tongue. The valley is colder than anywhere I have ever been and when I blink, my lashes freeze closed. A line of elk glows golden as they wade through the deep snow. They are keen to leave and I am not surprised. On the hill above us the female wolf, Dull-bar, howls and far away a lone grey male replies.

f

National Parks have been called America's best idea and Yellowstone was the first. The park covers 9,000km² (more than 2 million acres) in the Rocky Mountains of Wyoming, Montana and Idaho. It encompasses high peaks, forests, meadows, hot springs and geysers, and it was established so long ago that as many of its visitors have been killed by Nez Perce Indians as they have by bears.

By the 1870s America had been settled from coast to coast and the first transcontinental railroad had shortened the journey from the eastern cities to the western state of Oregon from six months to six days. The country was undergoing immense change when an unlikely idea surfaced: that some remnant of its vanishing wilderness should be preserved, 'for the benefit and enjoyment of the people'. Wilderness, though, means something different to everyone and ever since the National Parks were set up there have been arguments about how they should be used. Recently these differences have come to a head in Yellowstone, not least because of wolves.

The park's campsites and lodges close for the winter. In a gas station that's about to turn off its pumps, I ask the checkout girl about her plans: 'I'm going back to the real world,' she says, but for a growing number of people Yellowstone in winter *is* the real world. Many come here for the same reason as I have: to see the wolves.

As well as filming them hunting I have been asked to reveal the subtle relationships within a pack. There is nowhere better in the world to do this, but filming them will still not be easy. Even in the National Park wolves are wary of people and by midwinter they will be able to move more easily than I can, through the knee-deep snow. It will be impossible to follow them on foot, and anyway it is against the law to disturb an endangered species, so most of the filming will have to happen from the roadside. There is one thing in my favour: when the wolves' breeding season starts some of them might try to find mates outside their own packs and that might bring them within range of the camera, perhaps even giving me a chance to film them hunting.

When Nathan, the film's director, and I drive into Yellowstone, we take the only road to be kept open by snowploughs all winter. It's a 90km (56-mile) journey through the park's north-east corner, ending in Cooke City, where we'll be staying for the next month. The road crosses a bridge high above the Yellowstone River and in the middle we meet a herd of bison. We are not sure what to do so Nathan turns

off the engine and the bison approach in a dense mass. The bridge is narrow and they pass on both sides of the car, brushing its wing mirrors with their curly hair. Their down-curved horns are level with our heads and dark liquid eyes roll sideways to look at us. Their breath steams in the cold. The females weigh half a ton and the single bull almost twice as much. A calf prances down the road behind them, with its shadow projected onto its own exhaled breath. The bridge vibrates in time with their hooves. Nathan and I sit completely still until they have gone. The rules are different here. In the world outside, animals seldom have the right of way.

Yellowstone is the only place in the United States where bison have lived continuously since prehistoric times, but by 1903 there were just twenty-three of them left in the park and they were not breeding successfully. The continent's once vast herds had already been shot to oblivion. A few captive survivors were brought to join the small wild herd here and they made a crucial difference. Since then Yellowstone's bison have slowly recovered.

The wolves had an even harder time. There were once more than a million grey wolves in North America and they killed animals from the settlers' herds as readily as they hunted elk or bison. Killing wolves to protect cattle was seen as a matter of pride and necessity for ranchers and the government. Even living in a National Park was no protection. When the Secretary of the Interior protected most of the park's animals from hunting in 1883, the regulations did not apply to wolves and everyone shot them, including the army. The last two wolves in Yellowstone were killed in 1926 and, with their main predators gone, the park's elk boomed. They overgrazed the plants, suppressing other herbivores, such as beavers. To redress the balance, and amidst great controversy, in 1995 and 1996 a government agency brought thirty-one wolves here from Canada and released them in the Lamar Valley, close to Druid Peak.

Our journey takes us past this mountain, which gave its name to the first pack of wolves to live in its shadow in seventy years. The Druid Peak wolves thrived here, among the naïve herds of elk. In time the elk numbers started to fall, of course, but there are still plenty here and this morning we can see their tracks in the snow, as though they have been writing their stories on a page: stories about their search for food and shelter during the night, about their urge to seek safety with others and

sometimes even the story of their death. All the valley's recent history is laid out for anyone to read, until the next snowfall wipes it clean. Most of the female elk and their calves are high on the hillside, digging with their front feet to expose sparse, dry grasses. Perhaps they feel safer up there, where the snow is not too deep to run away. Even so they are barely scratching a living, becoming weaker every day and a little easier to catch. By the end of the winter some of them will have had to absorb the marrow in their own bones.

A raven passes overhead, flying high and direct. We follow its line across the river and it leads us to the wolves. The whole Druid pack is gathered in a clearing on the forest edge. We watch them intently, studying how each wolf fits into its extended family. Some are curled up asleep. One stands off to the side, leaping again and again, trying to bite a dangling pine cone from a tree. When it succeeds it immediately drops the cone and starts to chase its own tail. A dark wolf, clearly subordinate, greets the palest one, wagging his tail and squirming as low as he can, to lick her muzzle. This is how the hierarchy works, each pack member is in its own place below the pale wolf and her mate: the alpha pair. It's fascinating to see this played out, but there are sixteen wolves to keep track of and there's a kilometre or so between us. To the naked eye they are not much more than dots. To film them closer than this we will need to find and follow them every day, but wolves can travel enormous distances in just a few hours and for two-thirds of our time here it is going to be dark.

Each year since the wolves were reintroduced, scientists have fitted some of them with collars carrying radio transmitters. Rick McIntyre is a biological technician for the Yellowstone Wolf Project. His job is to monitor the radio collars in this part of the park and to record as much as he can about the behaviour of the Druid Peak wolves, and several other packs too. We find him by the roadside, surrounded by a large group of people with telescopes on tripods. Rick is staring through his own telescope and patiently describing exactly where the wolves are, using rocks and trees as landmarks, so the visitors can find them too. He raises an aerial, turns it this way and that, while listening for the collars' beeps, then changes the orientation and listens again. He speaks into a pocket recorder: 'OK, 569 is there right now and so is 480; 302 is out of sight somewhere to the right.'

On their way here, other people have seen different wolves. Like

Rick's, their descriptions are a jumble of numbers. Nathan and I meet Laurie, a visitor who has spent years watching Yellowstone's wolves. She explains to us how to tell the sixteen Druid wolves apart. Eight of them are black and eight are 'grey' (actually a sandy and dark mixture, quite like a pale German Shepherd). Four are collared and known by numbers: 569F is the beautiful alpha female, so pale she is almost white. Her mate, 480M, is the black alpha male and his brother is 302M. The other collared wolf is also a male. Laurie says male wolves are collared more often than females because they stop to look back at the helicopter carrying a biologist with a dart gun, instead of making straight for the trees. Once the scientists have collared the unconscious wolves they move them to the centre of their territory and revive them together. It's safer than waking up alone, feeling groggy, with another potentially hostile pack nearby.

Laurie carries on listing the Druids. It's a dizzying mass of information. There are six yearlings, some with marks on their fronts and sides, like the grey bars that separate the black wolves known as Lightbar and Dull-bar. Most of these yearlings are the alpha pair's pups from two summers ago, which the whole pack helped to raise. They are all female. There are seven younger wolves too, the most recent pups, now fully grown. None of them have names and even Laurie finds them hard to tell apart. She recognises this group by the ruffs on their necks, which look like raised hackles, and because they behave like pups too: it was probably one of these we saw jumping for the pine cone. Identifying the wolves is the vital first stage in predicting what they might do. It could make all the difference between being in the right place or the wrong one when it comes to filming. There's a lot to learn and we have a month in which to do it.

The visitors have come from a wide range of countries. Many have seen and been captivated by these wolves on television or on the internet: the Druids are the most famous wolf pack in the world and the most watched. The male numbered 302 is everyone's favourite. He was nicknamed Casanova when he was young, for the daring liaisons he had with females from other packs, under the noses of their own males. He even has his own blog, run by someone in Florida. Since the demise of the Plains Indian tribes, a century or more ago, people have rarely connected so strongly with wild wolves. Such empathy is possible only because Rick, Laurie and many others have spent an immense amount

of time coming to know individual wolves and their stories. During our time in Yellowstone, Rick passes his 2,555th consecutive day – that's every day for seven years. When Laurie introduces us he hides his dedication with a joke:

'I once caught a cold in 1997 but I came in anyway.'

Rick welcomes us and explains that the pack usually moves every few days, but this year the heavy snow has kept them in the Lamar Valley for an unprecedented six weeks. Although they have often been visible from the road, they could decide to leave at any time.

f

In the evening there is a fight in one of Cooke City's bars and afterwards we hear engines roaring, as boys from Idaho play chicken with their huge snowmobiles on the icy main street. We had an early night, not to avoid the fighting, but to be up at 4.30 and ready to drive into the park. A dog barks as we leave town. In the Roman world, where wolves were common everywhere, *inter canem et lupum* ('between the dog and the wolf') meant twilight. Cooke City's dogs must be early risers: there is not a hint of light in the sky as we drive towards the park entrance.

Dark mountains crowd close to the road: Abiathar Peak, Mount Norris and the Thunderer. There is nowhere in Yellowstone lower than the top of Britain's highest summit and these mountains are more than twice that high. Through gaps in the trees we glimpse snow-covered prairies, where streams trickle between hummocks as smooth and white as iced cakes. How should we search for a single pack of wolves in so much space? As we near the Lamar Valley the light comes up and we stop to search for wolf-shapes moving on the snow. We study the elk closely, looking where they are looking. They seem relaxed and nothing moves, so we drive on and try again. In each place we listen and finally we hear the Druids howl.

America's early settlers described wolf howls as mournful or blood-curdling, a projection of their own fears onto the sounds made by wolves to keep their packs together and their neighbours away. For a wolf pack to thrive they need the exclusive use of a large territory with plenty of prey. Advertising their numbers by howling together is a show of strength. To us, without any livestock to lose, they sound beautiful, like a choir singing in close harmony. Each wolf joins in with

the others at a different pitch, to give the impression of a stronger pack: one to leave alone. Their voices carry astonishingly far, echoing from the face of the Thunderer and sustained by the distance, long after they have lowered their muzzles. It is wild music I do not want to end.

We find Rick at a place called Round Prairie, checking the signals from the radio collars. He says there are wolves close by, somewhere in the trees, so we set up the camera and wait, hoping they will show themselves. There are seven bull elk in the meadow: enormous deer with pointed antlers, spanning more than a metre (3ft) on either side. They seem very wary, eyeing the shadows. Perhaps the wolves are just checking them, staying out of sight rather than facing one down, as Rick says they sometimes do to test its resolve; daring the elk to make the first move.

The signals fade. The wolves are moving away down the valley, hidden by the trees. We follow along the road until they appear on the far side of the river, trotting in a line: first the alpha pair then 302 and a few of the others. While the adults have been away another wolf has used their absence to introduce himself to the younger pack members. He's a lone grey male. The yearling females are particularly pleased to see him and there is a great deal of sniffing and tail wagging. The lone wolf knows he is taking a risk and when he's spotted by the returning Druid males, 480 and 302, he immediately breaks into a run. They give chase but the alpha male soon stops. His brother 302 runs on. He has more to lose because he'll be able to mate with the young females in his pack, as long as he sees off the competition. The interloper runs in a loop, knowing his pursuer will follow his trail by scent rather than cutting the corner, which allows him to check whether he is still being followed. He is, and 302 chases him into the distance.

One of the young females, Dull-bar, leaves the others and, nose to the ground, she follows the lone wolf's tracks. Where I would just see a set of prints in the snow, her sensitive nose can pick up a far richer story, of exactly who has passed, when and sometimes even why. The drawback with smelling footprints is that she cannot immediately tell which way the male has gone, and she trots in the wrong direction for a while before returning to lie in his tracks with her ears pricked. Her

father, 480, comes to sit beside her and a silent message passes between them. Laurie speaks it out loud: 'What are you doing here, young lady?'

Dull-bar has the most to gain if she can meet the interloper. He is a potential mate with different genes to the males in her own pack, but while her dad and her uncle are on guard she may never have the opportunity. When 302 returns he is walking stiffly. At eight years old he is getting on a bit for a wild wolf, so perhaps Dull-bar will have her chance after all. Except for the alpha pair, most adult wolves try to mate outside their pack and some, like 302, even manage to change packs and keep the rare ability to move through others' territories without being killed. There is clearly a good deal of politics among wolves.

We watch the Druids for some hours, hoping that the lone wolf might return. Alongside us is a local cameraman, Bob Landis, who has worked here for years. He has an uncanny knack of being in the right place to film wolf behaviour. Like everyone else, Bob is generous with his knowledge. He says an essential skill for filming in Yellowstone is being able to find one of the few parking spots, and nipping into it quickly. It is an offence to stop anywhere else.

A couple of visitors arrive and tell us they have been watching a black wolf teasing a bison, just around the corner. The grey interloper joined it and they played together in the snow before the black wolf waded into the river. For twenty minutes it chewed a carcass in the water. We know all this because the visitors photographed every stage and kindly came back to show us, once the wolves had gone. There can be few places in the world where more natural drama happens, and hardly any others where you know so precisely what you have missed.

f

Snowflakes settle on my sleeve: ephemeral hexagonal beauties, melting away but soon replaced by larger clumps of snow, millions of tons of it, falling from the sky across the Rockies. It accumulates overnight and covers the bison where they sleep, as if they were boulders. We have yet to film any interesting wolf behaviour and the clock is ticking. We hope the heavy snow might keep the wolves in view a little longer, by making walking difficult, but when we see Rick the next morning he has bad news. Three of the radio collars are out of range and the signal from the fourth is so faint it could just be an echo bouncing off a mountainside. It

seems the wolves have moved far away, despite the snow. This is what we have been dreading, that they will leave the valley and the area's only road.

The snow has made the tarmac treacherous. We drive slowly and come across several cars stuck in ditches. The bison are taking things slowly too, all of them are still asleep under the snow, except for one big bull who is almost invisible in the hole he has cleared to reach the grass, sweeping the snow away with his head while ice cakes his muzzle and his lashes.

By the afternoon there's a gale blowing. The sky, the ground and the trees have all turned white but it doesn't matter, because the wolves are back. Perhaps they found the drifts were too deep to cross. The blizzard clears enough for us to glimpse them bedded down on the mountainside and showing no sign of moving. Even through a telescope they are easy to miss. It is best to look at them slightly askew, like searching the sky for a faint star. They have not left us after all and we may have another chance.

That chance comes when the storm blows through. It's Sunday morning and quiet on the road. Rick's car is parked again at Round Prairie and so is Laurie's. Nathan and I are the only other people there. It's still almost dark. The forest is a shapeless mass whose shadows lie like blue icicles on the snow, but the radio collars' signals show that all the collared wolves are hidden among the trees. Perhaps the whole pack is there.

Rick is the first to see them: two wolves dart from the shadows and run across the flank of a small hill, almost a mile away, and merge with the dark shape of the rest of the pack. It is hard to see what is happening until a single large form breaks free and plunges down the slope into deeper snow: it's a bull elk, dauntingly solid, deep-necked and fast, but the wolves are faster still. The whole pack streams after him, stretching out in huge bounds and disappearing to their bellies with every leap. The yearlings lead the chase, fast and light across the soft surface. In seventy metres they have caught up with the elk and are holding his neck, his flanks and rear. He wheels and bucks, trying to break their grip, sweeping them away with his antlers, but as each wolf leaps clear, more bind on.

Beside me Rick's soft voice calmly records the time and describes

what is happening: 'The bull's head is down, a black wolf has him by the throat.'

The elk stumbles twice and recovers but the third time there is no coming back. His head sinks, his antlers move with less force and the pack merges into a seething pool of darkness.

'The killing grip: 302 on the throat,' says Rick, emotionless. The tide of wolves rises and the elk vanishes as completely as if he had dissolved.

None of us cheer the wolves' success. We would look askance at anyone who did. A feeling, thinking animal has lost its life but the wolves have to kill in order to eat. In our past we have been there too: both as predators and as prey, though in the latter case only very rarely of wolves. Nathan and I had both hoped the elk would escape, even though filming a hunt is at the top of our list. Its last minutes were sanitised by the half-light and the distance, so we were spared the snapping teeth, the blood on the snow and the rattle of its dying, but we can too easily imagine being chased and pulled down by the pack.

In a year only a handful of people will see a wolf pack catch an elk, and fewer still will ever film it. Today we are not among them: it was too dark for the camera. Rick notices that we are subdued and asks, 'How was the light? Ah, I see – I'm sorry.' We tell him how privileged we feel to have seen the hunt and his reply surprises us: 'Many people would have cussed their luck instead of making the most of being here. You are setting a good example.'

He turns back to his telescope, to record who gives way to who. It's valuable data about the pack's hierarchy, which may change as the younger wolves mature. He points out that while the others open the carcass and feed, 480 and 302 are waiting to one side: 'Perhaps they have broken teeth or maybe the alpha male just figures he does not need to peel his own potatoes. He could be waiting for the best food.'

Wolves are built like Olympic athletes and they carry almost no reserves of fat: otherwise it would be impossible to chase and bring down animals so much larger and stronger than themselves. The elk's meat will be very lean too, which makes its fatty internal organs the wolves' favourite parts.

Now the ravens are coming, ten of them, black, like flakes of the night. Today is the thirteenth anniversary of the wolves returning to Yellowstone.

f

As we learn more about the Druid pack and become better at identifying individuals, it's satisfying to add our sightings to everyone else's. Like all visitors to the park we must strike a crucial balance: watching the wolves but not changing what they do. Drivers can separate them by hurrying to intercept the pack when the wolves cross the road. This can leave some of the youngsters isolated, howling for the others, wasting precious energy and unable to hunt.

More days go by, cold days spent scanning the hills but seeing little. We have one or two close encounters with the lone grey male who is still hanging around the fringes of the Druids, but the other wolves keep their distance. Ravens, perched like black pears in a tree on the far side of the valley, show us where the pack has killed during the night. They make up for the paucity of other birds in the winter by calling in a hundred voices. One crouches with his nape ruffled and knocks like a wooden glockenspiel, his wings jerking with the effort. He is calling others to feed.

Since the snowstorm the wolves have not tried to leave the valley. After so many weeks trapped in the same place the elk must know them very well, but their knowledge does little to protect them in the dark.

f

Spending our days by the roadside, looking for wolves, means we are meeting more people than I usually would when I'm filming wildlife. Some have little to say, except perhaps that they need the bathroom, 'not imminently but, like, soon, you know?' Others have strong opinions, like the rancher towing a snowmobile, who stops to ask what we are looking at.

'There is a pack of wolves over there on the valley side.'

'Darn things. Our ancestors tried real hard to be rid of them. Should never have been brought back.'

Many people share his feelings. One of the first pairs of wolves to be released here soon left the park, and the male was shot by a man opposed to the reintroduction. He beheaded and showed off the corpse to make his point. When the heavily pregnant female denned nearby and gave birth to their pups, a team of biologists searched for the family

and brought them back inside. One of those pups became the alpha male of the Druid pack.

Some of my ancestors would most likely have agreed with the rancher. There is a place near my home in Scotland called Wolf Island. It has not seen a wolf in more than 400 years and most of the livestock farmers who have lived there since would have been glad about that, if they even knew. People wiped out Britain's wolves by much the same means as they did in America, yet we have more in common with wolves than we care to admit: like us they live in extended families, showing great loyalty to their group and even cooperating to raise each other's young. We share their darker side too, sometimes unleashing violence to defend or feed our families. No wonder the hunting tribes of North America admired these consummate predators, and no wonder herdsmen have always hated them. The earliest farmers found they could best protect their flocks by turning the wolves against themselves, taming and converting them into domestic dogs.

Attitudes have been gradually changing and now, for many of us, wolves epitomise what wilderness means. People have discovered that they care whether wolves exist, not just to manage the elk population but for the same reason it's good to know that Yellowstone exists: wild places and wild lives like these are ideas to cling to. In a fast-changing, man-made world they offer us the possibility of escape, even if we never take it up.

Later, someone else pulls over on the roadside and tells me that she sometimes takes a captive-bred wolf into schools, as an 'ambassador' for his species. Before one such visit a class had drawn what they imagined the wolf would be like – all sharp teeth and snarls, like the wolves they knew from fairy tales. After meeting him the children drew quite different pictures: a wolf whose fur was soft, with bright eyes and enormous paws.

f

The weather is bad again and Rick can see all the Druid wolves bedded down on a distant ridge. There is no more data for him to gather so we talk about his work. He describes it as being more like anthropology than zoology, as if he has come to live among a tribe in order to work out, just by watching them, why they behave the way they do. Wolves

are profoundly affected by each other and they are so adaptable that on different days the same animal may make different choices, when to us the circumstances seem identical. This makes them endlessly fascinating to Rick. To show me what he means, he describes Dull-bar's dilemma: as a junior female she has to choose between mating within her pack or looking outside. An outsider would be less closely related to her, so he'd make a better mate, especially if they could stay together and set up a new pack of their own. Her problem is that, in Yellowstone, all the territories are full and the established packs will attack new settlers. It would be safer for her to mate and then come home to have her pups, but playing safe also has its downside: to ensure that their own future pups won't go hungry, the alpha pair will hound the pack's other females, even their own daughters like Dull-bar, to prevent them giving birth to pups of their own.

A few days later the wolves show us exactly what Rick means about their adaptability. Bob Landis has found a black wolf where the visitors had photographed one chewing the elk carcass in the river. By the time my assistant, Kathy, and I arrive the wolf has gone but the remains of the elk are still there, just one antler and a few bones. The channel is a few metres wide and at first glance it seems quite ordinary, then Bob points out other antlers showing above the water. Several elk have died here. There is something else unusual about this river: although the air is so cold it's freezing the fingers inside our gloves, the surface is not completely iced over. Bob explains that the water is kept warm by a plume of magma underlying the park. There is less heat here than at the hot springs and geysers around Old Faithful, but it's enough to keep the ice at bay. While we wait Bob describes how he has seen the park change since the wolves came back. The artificially high elk population has fallen by a half and the wolves' numbers are now being limited by competition for food and by packs fighting over territory.

We stop talking instantly: the lone grey interloper and a black female wolf have appeared from the trees. The male waits on the bank and watches her wade out to the sunken elk. A magpie flies to perch on its antlers, looking down as she chews the shoulder bone, but the wolf drops no scraps. Through the lens I can see her whiskers, covered in

frost, and her amber eyes. She turns to look directly at me. It's the first eye contact I have had with any of the wolves. After twenty electrifying minutes she wades ashore and they leave together.

All this time I have been gripping the tripod's handle. It is made of very cold metal and my fingers feel like icicles when I try to warm them inside the neck of my shirt. The nights here are much colder than this and the wolves spend them outside. Their fur must be superb. It's a relief to pack up and put some warmth back into our legs by walking back to the cars, which is when we see what a terrible mistake we have made by leaving: a bull elk breaks from the forest, with the whole Druid pack hard on his heels. He makes it to the river just ahead of them, splashes into the water and lowers his antlers to hold them at bay. He is standing exactly where we were filming just now. The dead elk were not in that bend of the river by chance.

We rush back up the road, furious with ourselves for giving in to the cold. The elk is still there, standing his ground with water up to his belly. The wolves are on both banks, surrounding him, but whenever they enter the river he thrashes the water with his hooves and lowers his antlers to stop them reaching his throat. The adults recognise the stalemate and move off to rest a few hundred metres away, but the yearlings and pups are reluctant to leave while there is such a large deer close by. Although they feint and rush at him, he always spins to present them with a face-full of antler tines. The alpha female rests her head on her paws and watches. It is easy to imagine that she has done this before and that she knows the elk will not be able to stand in the water for ever. He is chilling fast and when he leaves he will be weaker: so she waits.

Gradually the yearlings lose interest until only one grey is left, lying on the bank. The elk judges his chance has come and he starts to walk slowly downstream, stepping absurdly high, as though he is tiptoeing away and hoping not to be noticed. When it seems that none of the wolves have seen him, he climbs the bank and makes for the trees. The grey yearling springs up and the other young wolves join her. They turn the elk and he bolts back to the river. Fifteen minutes later he tries again and this time most of the wolves barely raise their heads as he runs. Only the grey yearling chases him into the trees. The rest of the pack rouses and follow the same line until they disappear, far away. It's all over.

A group of visitors has accumulated around us during the drama

and now we all stretch and blow on our hands. The others drift back towards their cars but this time Kathy and I linger, despite the gnawing cold. I can't think what else to do and I still wish I had been here when the elk ran into the river. It would have been the perfect beginning to our sequence about how flexible and intelligent wolves are when they are hunting.

The others have reached the cars and I am starting to wonder how much longer I can take the cold when the entire scene is played out again: the same bull elk charges from the trees, directly opposite the river, and the whole pack chases him straight towards the camera and into the water. It's exactly the shot I had hoped for.

This time the adults rest immediately and most of the younger wolves join them. The cold water saps more heat from the elk's belly and legs. When the last young wolf drifts away he climbs out stiffly. There is ice glinting on his fur. To my surprise the wolves watch him go, until he reaches the forest and disappears. Only then does the alpha female lead the others to the river, where she sniffs the elk's footprints thoroughly. She chooses the most recent set among the confusing mass of tracks and follows them, with her nose to the ground and her pack close behind. They enter the woods exactly where the elk did and this time they do not reappear.

An event like this is almost impossible to predict, but with help from many people and a bit of luck we have managed to film the wolves hunting after all, and they have shown us how adaptable a pack can be when it has a clever leader. Trapped in the valley, the elk have been learning to hold their dangerous neighbours at bay, but the wolves have been learning too. The alpha female especially seems to be playing a long game, testing the elk for weakness and coming to know many of them individually. Who knows what clues her extraordinary sense of smell has gathered about this bull's condition, after his long spell in the water? Perhaps he will survive this latest test, but the wolves now know exactly how weak he is and where he is most likely to run next time.

Snow starts to fall as we leave the valley, gently erasing the record of the drama by the river and wiping the page clean for tomorrow's news.

f

My last sight of the Druid pack is of the alpha male leading the way up a steep slope. He moves powerfully through the snow. At this range the wolves could be a line of people, with a father breaking trail for his family: fourteen of them following him, stepping exactly in his footprints. The whole pack apart from Dull-bar.

She is on a different hillside with the lone male. They are bounding together through the powder and coming up for air like dolphins, in showers of white spray. Somehow the interloper has called her out from her pack, under the noses of her father and her uncle, much as the young 302 used to when he was known as Casanova. They chase each other along the skyline, pausing at a single pine to check it for scents. The male wags his tail and follows Dull-bar onward. Mountains fill the space beyond them, fresh cast in white metal and sharp in the intensely cold air. Every shadow is filled with reflected light.

Rick murmurs observations into his recorder. He's smiling. It's time for me to go: I thank him and as he turns back to his 'scope Laurie gives me a hug. I understand now why Rick spends every day here. It's a wrench for me to leave while Dull-bar's story is still unfinished, to no longer have any sightings to share with others who admire and appreciate Yellowstone's wolves. Many of our best achievements come from dedicated groups like this: we are like wolves in that respect as well.

On the drive I savour the wildness of the Lamar Valley for the last time, passing the landmarks of the weeks I have spent here: the silhouetted trees where the angel dust danced in its own rainbow, the prairie where the pack hunted in the dark and Rick said 'well done', the ordinary-looking bend in the river where the extraordinary bull elk saw off sixteen wolves and where the alpha female showed me why she is the leader of her pack.

As I pass under the Roosevelt arch at the park entrance I see Yellowstone's founding statement reflected in the mirror: *For the Benefit and Enjoyment of the People*. National Parks have moved on now, and quite rightly: they are as much or more for the benefit of the elk and the wolves and all the wild things living there.

f

The silver river gives way to fast-food joints and car dealerships, to the geometric shapes and garish colours of the 'real world'. One of the

park's visitors told me that hearing a wolf howl would not have mattered to her ten years ago, but now it does and this is why: the wolves' world is more real than where most of us live.

I spend my last night in Montana in an old hotel in Livingstone, where two rocking chairs rest side by side in the quiet corridor, like an elderly couple, comfortable with each other's silence. An antique elevator, operated by a lever like a ship's telegraph, is a welcome respite from modern America. It takes my mind off the sense of loss.

That evening, when I break the seal on the camera case, I find the astonishing cold of the wolves' valley stored there, deep inside the metal and glass, like a memory.

AN UPDATE ON YELLOWSTONE'S WOLVES

*W*hen I filmed the Druid pack in the winter of 2007/8 there were 170
wolves living in Yellowstone. A year later there were only 120. The
deaths were caused by infighting over territory and access to the herds of elk,
which had continued to shrink and adapt to their predators. Other wolves
died of distemper, complicated by mange. Of the Druids' pups born the next
spring, just the alpha pair's survived. Only one other pack had any surviving
pups and four packs dissolved completely. In August 2008, 302 split off from
the Druids with some of the young males we had filmed. They formed a new
pack with three females from elsewhere. He became the alpha male and had
six healthy pups of his own. A year or so later, the nous that had helped him
slink through other wolves' territories unscathed finally let him down and he
was killed in a fight. That autumn, the Druid's alpha female was also killed
by other wolves. Her mate, 480, survived, but all their pups died and for
him it was the end of the line. He could not breed with any of the remaining
females because they were all his relations and when another male moved in,
480 left the Druids and was not seen alive again. His sons and some of his
daughters left too, reducing the pack to five. In 2010, the last radio-collared
Druid wolf was shot by a rancher outside the park.

We were lucky to have filmed them when we did. Other wolves have
now occupied the Lamar Valley but with the elk population at a more natu-
ral level their numbers will never match the Druids' in the glory days of
2001, when their pack was thirty-seven strong: one of the largest wolf packs
ever seen.

In May 2011, Yellowstone's wolves were officially downgraded from
their protected status. Perversely it was a sign that the reintroduction had
worked, but the change proved deadly for many of them because they could

now be killed legally outside the park. Montana and Idaho quickly issued hunting permits and annual quotas. In 2012, they were joined by Wyoming, which allowed wolves to be killed without a permit in more than 80 per cent of that state and hunted as trophies under licence in the remainder. For the first time since they had returned, the National Park's wolves were being hunted on every side. In 2013, a record 12 per cent of them were killed.

After a legal challenge a year later, a federal judge ruled that Wyoming's policy was not appropriate and returned the responsibility for managing the state's wolves to the government, restoring some degree of protection. A similar decision was reached earlier in the year regarding wolves in the Great Lakes states, which restored their 'endangered' status there. No doubt these rulings will be challenged in turn. Meanwhile, wolf hunting and trapping continues in Montana, Idaho and elsewhere.

Within Yellowstone's boundaries there are now around 100 adult wolves. In 2014 they had about thirty pups. Perhaps these young wolves will grow up to be more wary than their parents, of the traps and guns waiting for them outside.

Rick is still doing a sterling job. At the time of writing he has been there every day of the week for nearly fifteen years. He reckons he has talked to more than 700,000 visitors about Yellowstone's wolves, which he watches with as much interest as ever. As he puts it:

'How could I stop now? It's an ongoing story, like living through the Civil War or the Russian Revolution.'

The Peregrines
of
New York City

Circles show the
approximate locations
of some of the city's 17
peregrine territories

Riverside
Church

Throgs Neck
Bridge

Hudson River

MANHATTAN

East River

Brooklyn
Detention
Complex

QUEENS

BROOKLYN

Verrazano
Narrows
Bridge

CANADA

UNITED
STATES
of
AMERICA

New
York
City

PEREGRINES AMONG THE SKYSCRAPERS

Other reintroductions have been less controversial than the wolves'. New York City is not an obvious place to film wildlife, yet it's home to one of the world's most exciting birds: the peregrine falcon. This bird of prey has come back from the brink. In the twentieth century peregrines were all but wiped out in America. The story of their recovery shows that, given a helping hand, some wild animals can adapt well to the modern world.

f

A policeman spills his coffee, sets his car's wheels spinning and zooms away, with blue and red lights flashing.

'We got a deer dying on the approach way, we got a cat on the upper roadway, we got falcons on the tower: it's like being back in the country,' says the manager. 'Welcome to the Verrazano-Narrows Bridge.'

The bridge was built during the 1960s: a time of confident expansion in the United States when, alongside ambitious engineering projects like building the Apollo moon rockets, the country's chemical industry was in full flow, producing a miracle pesticide called DDT. Seeds were soaked in it before being sown and tractors sprayed it onto orchards and fields. Crop yields soared as a result.

When the bridge was built across the Hudson River, at the

Verrazano Narrows, it had the world's longest span, suspended from cables almost a metre thick, running from towers more than 200 metres (about 700ft) tall. The peregrines are nesting on top of one of these towers so filming them will be complicated. Without Chris Nadareski it would be impossible. Chris works for the city's Department of Environmental Protection and every year he visits all the accessible peregrine eyries in New York City, to fit numbered and coloured bands (known as rings in Europe) to the legs of their chicks.

We each put on a harness and a hard hat and are driven in a slow convoy across the bridge to the base of one of the towers. It soars above us like a huge staple. The traffic lane is closed while we unload our gear and take turns to duck through a door small enough to challenge some of today's larger engineers. Inside there are hot, cramped metal cells, studded with bolts on every surface. The sound is extraordinary: a bass rumble of traffic on the bridge's twin six-lane highways, stacked one above the other. Sometimes there are loud and inexplicable booms, as if we were deep in the guts of an iron beast. There are very few lights. The elevator is just large enough for three of us. It feels like squeezing into a suitcase. The controls have notes beside them, handwritten in correcting fluid: *TOP* next to one button and *Don't press, don't press!* by the one above it. Clanking upwards, we all look through a hole in the ceiling, watching the cable winding into and out of the darkness. To reach the uppermost level we climb through circular holes cut in the steel decking, hauling our gear after us with ropes.

When Chris opens the hatch onto the roof there is a welcome flood of fresh air and immediately we can hear the peregrines' alarm calls. He climbs out and I set up to film. We must all leave once the last chick is banded, so there is not much time. The top of the tower is a smooth metal surface, enclosed by a low rail. The bridge below has shrunk to the width of a pencil and its trucks are the size of rice grains. A container ship passes easily beneath the span. I don't mind the height but I am worried about the consequences of dropping anything over the side, so I tuck everything loose into my bag before concentrating on the job in hand, which is to film the peregrines as they hurtle past.

They circle, superbly indifferent to the gulf of air below them, taking turns to dive at Chris's head. He approaches their nest, which is in a wooden box, roofed with plywood and floored with pea gravel. Chris put the box here to encourage the birds to move home because their

old eyrie, under the bridge, was in the way of maintenance work. They adopted the new one the next spring. I can see him deftly checking the four young falcons and fitting their bands. The bridge maintenance crew crouch, holding brooms over their shoulders to protect the backs of their heads. Chris takes the chance to show them what he is doing. Part of his skill is in explaining why it matters to balance the birds' needs with theirs. After all, 190,000 vehicles cross this bridge every day and it was no small ask to interrupt the traffic so we could come up here. By placing the peregrines' nest box where the birds will have the least effect on the workings of the bridge, Chris is giving something back on their behalf.

On the way down, the guy in the lift says he grew up on Staten Island, where he could see the bridge being built from his house. On its opening day his parents drove him here, intending to cross, but the sign above the toll-booths brought them to a screeching halt. Fifty cents! They drove straight home. That was in 1964.

In the preceding four years, not one pair of peregrines had bred anywhere on the eastern seaboard of the USA.

f

During the 1960s Professor Tom Cade, of Cornell University's Ornithology Lab, realised that something was wrong. As well as being a scientist, Cade was a falconer and he loved peregrines. His research, and others', proved there was a connection between the high levels of DDT accumulating in birds of prey and their inability to raise chicks. Top predators such as peregrines were swallowing the chemical whenever they ate birds that had fed on treated seeds or insects. Cade even found DDT in peregrines in Alaska, far from sprayed fields, and concluded that they had encountered the poison while on migration. It so weakened the falcons' eggshells that the incubating adults crushed them, killing their unborn chicks. Peregrines faced extinction in America and wherever else DDT was used.

Cade came up with an ambitious plan. He founded the Peregrine Fund to breed the birds in captivity, on an unprecedented scale, and to release them into the wild. If it worked they would at least have a better world in which to hunt because, by 1972, Cade's research had helped win the fight to have DDT banned. By then it had been found in

animals all over the globe, even Adélie penguins in the Antarctic. The Peregrine Fund's first captive-bred birds hatched the following year, but the most difficult part of the plan to bring back the peregrine still lay ahead.

f

I have been asked to film New York's peregrines for a programme about urban wildlife, being made by a producer called Fredi. He dreams of filming a city peregrine hunting to feed its family, among the skyscrapers of Manhattan. It would be the ultimate proof that the falcons have adapted fully to life in the city. Filming a peregrine hunting is one of the hardest things a cameraman can do. They dive at more than 300kph (up to 200mph), often from such a height that they are invisible to the naked eye. Just following a fast-stooping bird through a long lens is hard enough, never mind the difficulties of keeping it in focus, and to make matters worse they often travel so far that their stoops end out of sight. That problem at least would be eased by filming from higher up. In the wild that's only possible if you can find a convenient hill but in New York it's easy. When Paul, the programme's researcher, reads out Chris's list of peregrine nest sites, it sounds as though he is describing the city itself: there are several hospitals, skyscrapers overlooking Park Avenue, America's tallest church, a detention complex and many bridges. They all share the thing most useful to us and the peregrines: elevation.

We are captivated by New York's peregrines as soon as we step onto our first rooftop, which belongs to a building directly opposite the tall church. The male peregrine (called a tiercel) from the pair nesting on the church tower rides the wind up the vertical walls and passes us slowly, just beyond arm's reach. The skin around his beak and eyes, and on his legs, is the same bright yellow as the taxis in the streets below. He seems completely at ease in the upper air among the towers, where light bounces from building to mirrored building, dappling some like skin and banishing shadows from dark corners. He hardly glances at the city's people and its cars crawling far below, as if they were sea creatures on the bottom of the ocean.

f

Matt, a peregrine expert, stands beside me, to help spot the falcons and their potential prey. Paul and Fredi station themselves with radios on different corners of the roof. Feathers swirl in bright eddies against its plain surface: the glinting wing feathers of a jay, flashing indigo and blue. We stand near the edge with a wall of metal shutters at our backs. To our amazement, the female peregrine lands on it, less than twenty metres away. In the countryside, birds would be far more wary than this. She is larger than her mate and more heavily built. Her talons scratch a little on the metal as she rouses, opening her feathers for a shake, then preening them in the sun. This pair have chosen well: from their nest behind a gargoyle they have clear views across Harlem and the Hudson River. Their neighbours are carved devils and animals: a winged demon on a throne rests his chin on his hand, contemplating several big cats and a wicked pelican. All of them leer at us across the void. The tiercel perches on a stone lion, gripping its ear with his long bird-catching toes. His front is pale and streaked while his back is a subtle two-tone grey, like the carbon-fibre housing of the camera. With his white mask and black helmet he looks like an assassin: one whose home is a church. He stands as perfectly still as the gargoyles and stares intently across the river.

This pair must be good hunters. We saw their five chicks yesterday, when Chris took us up the church tower to fit their bands. He had moved the young birds from the nest into a cluttered room, where elevator motors whirred. The female was so defensive of her family that when Chris went to lift the first chick, she flew at his face with her talons outstretched. Astonishingly he caught her calmly by her legs in the split second before she struck, then put her in a box where she would not harm herself while he worked. He joked that over the years he has 'had the honour of multiple body parts being autographed' by falcons' talons. As soon as her chicks were back in the nest, Chris released the female and she settled at once.

From our filming position on the roof we can see messages drifting up from the streets. They are printed on helium balloons and they are always the same: *Happy Birthday!* Usually the birthday balloons come in ones or twos but this morning forty pass together, hinting at a day's lost profits or a party spoiled. They separate and drift among the buildings, rising over some and between others, revealing the air currents the falcons ride so effortlessly as they search for prey below them in the deep. It's breezy down there too, where a bride struggles to control her

billowing dress. Laughter rises above the sounds of traffic. So does bird-song from the park. The peregrines watch these other birds like hawks (of course) but they'll be hard to catch as long as they stay close to the trees. The falcons watch the river too, where reflected light makes patterns on the surface like a leopard's fur. While we wait, the shadow of a tall building creeps across the water: a gnomon in the largest of sundials.

The tiercel takes off and accelerates astonishingly quickly, pumping his wings. He has spotted the flicker of wings, catching the sunlight a kilometre away. Through the long lens I can see that it's a grackle, flying above the river's far bank, which is so distant that with my naked eyes I can't even make out people. The grackle sees him coming and at the last moment dives into the trees. The tiercel returns to perch on a different gargoyle: a stone bird of prey, whose hooked beak and talons are just like his own, but it has flowers for its eyes. Beside him rows of stone saints gaze vacantly across Manhattan.

On the stroke of five the church bells chime in chorus while, on our rooftop, more secular air-conditioning fans come to life. As we leave the building the lady behind the reception desk asks, 'How's my birds?' and we pass the pipe band of the New York Fire Service, arriving to practise in their kilts.

f

First saints and now sinners: above the door of the building we are facing in Brooklyn, it says *Department of Correction*: it's not quite *Abandon Hope All Ye Who Enter Here* but it's near enough. There are high walls, surveillance cameras and coils of razor wire. Outside, a policeman patrols on foot. He's armed, of course, and when Fredi runs up behind him, to explain why we are pointing a long lens at his jail, the rest of us wince at the potential for misunderstanding. When he comes back, un-arrested, Fredi says, 'People have been filing complaints about voodoo rites – it was the peregrines, dropping dead pigeons at their feet. I asked him about filming them and he just said, "God bless …"'

The policeman is not the only one who's interested in what we are doing. A woman stops to ask, 'What are you filming?'

'Falcons, on the jail.'

'Felons?'

'No, falcons. Birds.'

'Boids? Boids? I thought you were paparazzi and it must be some high-profile criminal that was in there. We get them around here too, you know.'

This pair of peregrines have chosen to nest behind a grating in a ventilation shaft in the detention complex's wall. To reach their chicks the adults have to break into the prison by squeezing between the bars. With a little more height we would be able to see into their nest, so Paul has cleared the way for us to film from the roof of a building nearby. On the way up the stairs we ask the owner whether he is hoping to be paid and if he thinks anyone will mind us filming the jail. He says, 'I don't much care for money. Don't much care for rules neither.' He points out the liquor store down the street and leaves us to it.

A peregrine's shadow, sharp-edged and curve-winged, slides across the prison's walls. Prisoners are playing basketball inside a wire cage on the roof. They stop and stare at us, miming, 'What are you filming?' Fredi points at the falcon, perched on a light fitting nearby, and waves his arms like wings.

'Birds?' their blank faces signal back. 'Really?'

She is plucking something in a blizzard of feathers. Some float across the road and Fredi catches one: another jay. With the extra height afforded by the roof, we can see her chicks inside the shaft. They are real jailbirds, pushing their heads through the bars and testing the metal with their claws. Matt can sex them by their size: the females are larger. They line up to watch the sky and all three pan their heads around as if they were one, to track passing pigeons. The pigeons fly low and fast, aware of the risk from the peregrines but getting on with their lives like pragmatic New Yorkers. The young falcons are no threat yet. Their down is slowly giving way to brown feathers and it will be some weeks before they can fly. They take turns to exercise their wings, blasting dust through the grille. We leave the roof when it starts to rain.

Thunder echoes through the canyons of New York and the spray from tyres, lit by the headlights behind, makes the cars look rocket-propelled. The tops of the buildings have vanished into cloud, which makes them seem to go on up for ever. The uppermost windows of the Chrysler Building glow yellow through the mist, as if a spacecraft was hovering there. An ambulance passes, hooting like a gibbon, and in the distance a fire engine seems to answer with a primeval wail, forlorn and fading, calling for company and finding none.

f

Hunting does not come much harder than catching a bird in flight, yet peregrines do almost nothing else. In the wild the parent birds will feed their young until they have learned how to intercept their prey at blistering speeds, but when the Peregrine Fund freed its captive-bred youngsters, they had to manage on their own. In all, 6,000 were released in places where they had lived before DDT took its toll. Chris Nadareski joined the army of helpers who kept the birds alive by providing them with food while they taught themselves to hunt (a process called 'hacking back'). The peregrines' recovery was slow at first because the young birds were vulnerable without their parents' protection. Many were killed by golden eagles and great horned owls. The eagles avoid urban America and the owls are less of a problem there too, so the Peregrine Fund tried something bold. They released some of their birds in New York City.

f

From fifty storeys up, on top of a skyscraper, I look around midtown Manhattan. The surrounding buildings have plenty of ledges for falcons to nest on but they can be dangerous too. Distorted reflections of taxis and people slide along walls made of glass and metal. Some almost perfectly reflect the sky, so puffy clouds disguise their hard surfaces, and at night many windows will be brightly lit. It is a complex and confusing home for the fastest animal on Earth and it was by no means certain that the peregrines would be able to adapt, yet they did. The first two pairs nested in New York City in 1983, on the Verrazano-Narrows and Throgs Neck bridges. Chris Nadareski had been inspired by the work of Tom Cade and others to study the falcons as they recovered. He says with pride that the city has the highest density of urban peregrines in the world. There are seventeen pairs in the five boroughs, soaring and nesting among New York's tallest buildings, on its bridges, its offices and the penthouse mansions of millionaires. Some have even learned to use the city's lights to hunt birds migrating above it at night, and their street-wise youngsters are helping to repopulate the countryside.

The falcons were there too when the Twin Towers fell. Chris talks quietly about joining the bucket brigades: the human chains that

moved rubble away from Ground Zero by hand. Among the chaos of that dreadful day he looked up to see a pair of peregrines passing overhead. It was a reminder, he says, that good can follow disaster and that lives can be repaired.

ϟ

Between stints spent on the roofs we drop down to the city's parks, to film one of the reasons that the falcons are doing so well here: New York has a thriving population of feral pigeons. These birds are the descendants of wild rock doves, coastal European pigeons, which were carried around the world by human colonists and kept for their eggs and meat. They adapted easily to the man-made cliffs and caves of city buildings and they have become so ubiquitous that we barely notice them. On the wild coasts of the Old World these birds were the peregrines' main prey, so it was a boon for the falcons to find them already established in New York and many other cities. Pigeons are far from easy to catch – they have spent millennia under the falcons' unwavering gaze and they have evolved their own ways to escape. With a special slow-motion camera we film pigeons turning completely upside down as they take off, then righting themselves within a body length. This ability to jink in flight can save their lives.

For experienced peregrines flying is easy: gravity powers their stoops and sunshine warms the air, which raises them again without a flap, but finding suitable targets is much harder because the pigeons do not fly far and they stay low over the streets. The falcons' technique is as simple as it is effective: they go very high and use their exceptional eyesight to search, like the NYPD helicopters sharing their airspace.

We watch one pair scanning the surrounding space from the silver pinnacle of the Chrysler Building, in unconscious mimicry of its art deco eagles. Their other favourite hunting perch is the navigation light on the tip of the Bank of America tower, almost a quarter of a mile above the ground. When the tiercel stoops from there he folds his wings into a teardrop shape and hurtles through the lesser buildings, past mirrored glass, past steel and concrete, past video screens flickering green and red: falling like a meteor. He could almost have left a flaming trail or bubbles fizzing in his wake. When the pigeon sees him coming it dives for its life among the water tanks and rooftops. This time the

tiercel rises with empty talons to graze the reflection of his wingtips in a sheer glass wall, entirely at home.

On other days we film the peregrines chasing a pigeon out over the Hudson River, where there is nowhere to hide. The pair work together, taking turns to stoop until the tiercel binds on, then circles with their prize in his talons, calling to his mate. She flies up to receive the bird as he lets it fall and carries it back, to pluck and feed it to their chicks.

f

While we are in New York a rare alignment of the sunset and the city's cross-streets means the sun will touch the horizon exactly at the end of 42nd Street. This is close to where we have been filming, beside the beautiful Chrysler Building. When astrophysicist Neil deGrasse Tyson noticed this coincidence, which happens on a few days every year, he pointed out that future anthropologists might argue that the city's grid of streets had been aligned with the sun for just this purpose, like Stonehenge at the summer solstice.

Of course there is no significance to the alignment of New York's streets, except that their regularity makes it easier to navigate, but the sight is said to be spectacular, so we join the group of photographers looking down 42nd Street. Many have been waiting for hours in the hope that the showers will pass and the horizon will clear at the right moment. Everyone yearns for the perfect image of the sun, framed and reflected by the city's gleaming walls, while the tail lights of taxis stretch into the distance like a thousand suns in miniature. As the time approaches it is easy to grow excited with the crowd. DeGrasse Tyson encapsulated the feeling that the natural world has aligned with our own by naming this event 'Manhattanhenge'.

At the last moment the clouds break and the sunlit street becomes beautiful. People worship the moment with their cameras then rush to be the first to post their pictures online, to tweet their versions of 'I am here. Now'.

No doubt we will always look for patterns in the world around us, for significance, even where there is none. For real significance I look up to the Chrysler Building, where a soaring peregrine catches the light of the setting sun and burns there like a star.

AN UPDATE ON NEW YORK CITY'S PEREGRINES

*T*aking your first flight is dangerous in the wild but flying from a building carries extra risks – the fledglings could easily end up among the traffic. That is exactly what happened to two of the birds we had filmed at the Brooklyn Detention Complex. Fortunately for them, Barbara Saunders, a biologist who works for the New York State Department of Environmental Conservation, was on standby when their time came to leave.

'I'd get a call, sometimes from building personnel at the nest site, or from someone who'd spotted a youngster on the street. I'd pick it up and drive it out to New Jersey to have it checked for injuries at the Raptor Trust. If all was well, back the youngster would go to the nest site for "take two". One week I was out there every day. I called myself the Peregrine Limo Service.'

When the first of the Brooklyn females squeezed between the jail's bars and launched herself out over the street, her maiden flight did not go too well: she fluttered down and was hit by a bus. A local person saw the collision, put the young bird in a box and took her to a veterinary surgeon, just half a block away – there are some advantages to being a city falcon. The vet called Barbara and the Peregrine Limo Service rolled into action.

Another of the Brooklyn youngsters crash-landed and was rescued by local people. It ended up in an even stranger situation than its sister.

'These neighbourhood guys were incredible. They managed to catch the falcon and put it under a lampshade. It kept trying to pop out so they added a second lampshade but when that didn't help much they replaced it with an upside-down laundry basket, topped with a brick ... New Yorkers are a very resourceful bunch!'

Off went the young peregrine to the Raptor Trust. She was not injured and after a rest and some food she was banded and released.

As well as enjoying the fun and games, Barbara is delighted to see so many people involving themselves with their city's peregrine falcons.

Bandhavgarh
National Park
- Madhya Pradesh -

↑ Tala

Lord
Shiva's
Temple

Chakradhara
Meadow

Reclining Vishnu
Statue

Temple and Fort

Bandhavgarh
Hill

Rajbehra
Meadow

Reservoir

Scale (km)

0 1 2

INDIA

Bandhavgarh

Bay of
Bengal

Barhi
Panpatha

Majhauli

Tala

MAP
ABOVE

Dhamok

Baderi

Umaria

BANDHAVGARH
PARK BOUNDARY

-FOUR-

HUNTING FOR TIGERS

Get set for a better tomorrow, 'til then inconvenience is regretted. The
sign in New Delhi's airport reads like something dreamed up by
Douglas Adams. It seems to sum up India's rush to change. Well over a
billion people live here, but hanging on, in a few green places, so do the
last of India's tigers. It's April 2008 and we are flying to the heart of the
subcontinent, which most foreigners avoid at this time of year because
it's so hot. We've come here now as this is the best time to film tigers. In
the whole of India there are just a few thousand left. There are more
than that, in captivity, in Texas. Having such large predators as neigh-
bours is a very different matter from the peregrines in New York City,
or even Yellowstone's wolves.

f

It's ten to five and I'm sitting in the dark, sipping tea. Around me I
can hear the jungle waking up: the sounds of my first dawn at Band-
havgarh. I can recognise some of the birds from their calls, like the
greater coucals booming to each other, but as the chorus builds most
of the birds making it are still a mystery to me. One stands out, with
its call growing in pitch and intensity: '*Brain fe-ver,*' it says, faster and
faster; '*Brain fe-ver, brain fe-ver,*' putting me on edge. As a cameraman
I rely mostly on my eyes but, while we are searching for tigers in Band-
havgarh's tangled forests, I can tell that my ears are going to be working

61

hard too. We have come here to film tigers hunting and what their prey do to avoid being caught. It seems almost impossible and I am worried that we will fail.

As soon as I have finished my tea it's time to go. Before I have fitted the tripod head to its mounting in the back of the jeep the sky has brightened enough to see trees silhouetted ahead of us. Our guide, Digpal, starts the engine. He is a genial Rajasthani, with a jewelled earring, sideburns and a drooping moustache. He wears a leather hat with his sunglasses perched on the brim. Laughter creases his face. The brainfever bird is an Indian hawk cuckoo, he says, and lets in the clutch. In a cloud of pale dust we head for the gates to join our park guide, Ramjas. His embroidered shoes are as colourful as garden flowers, with camouflaged trousers providing the foliage. There is another sign here, a painted tiger with a speech bubble. It could have been written with us in mind:

Dear friends. My sighting in wild is a matter of chance. Single-minded objective for me during park visit, may disappoint you in a great way.

The gates open and as Digpal drives through we pass a man who is beating what seems to be a huge domed rock with a cloth. He is dusting an elephant. It is kneeling as a devotee would in a church, with the wrinkled soles of its feet facing upwards. The man finishes one side and addresses the elephant sternly, asking it to turn around, which it does, rising ponderously and settling again, facing the other way, so the man can dust behind its ears. Digpal waves as we pass and, driving on through the warm air of a ravine among the trees, he chuckles about another of Bandhavgarh's mahouts: a man who was as fond of a drink as he was of his elephant. The elephant's name was Gautam, which in Hindi means 'wise'. The mahout used to ride him to village bars and get drunk. When he collapsed one night some men came forward, intending to harm him, but Gautam picked up his mahout, laid him across his tusks and carried him home. The man has since died but every year his widow travels from southern India to visit the elephant Gautam and bring him a present.

We pass a temple beside the road. It is just four pillars painted green and red, supporting a corrugated roof, with a lingam stone in

the centre and a small bell. Without stopping, Digpal takes both hands from the steering wheel and, in a strangely gentle movement, places his thumbs below his nose, his fingertips against its bridge, then shuts his eyes to pray to Shiva, the Hindu God of Destruction. Ramjas does the same: their hands making synchronised, practised moves, down and up and down again. We are still driving at twenty miles an hour so I'm relieved when Digpal opens his eyes and explains that people who have not seen a tiger sometimes come here to make offerings to Lord Shiva: 'You might not believe it but it always works.'

f

The sun rises: an orange circle above a meadow filled with deer. Moments later it is too bright to look at. The stags strut and bellow around the females, who graze on, untroubled, in the tall grass, lit by the sunrise to the colour of flames. They are spotted deer or chital, doe-eyed and slender, russet with white spots on their flanks like our fallow deer, or white-tailed deer in America, when they are young. Among them walk troupes of elegant monkeys, Hanuman langurs, their long tails held high like thin question marks. Above the grassland and its fringe of forest looms an escarpment, with cliffs whitewashed by generations of nesting vultures, and crowned by a 2,000-year-old fort and a temple.

Digpal and Ramjas are watching the track closely. A snake has left its slither mark in the dust like a mocking echo of flowing water. It has not rained here for many months and the monsoon is still eight weeks away. We pass a flame-of-the-forest tree where macaques have fed, scattering red flowers. Digpal slows to point out some narrow foot-prints with claws: 'A sloth bear, Baloo.' On the trunk of a gum tree there are long incisions where the bear has climbed to a bees' nest, look-ing for honey. At the gate this morning, Digpal had pointed out a man wearing a scarf high across his mouth and nose to hide his ruined lower face. This Baloo is not a friendly *Jungle Book* character. Like sloth bears, tigers are nocturnal, so dawn is a good time to glimpse them, as the night shift gets ready for bed.

Digpal stops the car abruptly, pointing down. There are pugmarks pressed into the dust: tigers' footprints. Ramjas puts both his hands together, side by side.

'Female,' he says. 'Male is this size.'

'Males have pointed toes,' says Digpal. 'Tigresses' toes are round.'

There are smaller marks too, the shape of a domestic cat's. They show that two cubs walked here with their mother. I wish, out loud, that the prints had times marked on them and Digpal says they do.

'These are on top of the jeep tracks from yesterday, so she has made them since the cars left last night, and they don't have any leaves on top of them yet. She was here this morning.'

The deer pay no attention to the tiger's marks. For them, movement, scent and sound are all that matter: signs of imminent danger. False alarms are dangerous too. If you are unsure where a tiger is it is better to stay put, rather than running blindly through the grass, especially in Bandhavgarh which has the highest density of tigers in the world. There are about forty-five of them in its 1,000km^2 (250,000 acres) of forest. The chital outnumber them three hundred to one but the tigers must kill every few days, so the deer cannot drop their guard. In this they have some unlikely allies. The langurs feed among them in distinct groups: mothers and babies in one troupe, with a watchful dominant male, and a separate crowd of rowdy young males causing trouble on the fringes. The monkeys' fur is the colour of safari suits and they have neat black feet, hands and faces. Their eyebrows are bushy enough to rival my dad's and they are champion frowners. While the chital have sensitive noses and ears which are never still, even when they lower their heads to feed, the monkeys have the sharpest eyes. Their lookouts stay in the treetops, ready to bark an alarm. Against this combination even a tiger would be hard put to creep within pouncing distance. The largest predators have a surprisingly hard time, for all their power.

f

Bandhavgarh is a patchwork of meadows between rocky hills and a forest dominated by spectacular trees called sal. Every other plant seems withered by the heat but they are superbly indifferent, putting out new leaves of the most brilliant green. The view between their straight, grey trunks could almost be of beech trees in southern England, but with the colours turned up. This is Rudyard Kipling's jungle, where Mowgli played with Baloo. It is home to Bagheera the panther, or leopard, and their overlord, Shere Kahn, the tiger: a fearsome presence but scarcely

seen. I cannot imagine a better place for him to hide than here, among the trees' long shadows, where light slashes fall on the red-brown forest floor. Filming how tigers hide and hunt in these dappled places strains every sense to detect them. I have never seen a wild tiger and I hope that Digpal and Ramjas can teach me to find them.

Without a sound an elephant walks up behind us. It rumbles and blows a whoosh of air from its trunk. I jump round to find it just a few feet away. We are eye to eye, even though I am standing in the back of the open jeep. It's as shocking as if a whale had surfaced alongside. If I can't tell that a four-ton elephant is coming, what are my chances of spotting a hunting tiger?

'He is Inderjeet, John. It means "indigo", like the colour in a rainbow.'

All the elephants in Bandhavgarh have names: one is called the King of the Forest, another male is Beautiful Elephant. There are females too: one called Storm sometimes badly shakes the people riding on her back. Digpal says another is named after 'the beautiful thing you see first when you wake', a Hindu concept that makes people put pictures of gods beside their beds. One of them is the elephant god, Ganesh, who brings good luck and is always the first to be invited to weddings.

Inderjeet's eyes are downcast, their irises bright hazel under his long lashes. I gently touch his skin, which is soft and warm. It is grey, except on his forehead and at the edges of his ears, where it thins gradually into sparse dots, like a blown-up picture in a newspaper, revealing the pink underneath. He shifts his weight and his rope harness and its massive knots creak like leather. He is thirty years old: creased, pleated and comfortably baggy. He flaps his ears with the sound of a hand being clapped over an open jar. They are the classic 'map of India' shape of all Asian elephants' ears, even seeming to include the Ganges delta, much of which is now in Bangladesh. Inderjeet's ears may not have kept pace with geography but he is our best hope of finding tigers.

High on his back sits the mahout. He paddles the elephant's neck with his bare feet. The instructions seem at odds with the result, as if the driver is frantically trying to backpedal, while Inderjeet makes a series of sideways steps and turns. As he does so he snaps a branch from a sal tree with his trunk, strips off the leaves, which he eats, and tucks the stick carefully between his trunk and one tusk, as I might

store a pencil behind my ear. He will use it later to swat flies or scratch an itch. The mahout waves his radio and says he will let us know what he finds, then paddles again on the elephant's neck and Inderjeet pads quietly away, leaving footprints larger than dinner plates, criss-crossed by pucker-lines in the dust. These marks are as specific to each elephant as fingerprints are to people.

Digpal has been watching him too: 'Once there was an elephant with four visitors and the mahout on his back. They were looking at a tiger when a spotted deer jumped out in front of them. The deer ran between the elephant's legs and the tiger chased it right through as well. The elephant panicked and turned around so quickly that all the people fell off. He ran five kilometres, all the way back to the camp.' Digpal's shoulders shake with laughter.

Jeeps and elephants are the only ways visitors are allowed to travel around Bandhavgarh. In this tangled forest it would be too dangerous to be on foot. Elephants have the great advantages that they can leave the road and they can find the tigers by smell, but filming from their backs with a long lens is nigh on impossible. Sometimes cameramen use monstrously tall tripods, climbing onto them from an elephant's back. I ask Digpal about this and he says that choosing the right elephant is vital: Inderjeet would not be ideal because he is too tall and, while younger ones are keen and fast, they fidget too much to be safe. An Indian cameraman called Alfonse Roy once toppled over when his tripod was nudged by a young elephant. He fell straight onto a tigresses' kill, then picked himself up and filmed her as he backed away, in case she charged.

'He had unusual presence of mind,' says Digpal. 'Most people charged by a tiger lose control of their bladders. Some mahouts make a lot in extra tips when that happens by complaining that they will have to wash the covers on the houdah.'

I stare into the forest on either side as we bounce along the tracks. The more closely I look at the trees, the stranger they become. Some seem to have been shot-blasted or beaten with a ball hammer. Others shed strips of bark like brown paper, revealing smooth green skins. One is a rare and beautiful Indian ghost gum, so pale that it glows by moon-light and soft enough to mark with a fingernail. Another has bark like crocodile skin. These trees show less reserve than the ones at home, fusing with each other, then parting their trunks only to merge again

seamlessly further up. Some are draped with parasitic strangler figs, flowing down and around their hosts as if they were rivulets of molten wax. The figs' limbs will tighten over decades. Any tigers in this patchwork jungle will appear behind a jumble of plants that could hide a thousand big cats. I am struggling because I don't know what shapes to look for between the fast-moving trunks and branches. Perhaps I should be searching for a flicking ear or the twitch of a tail, maybe the shadow of a long back or just a strange stillness in the grass. On my first morning I'm unlikely to see anything at all, but the *sounds* of the jungle are a different matter. There are audible clues everywhere if you can understand what they mean.

Sound matters to our filming in another way. Our director, Mike, is interested in how cinema uses sound to reveal what you cannot see. He has been inspired by the cowboy movie, *Once Upon a Time in the West*. The rhythmic squeak of a wind pump, the drip of water and a buzzing fly were used artfully to build tension towards the inevitable gunfight. Mike wants to use natural sounds to do the same thing in this film: he imagines a bird calling regularly, with the timing of a human pulse, speeding up as the tiger makes its move. The brainfever cuckoo would be ideal. We have an expert recordist with us, Andrew, who will collect the sounds. I need to film shots to complement this approach, hinting at what might happen, as well as showing what does: giving a tiger's perspective of the chital for instance, seen through grass and leaves, and the ambiguous view the deer have, looking back. This is not everyday wildlife filming and I relish the challenge.

We have come to the edge of a small meadow, a cool place of grass and pools between the trees, and when we round a bend there are three tigers lying in front of us, as if they have been carefully laid out on display. We see them so suddenly and so clearly that I'm taken completely by surprise. They are exquisite. The tigress stands and stretches. She has the contained energy and poise of all big cats. In isolation tigers seem almost absurdly patterned, overdone, but the boldness of her stripes and her orange fur fit this forest perfectly.

I scramble to mount the camera on the tripod, desperate not to startle them, groping to plug in the cables, trying not to click metal on

metal. I had imagined that my first wild tigers would seem small compared to those I've seen in zoos, reduced by this larger landscape, but the opposite is true. Another tiger is up and moving: it's a cub as large as a Great Dane. It walks into the grass where twitching stems give away its progress until it emerges beside its mother. They bump heads and rub cheeks. She raises her muzzle and half closes her eyes as the cub brushes under her chin. She seems relaxed and unafraid. The cub rolls onto his back and lies with his wrists bent, his paws above his chest. His feet are enormous: a promise of the power into which he'll grow. The tigress rises with an easy grace and I cannot take my eyes off her as she walks away through the trees, her shoulders rising and falling smoothly under the pattern of her stripes, like a body moving beneath a dress. Her cubs follow, climbing over fallen tree trunks and pouncing on each other.

'They are nine months old,' says Digpal. 'They will stay with her for another year. By then they'll be as big as she is,' and the thought of three huge tigers, strolling together through these woods, makes him smile.

It has become possible only quite recently to make films about tigers and to take photographs of them while you are on holiday. Before 1969, when tiger hunting was stopped in India, they were entirely nocturnal and terrified of lights. Most of India's forests have vanished since then and there are far fewer tigers now, but the remaining ones have learned that they won't always be shot at in daylight and they have become less reluctant to show themselves. It's this change that has made tiger tourism a reality and produced a surge of television programmes like ours, which in turn have increased the number of visitors. Tourism and television can create a rosy impression that all is well in the land of the tiger, yet, in eight years, Digpal has seen at least twenty-four cubs born here while the population has stayed the same. All those young tigers must be going somewhere. Most of them, especially the males, are killed or driven away by adults and forced to leave the forest.

Many Indians are astonishingly tolerant of living alongside such powerful predators. Tigers are protected by law, of course, and the poorest farmers' opinions carry little weight, but it is hard to imagine most people in Britain or the United States accepting the same risk.

Even so, it is a precarious existence outside. The nearest protected forest, with enough food to support a population of tigers, is about 200km (125 miles) away. They do occasionally walk that far across farmed land, but the chance of finding such a rare place is very slim, and most of the young tigers that leave Bandhavgarh are never seen again. Some are poached. Others are electrocuted by fences wired directly into power lines to protect crops from other animals, or poisoned if they kill livestock. Sometimes the authorities send a mahout and an elephant to keep an eye on the tigers that stray outside, and occasionally they take them into captivity, but with nowhere else to release them that is usually a one-way trip.

In South-east Asia, tiger-penis soup costs more than £200 a bowl. It is believed, without any evidence, to boost virility. Tiger-bone wine can fetch £20,000 ($32,000) a case. It is said 'to ward off chills', among other things, but these astronomical prices have more to do with wealth than health. The best chance for India's remaining tigers is to be worth more alive than they are dead, and they certainly earn their stripes: 100 tourist cars means 200 jobs for the drivers and guides, as well as for all the other people earning money from visitors outside the reserve. Even so, the rush to cash in on the tigers can be a problem in its own right.

News of the obligingly visible family has spread quickly. The park's regulations force drivers to take different routes in the morning, to avoid crowding, but this afternoon at least twenty-five cars have come straight here. Many of the guides and drivers greet Digpal respectfully as they pull alongside. He often helps them with money or to sort out problems. Ramjas has been struggling to see his family during the reserve's nine-month open season, because he works every day, but Digpal is helping him to buy a motorbike so he can visit his village in the evenings.

I am in no position to complain about the number of cars because two of them are ours, but I do mind how aggressively some are being driven, especially close to the tigers. Digpal does his best to explain to those drivers that, by being selfish, they are spoiling the experience for everyone. He says that some of them care more about earning good tips than about the tigers' well-being. The others will get no tips at all if they don't seem to be trying equally hard, so there's a race to be the closest. He says he watched one woman throw her camera to the ground, shouting, 'Why are we always last to arrive?'

It's easy for me to see it this way, of course, with the luxury of hav-
ing time to wait for the tigers to come closer, but most visitors have only
a day or two to get their pictures. It's a classic environmental problem,
with everyone scrambling to take a share while it's still there to be had.
This is how people are everywhere, not just in India. When something
is rare, the prices rise: from the tips earned by the pushiest drivers, to
the land sold for building new lodges around the reserve and the prices
fetched by poachers selling tiger bones to the Far East. Even the images
taken by people like me become more precious as the tigers dwindle.

Digpal, typically, points out something positive, which I am
ashamed I had not already noticed: most of the visitors are Indian and
many are carrying binoculars and cameras with long lenses. This is
something new, he says. These are Indians who really want to see their
tigers.

f

By midday the heat is oppressive, especially for someone more used to
filming in colder places. The tigers have disappeared into the shade and
even Digpal is feeling hot. He suggests we visit a statue of Lord Vishnu,
reclining by a spring. It is the only place we can get out of the cars
and stretch our legs. The statue was carved from the rock centuries
ago, in such a way that the spring water wells up beneath its feet. This
is Charan-ganga, a tributary of the River Ganges, which will eventu-
ally flow into the Bay of Bengal, many hundreds of miles away. Gen-
erations of tigers have brought their cubs here, to drink and rest in the
shade. The year-round water supply flows into pools among the trees
and grows lush grass for the deer. Like many of the world's best nature
reserves, this forest was first protected as an exclusive royal hunting
ground, partly because of the water from this spring.

Cicadas start up among the trees, with the shriek of saw blades
cutting sheets of metal: it's a perfect soundtrack for the white-hot sun.
We leave Lord Vishnu and park in the shade beside a meadow and a
small dam, where the deer and monkeys have gathered by the water.
One chital dozes with two monkeys' tails draped like bell-ropes across
her face. The langurs sit with their hands folded in their laps, their
heads nodding, struggling to keep their eyes open. They're at their most
vulnerable now but there is a third lookout in this coalition, a bird the

locals say is so vain about its gorgeous tail that when it sees its ugly legs it can't help but cry. It's the peacock, of course, which shrieks whenever it sees a predator.

A kingfisher splashes into the pool. In the trees around us the baby langurs barely stir. They have their heads tucked into their mothers' chests, their tails hanging straight down. Whole families are fast asleep on a branch. The chitals' sentries are sleeping on the job. I film a breeze stirring the leaves. It is not enough to wake the monkeys but perhaps it will waft the scent of chital towards a tiger's nose. We listen hard but there are no alarm calls. Nothing stirs.

Digpal takes us to the Shiva temple near the reserve entrance. He has brought some coconuts as an offering, in the hope that our filming will be lucky. I have the camera ready to film close-ups of the langurs because the sound of the bell and the coconuts being broken on the stones brings the monkeys running. They are used to people and they settle close by, then one chatters an alarm and all the others spring into the trees. On the other side of the meadow, a tiger is passing through the forest. I film the monkeys giving their alarm calls and the look on Digpal's face says, 'I told you.'

In the afternoon we have a choice: the water behind the dam may bring a tiger down to drink but it's a long shot. On the other hand, the mother and the cubs we have filmed before are more likely to appear, despite the scrum of cars. Andrew needs a quiet place to record, so we leave him by the dam. I admire the way he has involved the guys in his car, giving them their own headphones so they can hear the beautiful calls for themselves, as well as the extraordinary level of quietness he needs to make good recordings. They have become adept at staying very still.

At the tiger family's clearing there is no sign of the mother. Her cubs mostly stay out of sight in the tall grass, so by the time we meet Andrew again, at dusk, we have not filmed much. He says to his guide, 'Will you tell them or shall I?'

After we had left a tall samba deer came down to drink, followed by a tigress, which stalked and chased it into the water. The deer swam across the pool and escaped into the jungle, past Andrew's car. The

tigress was joined by her three small cubs, which spent twenty minutes leaping from the bank onto her back and playing together in the water. No one else was there and Andrew made a wonderful sound recording of their games. We have no pictures to go with it.

During each shoot there is usually just one chance at the thing you really hope will happen and this time it looks like it has fallen to Andrew.

f

A few days later, word comes from Inderjeet Mobile (the mahout's call sign is his elephant's name, rather than his own) that the tigress with the two large cubs is visible again. As we bump on our way, the car scatters masses of butterflies. Their wings flash as purple as the after-image of a welding arc. We are travelling on a track made of smashed bricks and flattened houses. All the meadows here once encircled villages, seven of them, but their people were resettled elsewhere during the 1970s, to make Bandhavgarh the reserve it is today. Ramjas is sitting in the front seat, quietly teasing Digpal. I wonder if he thinks about this every time he passes. His village is in a block of forest adjoining the park and several years ago authority was granted to remove everyone from it, and from ten other villages, then to raze the houses to make more space for tigers. Only regional politics have postponed this happening so far: the delay was a vote-winning exercise. As a guide he is paid six or seven times more than a labourer (plus tips). Even so, for his Rs450 (£4.40) a day, he might soon find himself guiding visitors across the ruins of his family's home. For people like Ramjas, the price of giving India's tigers a place to live has been very high indeed, but if it had not been for the extraordinary efforts made to set up these reserves in the 1970s, there might now be no tigers in India at all.

f

The mahout's report was right and when we turn the last corner the tigress is lying beside the track. There are people here too, many of them in their jeeps, all mesmerised, all quiet. In the heat of the late afternoon we wait for her to do something as the smells of the forest intensify, coming forward and lingering in pockets of warm air. There is a burst of honey, then the intense scent of jasmine from a tamarind

tree. The urgent smell of urine mixed with musk is replaced by spices and green hints of germination, then by something corrupt. Digpal says it is fallen leaves rotting in a streambed, rather than the corpse it seems to be. Gradually the temperature falls from roast to bake and then simmer, until the air feels exactly as warm as my skin. It's a delicious feeling, like being cradled by a warm sea, and it is fittingly dreamlike for being here, beside this tiger.

She stands. Something is moving through the trees, something I can't make out. I start the camera and focus on her face, framed by tall grasses. She is staring intently. Her eyes are a frosty green and they are absolutely still, as if she's taking aim down the length of her nose. Still I cannot see what she has seen. Slowly she takes a step. A fallen branch is blocking her way and by clearing it she will surely make a noise, attracting attention. She gathers her haunches and springs without looking down, without even altering her gaze, and lands in complete silence, as if it were nothing. My reactions are no match for hers but to follow her when she goes I will have to focus and swing the camera in an instant. The tension is immense. I cannot move and nor can she. No monkey or peacock calls.

Muscles bunch under her stripes and she's going! A huge leap and I pan and she's still in frame, still in focus, moving silently and astonishingly fast, in huge bounds away from me and into the forest: the very image of grace and power. I lose her quickly among the trees but I know the shot has worked and I can unwind and smile at Digpal, who is grinning back wildly. Three chital erupt from the grass beside us, where they've been hiding the whole time, and I jump a mile. Rigid with fear, they bark after the tigress, spit flying, stamping their feet.

She returns, this time without prey, knowing that she has been seen and twitching her tail as though she doesn't care. Her cubs are on the other side of the track. To reach them she will have to cross directly in front of the massed jeeps. The people in them are not silent any more and I feel an urge to turn the camera round, to record what this tigress sees: the ranks of jeeps three deep and six or seven wide, the fifty people watching her through their fifty unblinking lenses, the blaze of flash-guns reflected in her wide eyes. It's not that sort of film, I say to myself, half-heartedly. I'm here to film glossy shots of her natural behaviour. They will complement a smooth narration about how a tigress living in a pristine forest struggles to outwit her prey – but I want to shout, 'Look! *This* is what she sees every day.'

She crosses the track and I film her anyway, as she summons her courage, bares her teeth and snarls, facing them down like a harassed celebrity in the limelight. I know the shot will never be used and, of course, I'm part of this paparazzi: my filming will encourage more people to come.

Perhaps all this attention is the price of being rare and beautiful – the price of fame. Like the sign said in the airport, it's another of India's unavoidable inconveniences, to be regretted.

Perhaps also, for the tiger, it's the price of survival.

AN UPDATE ON
BANDHAVGARH'S TIGERS

*B*andhavgarh is closed to visitors from July to October. During that time *a forest watchman was killed, close to where we had filmed the tiger family. He was alone, so the account of what happened was pieced together from where his bicycle was found, abandoned on the track, and from his partially-eaten body, some distance away in the jungle. The park authorities concluded that he had probably been killed by one of the cubs, which had followed him into the trees. Both cubs were darted and moved to a park in the city of Bhopal, where they now live in captivity. Their mother stayed in the reserve. She has not been seen since 2013 but her daughter took over her patch and has raised several cubs there. Like many of Bandhavgarh's young tigers, some of them have been killed by adult males.*

There have been some changes since I filmed there in 2008. Some parts of the park have been permanently closed to tourists and the number of jeeps in the core areas has been greatly reduced, to minimise disturbance. As a result there is less work for the park guides, whose income has fallen. Last year the Forest Department removed two or three villages adjacent to the reserve. Ramjas's village may be demolished any day.

Elsewhere in India, such as Karnataka in the south, efforts are being made to connect isolated pockets of forests with vegetated corridors, so the tigers can move more easily between them. With the skin and body parts of a single tiger fetching upwards of $50,000 it's not surprising that poaching

is still rife and there is no doubt that tigers are in desperate trouble, but even with all their problems they are luckier than many endangered animals because we have at least protected some of the places they live, despite the human cost. This has happened partly because so many of us admire these charismatic cats.

f

Habitat loss is the largest threat to the diversity of life on Earth but raising money to prevent it is tough, so conservation organisations often use attractive mammals as their cheerleaders. Protecting such 'flagship species' as tigers and giant pandas also protects their homes, along with all the other plants and animals living there, but what if you are a less appealing animal, which doesn't share a tiger's forest?

Each year the Indian government spends about half of its conservation funds on protecting tigers, so it has much less money to allocate to each of the 131 other Indian animals that share the tiger's 'critically endangered' status; the last stage before extinction. The Jerdon's courser, a shy nocturnal bird, may be down to as few as fifty individuals, yet no one rattles collecting tins in the street for them. Globally there are around 20,000 endangered species but fewer than 100 garner most of the attention and tigers are at the top of this list: more money has been spent on their conservation than on any other animal, around $47 million a year. To some extent it seems to be paying off.

In 2015 the government of India announced that by using new survey techniques, such as automatic camera traps, researchers had counted about 2,200 tigers in the country (the range is actually from 1,945 to 2,491), which is up from about 1,400 (between 1,165 and 1,657) in 2006. One state in which their numbers have increased is Madhya Pradesh, which includes the reserve at Bandhavgarh. Besides the improved survey methods this increase is put down to anti-poaching efforts and changes such as those I saw at Bandhavgarh, aimed at protecting as much tiger habitat as possible, including the crucial corridors between undisturbed core areas.

There is still a long way to go – worldwide there are now fewer than 5 per cent of the wild tigers that were alive a century ago and they are no longer found in half the countries where they used to live.

Our inclination to protect the animals we like best means that different

countries have their own priorities, for instance one of the world's rarest birds, the Siberian crane, is given special protection in China, where it is a symbol of luck.

RUSSIA

Kytalyk

Yangtse River
Hukou
Jiujiang

POYANG
LAKE

Nanchang

Jiangxi
Province

Siberia

Aldan

Zhalong
Momoge
Xianghai
Keerquin

CHINA

POYANG
LAKE

Eastern
Migration
of the
Siberian Crane

A LUCKY FEATHER

I'm almost warm in my sleeping bag, with a duvet, an electric blanket and two layers of clothes, but it's twenty to five and time to get up. When you are filming wildlife there's a simple rule: it's *Get Close*, and I have been hoping to get close to some of the many birds that spend the winter here, at Poyang Lake, near China's Yangtze River. Siberian cranes are its crown jewels but they are very rare and they have been elusive so far.

I have an assistant called Echo who is already waking the man who runs the research station where we're staying. She says he's a staunch communist. Privately we call him Uncle Jo. Although he is probably no older than me, he has the crinkled face of a kindly grandfather. He is bird-like and eccentric, gesticulating and jumping to emphasise every point. The research station doubles as one of several guardhouses for the reserve but security is not tight: the keys to the front doors have gone missing and they are left open all night, even in November. Yesterday we ate in a grimy white-tiled room with several policemen. It was so cold that the fridge had been turned off and used instead for storing crockery. Dinner was dog stew. I ate vegetables while Echo looked at the dirty walls. She pointed out two signs above the kitchen door.

'That one says: *Now wash your hands,*' she said.

'Does the other one say: *Kitchen?*'

'No, it says: *Be lucky!*'

Luck really matters in China. There is even a horoscope on the

wall of the corridor where I wait my turn to negotiate the noisome toilet. Today, it says, is a bad day for going places, for working outside and being with animals.

Our problems started during our first meeting in town with the director of the reserve, a sharp-suited businessman who seemed to think that keeping our camera tapes would be a fair exchange for allowing us to film. As Echo already had permission from the main office in Beijing, this seemed a bad bargain, so we negotiated a compromise: the director would send his deputy with us, to show us the best areas for birds, and we'd copy the rushes for him later on. He looked sceptical but agreed. A cook came too and, for reasons I could not fathom, we travelled in a police car. I shared my footwell in the back with a sack. It soon started to twitch. There was a scrawny chicken inside, belonging to the cook.

'Echo, is this going to be our dinner?'

'No, the cook says it is too thin and a holiday on a bird reserve will do it good.'

Few things in China are as they seem.

When the deputy director takes us out to look for cranes he too is wearing a suit and his choice of lakeshore has more to do with not getting mud on his highly polished shoes than whether it is good for birds. He stands with his arms folded, waiting impatiently for me to film something, but the lake is enormous and this part seems almost empty. I walk as far as I can from the DD, who is now pacing to and fro, pointedly looking at his watch, and crouch beside the tripod at the water's edge. Crickets zither in the wet plants and far away an oriental stork clatters its bill in alarm, sounding like an outboard motor. High in the sky, lines of white dots are moving towards the far shore, twisting like ribbons. They are tundra swans, arriving from the north. Parents reassure their youngsters with high whoops and they call back, excited to be flying with their families and not yet six months old. 'Are we nearly there yet?' I imagine them asking. The swans steer clear of our upright human shapes, lower their feet and set their wings to spiral down in the distance.

Birds are right to be wary of people: we invented the gun after all, as well as the camera, but their calls are not shy and they travel to us across the water. My friend Chris Watson, who is a wildlife sound recordist, has taught me to think of bird calls not as noises (a word that he says means something unwanted) but rather as sounds, which are always interesting.

From the far distance comes the continuous murmur of thousands of geese, their calls merging, except for occasional sharp clamours of argument, of fallings out and makings up, of bravado and answering boasts. Their flock is even further away than the swans: just a dappled band of grey on the horizon. It would be worth filming them taking off so I listen for a non-sound, the hushed warning that the flock might rise, but they murmur on, their voices rising and falling.

A plaintive sound carries on the wind and I turn, thinking someone is calling my name, but the three Chinese people are still distant figures. Our driver, Jun, is collecting plants. The DD is on his phone, ignoring Echo, who is trying to make sound recordings. She gives up and tries instead to identify the birds, using the book she's eagerly carried to the shore. She has never spent much time looking at birds and it has been a revelation for her to discover that she likes them. There are few birdwatchers in China but as people become better off they are gradually showing more interest in natural history. Even so, when I asked Echo earlier what most Chinese think of birds she said, 'Tasty!'

The call comes again: it's a water buffalo calf, wanting its mother. There is a series of distant thumps: thunder perhaps, or a gun, and the goose chatter stops immediately, creating an extra-silent silence. My hand is poised above the camera button and for a long moment I know that the thought in the mind of every goose is, *Should we fly?* The tundra swans on the lake are not alarmed and the geese soon relax and pick up their murmuring where they'd left off. From even further away come faint creaks, like the rusty hinges of a gate being swung to and fro: they are the calls of Siberian cranes. Although we wait all day the cranes do not show themselves, the geese do not fly and I film nothing at all.

After a week of being taken to lakes where the only birds are distant specks, Echo concludes that the deputy director might be leading us astray. Perhaps his boss did not believe we would give him copies of our tapes. She suggests that we sneak away by bus and join the old-style communist, Uncle Jo, who has a real love for the birds he studies.

f

There are no birds calling as we creep down to the lakeshore in the darkness, which is just as we'd hoped. Uncle Jo says that a big flock of tundra swans and a few cranes have spent the last few days here. There should be time to set up the hide in the dark before they stir, but first there's a river to cross and no sign of the boatman. Echo and Uncle Jo hurry off to yell at his house across the water, while I wait anxiously with the camera and my folded-up hide, listening to the wind in the trees, shivering and feeling rather far from home. There are splashes in the river: water voles maybe, or fish. Two pheasants fly over in a whirr of wings.

I think of the present Jun gave me yesterday. He was smiling as he held it out: a lovely white feather, longer than my hand. Its size, and finding it here, mean that it may have come from a Siberian crane, which would make it very special. There are fewer than 3,000 of them in the world and they almost all spend the winter at Poyang Lake.

Echo feels her way back along the dark riverbank to say that the boatman's wife has answered their shouts. Her husband was drunk last night, she says, but he'll row us anyway, meaning once she's booted him out of bed. He arrives after almost an hour, slumped over his oars and looking queasy. By now the sky is already light: he has probably blown our chances of filming anything. It was such a struggle to get here too, crammed into the bus with all the camera gear, then those frigid rooms and the foul toilets. Of course it's frustrating but wildlife filming is often like this. So much can go wrong and I have no control over most of it: the weather, for instance, or what the birds will do. I can only aim towards what I hope to film and ride out the chaos on the way, trusting to luck: so when we reach the lake I'm not very surprised to find there are no cranes or swans there at all. Instead the first light reveals a flock of thousands of wading birds, godwits, as vocal as a pet shop full of finches. They seem very confiding, so I set up the hide to face them instead. The godwits breed in Russia and they have come here for the winter. That's where my crane's feather came from too, by air of course, from the forests and wetlands of Siberia.

It's a wonderful thought, isn't it? Literally full of wonder.

f

Something spooks the godwits and they take off, their black and white tails and grey bodies tiling the sky. With their long bills sticking out in front and long legs trailing, they look curiously double-ended – push-me-pull-you birds – but what has made them fly? Three men are coming towards us from a row of tents. I'm sure the birds will leave now but Echo, bless her, splashes away to head them off. She has been worrying about these tents since we arrived because there might be 'grumpy people' sleeping in them, but she could do with a tent herself, as a shelter from the biting wind while I'm filming. She has promised to send a text to let me know she's all right. As I start putting up my hide in six inches of water the godwits return, the latecomers sifting down to land in the gaps, filling the shallows as they did the sky.

I really like hides. This tough green canvas and my cold hands are old friends, meeting each other again. Even its familiar smell brings back memories of other places and other films: this hide has been all over the world. I even like the ritual of putting it up: getting everything square and disguising the lens with scrim, then setting my little seat on the spare canvas, so it doesn't disappear into the mud as soon as I sit down. There are small domestic jobs too: placing chocolate and water near at hand, turning the stool just so, to postpone the toothache feeling in my spine. I will be in here for hours but this is my second home: if I could I would put the kettle on. Contented now, I sit back to wait and think again about that white feather.

Feathers make good gifts. They are precious in their own right, like the heron's pointy chest plumes my children loved to wear in their hair, pretending to be Indians, or the startlingly blue one fallen from a jay's wing, which I found thirty years ago, lying like a jewel in a dark wood. When Jun handed me the crane's feather he mimed writing and said 'pencil', meaning 'pen', or at least *plume*, in French. He was right of course. The end of the shaft, which people would once have carved into a nib, was strong and round. It would have made an excellent pen.

I have been struggling to pronounce the first part of Jun's name. It sounds quite like 'chewing', which has helped a bit, but it's not quite how Echo says it. She has been teaching me another sound in Mandarin, a lisping hiss, '*tsss*', shaped by pointing your tongue behind part-open teeth. She says it means 'word'. A small bird, a pipit, lifts from the plants beside the hide and makes the sound perfectly. There are many connections like this between natural sounds and the sounds we make

ourselves – the words we say – and sitting quietly in a hide seems a good way to notice them. Another bird calls '*tui-tui-tui*'. It's a wader, passing like a dark arrow, sharp and vital. It has a white chevron, bright on its back, which means it is not a godwit. I know the call and from it I can extract the colour of the bird's legs. It is a spotted redshank, so of course its shanks are red. '*Tui*', it calls again – the exact sound of Jun's name.

In the ancient world, overlaps like these, between birds' lives and peoples', were taken seriously. The crane was the symbol of Greek astrologers: it must have seemed reasonable that such high-flying and widely travelled birds knew a thing or two about the world and their flocks were scrutinised for clues about what the future might hold. The Romans also believed this and our word 'auspicious' (literally 'bird watching') comes from their practice of foretelling luck from the behaviour of birds. Other words have cranes in them too: the Romans called the birds grues, for their calls, and because cranes seemed to discuss and coordinate their actions, *congruere* became the Latin word for agreement. Our modern word 'congruence' comes from the same root. Several letters of the Greek alphabet are said to be based on the shapes of migrating flocks of cranes, including lambda, which gave us our letter L.

The birds may have been familiar but why they migrated was the subject of much speculation. Aristotle thought they flew to Africa for the winter but the ancient Chinese believed something else: that cranes bore away the spirits of the dead on the longest journey of all.

f

From the hide I check the sky. There is no sign that any cranes or swans are coming to join the godwits on the muddy fringes of the lake. The waders are chattering away out there, but their flock is not entirely harmonious. Their worst insult is a sharp jab of that long bill to another bird's backside. I recognise them now: these are black-tailed godwits, exactly the same type I watched as a boy, on the salt marshes close to Portsmouth. They're part of my childhood and I'm thrilled to be spending today with them all around me, quite unbothered. That's what I love about my hide: this sense of being invisible and of getting close.

Waders are great travellers. For black-tailed godwits there is no real difference between flying from Iceland to Britain, or from Russia to

China, as long as they have worms to eat when they arrive. Their close cousins, bar-tailed godwits, make some of the most impressive journeys of all: theirs are the longest continuous migration flights ever measured, flying 11,500km (more than 7,000 miles), directly between Alaska and New Zealand, in nine days at altitudes up to 4,000 metres (13,000ft). Siberian cranes travel over land, so unlike the bar-tailed godwits they can break their journeys to feed, but they still fly thousands of miles. None of it would be possible without the everyday miracle of feathers.

For its size my crane's feather weighs almost nothing but it is remarkably strong. It has a smooth shaft – the part that was once embedded in the bird – sending news about turbulence and airflow, faster than thought. Where the smoothness ends it sprouts threads of silk, like the plumed antennae of a male moth, as though the feather's heart has opened to the sky. I trace these new threads with my finger. They climb around the shaft on both sides, with the subtle curves of a boat or an aircraft, and together they form the vane, the aerofoil. My hand slides across it, as the air must do, almost without resistance.

There are clues about where on the crane this feather belonged, and what it was used for. It was not one of the wingtip 'fingers', the bird's primary feathers, which are the stiffest and longest, pre-stressed with a twist to bring them into their perfect aerodynamic shape in flight: an idea now mimicked by engineers. It was one of the secondaries, the wing's workhorses, which form its trailing edge and most of its lift-generating curve. I know this from its size, while from its bias and its curvature I can see that it once graced the bird's left wing.

The godwits have now surrounded my hide, all of them probing with their long bills, up to their eye sockets in ooze. Sometimes they plunge their heads completely underwater, shutting their eyes at the last moment – and here's something new: they have delightfully white eyelids, which somehow stay clean despite the mud. I watch one execute a perfect worm pull: plunge, grip, pull. Pause. Plunge again, adjust the grip and … pull. Out comes the worm. It is three seconds' work and the godwit moves on. They do need a lot of worms.

A tapping starts, gently, just an inch above my head: it's rain falling on the canvas. Hides are best of all when it rains, even better than

camping, with the cosy smugness that brings. A hide is just a tent with a picture window and I have seen so many memorable sights through this window. On the canvas next to it I often write the places and the animals I've filmed, so now I add, *Godwits at Poyang Lake*, avoiding the drips. On the birds' backs the rain makes silver beads, which run off like mercury.

The crane's feather has water droplets on it too, tiny lenses magnifying its details: the parallel threads, with even smaller threads branching from them into tiny hooks, all interlocked. I stretch their weft and warp across my finger with a sound like a zip being pulled, until it parts with a pop, but a feather can heal itself and, smoothed between my fingers, the tear becomes invisible. I imagine the thousands of times the crane did this simple, miraculous thing, by preening: mending itself with its beak.

Eventually feathers wear out. The vane of this one is ragged at the end, suggesting that the crane did not die to leave the feather where Jun found it: its job was done once it had helped the bird fly here from Siberia and it was moulted on purpose, to be replaced during the winter. Although Poyang is the best place in the world for Siberian cranes it seems unlikely that we will see any more of them than this feather. The lake is large enough for the birds to avoid people if they choose.

f

My phone beeps: it's a text from Echo. She's playing cards with those men in one of their tents. They weren't so grumpy after all. The rain falls faster and I film the godwits feeding on, stitching the mud like sewing machines. Water drums on the canvas, rushing down inside one wall of the hide and flooding my binoculars from a pocket. As the rain becomes torrential the birds fall silent and crouch into the wind, with drips forming on the ends of their bills. A heron marches among them and hunches there like a wet, grey skyscraper.

The rain slowly eases and the godwits twitter and preen, as if they've just bathed, which, in effect, they have. Preening is far from easy for them, with such long bills. Their equally long necks mean they can just about reach their breast feathers, but scratching an itch on their heads is more complicated and requires balancing on one leg, while the other one reaches over a wing. How ignominious for a godwit to lose its balance

and fall in the mud. Preening over, each one makes a brief helicopter flight to dry its wings, fanning its tail and spattering mud from its feet.

It has not been the day we'd planned but in a sense we have been lucky anyway, with the photogenic rain and the 'wrong' type of birds, and for that I have to thank the confiding godwits, as well as my hide, and even the drunken boatman.

The television news has been reporting that several Siberian cranes have been shot recently and part of the reserve is now closed to the public. None the less Uncle Jo is determined that we should not leave without seeing his cranes. On our last day he bends the rules and drives us there before dawn, without telling the guards who patrol the closed area. As we pass their guardhouse, the lights come on in the window.

Dangling from the rear-view mirror in his car there is a small picture of Chairman Mao. It sways wildly as we leave the road and bump away to sit in the darkness, watching the guards' headlights pass as they search for us in vain. We learn later that they thought we were poachers. Even their cook joined the search, armed with a meat cleaver.

At first light Uncle Jo shows me where I can creep to the edge of the lake. I crouch there, in a natural hide among the tall reeds, waiting for the cranes. Here, at last, they come flying: singly and in small family groups. Their wings are very long and square-ended, abruptly black, as though the white primary feathers have been dipped in ink. Pairs of adults flap in time with each other, gliding low and stalling to land with short runs, on the far side of a narrow strip of water. Some raise their wings and tails like bustles and call together, pointing their bills at the sky and then at the ground. They are elegant birds, standing taller than me while I'm crouching by the camera. The shapes and colours of the adults are as simple as they are beautiful. Red patches reach from their bills to just behind their pale yellow eyes and their legs are pink. Apart from the ends of their furled wings, their feathers are as pure white as the one Jun found. The few youngsters are quite different. Their plumage is mottled fawn and white. They make wheedling calls and follow their parents closely as they probe for food among the wet plants, ready to pick up titbits exposed by the adults.

In China cranes are revered for their longevity as well as being symbols of good luck. Their reputation for living a long time is justified. One captive Siberian crane in Wisconsin lived to be at least eighty-three and was still fathering chicks in his seventies. For a wild bird to

live that long would take a large dose of their famous luck because their round-trip migration of 9,000km (5,600 miles) puts them at great risk from hunters. Their lives also depend on finding wild and wet places to rest along the way. Increasingly these vital wetlands have been drained to grow crops. The greatest value of these places lies not in rice or wheat, but in something that is lost for ever when marshes are replaced by fields. The American conservationist Aldo Leopold wrote about this in the 1940s, in his classic *Sand County Almanac*:

> The ultimate value in these marshes is wildness, and the crane is wildness incarnate.

> Our ability to perceive quality in nature begins, as in art, with the pretty. It expands through successive stages of the beautiful to values as yet uncaptured by language. The quality of cranes lies, I think, in this higher gamut, as yet beyond the reach of words … Upon the place of their return they confer a peculiar distinction … The sadness discernible in some marshes arises, perhaps, from their once having harbored cranes.

Uncle Jo and I share no language but his face lights up when I play back the morning's shots in the viewfinder, and I know that he feels this too. He asks Echo to tell me that he has never seen the cranes in this way and she replies that, apart from a single feather, we have never seen them at all.

'Come on,' she says, 'it is our last day,' and she persuades him to join her on the roof of his car, where they stand laughing, with their arms outstretched like wings: being cranes.

We have passed whole days like this at Poyang Lake, laughing together while we watched or listened to distant birds, waiting for something to film. It is impossible to know precisely when the birds and the weather and the light will combine to make something beautiful, and often the long waits turn out to be for nothing. When that happens I can only try again and hope for better luck next time, but there is a point to all the waiting. Occasionally we do have a bit of luck and then, when the camera is close enough to the cranes or to a flock of godwits in the rain, half a billion Chinese television viewers might discover that birds are not just tasty: they can be mysterious and beautiful too.

AN UPDATE ON SIBERIAN CRANES

*T*here are so few Siberian cranes, and their lives are so fraught with risk, that they are officially classed as 'critically endangered' by the International Union for the Conservation of Nature. Helping them is made more difficult because they pass through, or spend the winter, in ten different countries, from Afghanistan to Uzbekistan and Mongolia to Iran. They all return to Russia to breed in the forests and marshes of Siberia. Although these areas are increasingly being exploited for oil and gas, the cranes' crucial nesting places have recently been given more protection.

The birds also ought to be safe at the other end of their long migration, when they arrive in the National Nature Reserve at Poyang Lake, where virtually all of them spend the winter. Unfortunately the lake also supplies water to a million people and its position, upriver from Shanghai, has made it a convenient source of the sand needed for the city's building boom. In recent years the lake has fallen to record lows, as more water is held back by dams upstream. Paradoxically, the biggest threat to Poyang Lake is a plan to raise the water level by damming its outflow, in order to improve navigation and generate power. This would flood the mudflats where we filmed the godwits and deprive the cranes of their most important food, the tubers of wetland plants that grow only in shallow water.

Following criticism of the hydroelectric scheme by Chinese ecologists, it remains to be seen whether the latest, simpler designs will make life more secure for the world's Siberian cranes. Wetlands like Poyang can be managed for the cranes' benefit but the birds will need all the luck they can muster if doing so brings them into competition with China's economic growth.

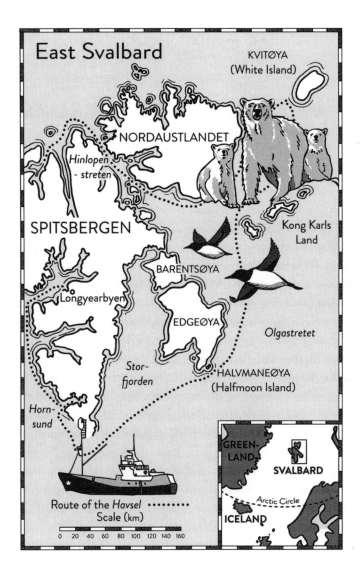

East Svalbard

KVITØYA
(White Island)

NORDAUSTLANDET

Hinlopen - streten

SPITSBERGEN

Kong Karls
Land

Longyearbyen

BARENTSØYA

EDGEØYA

Olgastretet

Stor- fjorden

HALVMANEØYA
(Halfmoon Island)

Horn- sund

Route of the *Havsel*
Scale (km)

0 20 40 60 80 100 120 140 160

GREEN- LAND

SVALBARD

ICELAND

Arctic Circle

THE PATIENCE
OF A BEAR

'So, you are a wildlife cameraman? You must be very patient.'
Everyone says this, but filming polar bears hunting is a good
way to find out if it's true. At the moment this entails standing on the
deck of the *Havsel*, as we edge towards some of the largest bird cliffs in
the far north. So far we can't see a thing. Cold air is blowing towards us
from the ice nearby. It smells like a struck flint and it is breeding fog,
which has shrunk the world around the ship to a circle 100 metres wide.
The chart of this coast shows that large areas have never been surveyed.
Bjørne is feeling his way towards the land like his Norse ancestors, who
discovered Iceland and Greenland by following birds. Streams of auks
fly out of the fog, passing us in a flash of dark wings and vanishing
again.

'Normal people, they don't go here,' Bjørne says.

We are almost touching the cliff when it looms out of the murk,
dark and immense.

A sound comes from it like surf crashing on a beach, drowning the
ship's engine. It is the massed voices of around a million seabirds, called
Brünnich's guillemots. Their backs are black and their bellies white as
they hurtle upward towards their nesting ledges, which are invisible
in the fog. We can certainly smell them. The overpowering mixture of
used fish and ammonia makes Bjørne's drying cod, still hanging from
the bow rail, seem even less appealing than usual. Icicles are growing
on them, as well as on the ship's rigging. Floating ice, patterned by the

birds' lozenge-shaped feet, presses against her sides. The water here is too deep for Bjørne to anchor and he says we must wait in a safer place until the fog has gone. One of the few marks on his chart of this coast is a light pencil cross. I ask Steinar if it shows an anchorage.

'No,' he says. 'That's where a friend of ours died this year, in May. His snowmobile fell through the ice.' Steinar, who rarely goes long without cracking a joke, is very quiet as we travel to the next fjord and drop anchor. After just a few hours the engineer comes in yelling, 'Wake up, wake up! The fog has gone.'

The ice floes have gone too and the water is now covered with guillemots, washing and diving for fish in front of the spectacular rock wall of their colony. It is like a Hollywood set designer's idea of how a bird cliff ought to be, with Gothic buttresses, turrets and perfectly level ledges. Steinar says he once saw a bear searching for eggs high on this cliff, spread-eagled like an inept human climber. When he came back a few hours later, it had fallen and was floating face downward in the sea.

There are no signs of bears today, apart from some footprints in the snow, so we set about filming the birds with an underwater camera on a pole. They cluster so closely around the boat that we can see their hazel irises and their pin-prick pupils. From below their bellies look like silver bowls with fast paddling feet. They peer down at the camera then tip vertically to fly below the surface, wearing layers of air like second skins. The guillemots can dive to 200 metres (650ft) but they are so buoyant that they return to the surface in moments, trailing bubbles. Above us the sky is so full of birds that they look like motes of dust caught in a shaft of light. We close our mouths when we look up, against the steady drizzle of their droppings. The cliff faces north, so only the midnight sun can light it, and to make the most of this golden time we switch to filming at night. The ship's crew stay on daylight hours, which makes for unusually hearty breakfasts, such as stew and dumplings. After one of these, Steinar, Mateo and I carry the camera equipment partway up the cliff, to be closer to the birds. In our red and white immersion suits we are hardly the world's most camouflaged wildlife filmmakers but a chasm separates us from the jam-packed guillemots and they seem unconcerned. Far below, ripples spread like a giant fingerprint across the sea. The water reflects the light and makes us comfortably warm for the first time.

Seabird colonies are fascinating places and we soon lose ourselves in the intricacies of the birds' lives: filming pairs gently preening each other's necks, their eyes half closed. There are occasional fights and glimpses of blue eggs. The buzz of birds coming and going does not falter, showing how productive the Arctic summer can be, when the sun never sets and the sea is full of fish.

As well as shining on us the midnight sun has been warming the snow on the steep cliff above, and with a crack like a rifle shot the whole mass breaks loose. An avalanche of snow and ice thunders down. I set the camera going and we stumble away. Pieces as big as footballs smack into our backs but most of them plunge past and down into the chasm. The camera's recording catches the moment when one flying piece hits the tripod, rocking it onto two legs before falling back onto all three. If it had toppled the other way the camera would have fallen into the sea. We had no inkling that the avalanche was coming and it's only afterwards that the near-miss sinks in: if slightly more snow had fallen, or its route had been a little different, the three of us would have joined the camera at the bottom of the cliff. Risks like this are similar to filming polar bears – the most dangerous are those you haven't seen coming.

After the excitement of the avalanche, life on the cliff returns to normal. The only mammals we see are Arctic foxes, scavenging lost eggs and dead guillemots and after several more nights it is clear that the sequence of polar bears struggling to find food in the summer, which Miles so hopes we will film, has eluded us again.

ƒ

Filming through the night makes planning more difficult because Bjørne is awake in the daytime, so 'tomorrow' means something different to each of us. Mateo, Ted and I have lost track of time to such an extent that we're making weekday forecasts: 'Today there is a strong chance of a Sunday, although patches of Saturday might persist in the north, with a possibility of Monday or even Tuesday later.'

Mateo grew up in the back of his parents' Land Rover, being driven around Africa and Asia, where his father painted pictures of the local people. Ted was an artist too, then a newspaper photographer in London. He covered everything from Pavarotti singing in Hyde Park to

riots and fraud trials, but he is a gentle person who grew tired of being unwelcome on so many doorsteps, and he switched to filming wildlife. He drops the strangest stories into our conversations: 'I fell into a sewer once, when I was walking down a street in Pakistan, straight in. Plop!' Or: 'Did I tell you about when I went to film lions and was bitten by a mouse?'

Meanwhile, the *Havsel* is heading north, following the edge of an ice cap as large as Lapland: this section stretches for around 180km (110 miles) and everywhere the melting snow has crowned the ice edge with hundreds of waterfalls. Some are large rivers, gushing from holes the size of cars, but most are delicate cascades. We cruise below the cliffs as the midnight sun gilds the falling water, projecting its shadows onto the pale screen of the ice. At the foot of the cliffs Steinar sees a swimming bear. Ted and the others launch the *Buster* and spend half an hour shadowing him, while I film the cliffs and waterfalls from the *Havsel*'s deck. The stabilised lens shows the small spray of water blown by the bear with every out-breath. The camera seems to be flying alongside him and when Ted slowly zooms out, to show the meltwater cascading from the ice cap behind the swimming bear, it is as powerful an image of the Arctic in summertime as Miles could have wished for.

Afterwards the bear climbs onto a sloping iceberg, struggling to grip its smooth surface, and lies down awkwardly. He might as well be resting on glass. He shuts his eyes and shivers. Bears are usually so well insulated by their layers of fat that they can remain comfortable for days in water that would kill a person in minutes, yet this bear is cold and tired. We have no idea how far he's swum but the ice cliffs are sheer and the nearest pack ice is far away. The intimacy of Ted's pictures reveals that life in the Arctic can be very hard when there is little ice, even for an animal as capable as a polar bear.

Bjørne has refilled *Havsel*'s fresh-water tanks and for the time being we are allowed more than one shower a week, so everyone smells unusually sweet as we wait on deck for an eclipse of the sun. It's the first day of August and this will be the only darkness we have seen since we arrived. We wonder whether polar bears lie down during eclipses, as

domestic animals sometimes do. Miles hands out dark glasses so we can look directly at the sun. After the many nights we have spent searching, he is suspicious that his cameramen might also be tempted to lie down in the darkness. The sun is gradually shaved to a crescent but it dims as little as if a cloud had passed. There are no bears in sight, sleeping or otherwise. Several fulmars carry on flying unconcernedly around the boat and the cameramen stay awake too.

We travel on and there is not a breath of wind. New land appears on the horizon: an island hidden by the Earth's curvature, rising into view. Its snow patches stretch into white chimneys and its hills become undercut at stem and stern, like tea-clippers. A glacier turns into an hour-glass, pinched at the waist, and in time the top floats free to hover above the water. Spitsbergen grows buttes and mesas to rival Monument Valley and the distant pack ice smears into a white stucco city from which skyscrapers climb, while the sea builds dark walls about their feet. It's a mirage called the Fata Morgana, caused by the still air settling into layers of different temperature. Explorers struggling towards the pole discovered to their cost that its fairy islands would melt and re-form elsewhere, like the bears' world of ice and water.

At night the sea is glassy and we launch two boats so Steinar, Mateo and I can look for bears while Ted films icebergs. He finds one striped blue and white, like a boiled sweet. Others have turned turtle and show their dirty undersides, studded with stones picked up by the glaciers on their way to the sea. As the ice melts they will fall and embed themselves in the seabed. Drop-stones like these are found wherever icebergs have drifted, some as far south as Portugal at the height of the last ice age. The oldest bergs become tinkling fretworks of glass and we leave Ted happily gliding around one of these, where three abstract shapes, like sculpted torsos, are all that show above the surface. He calls them his Henry Moores.

The coast is patterned like a Dalmatian, without a single leaf to interrupt its simplicity. Walruses dive in the shallows, blowing spray. They are busy feeding, angling their backs abruptly as they plunge. Fulmars paddle around them, dipping for food, then pattering into flight as we pass, kissing their own reflections as they glide away. A bear paces along the water's edge, watching us but taking his time. The sun is exactly behind him, lighting a single incandescent line, which defines

his head and flank against the blackness of a cliff. He decides to climb, engaging all his claws, and crests the rise as though it is no effort at all: a white bear cut out of black rock. Bands of light roll towards him like muscles moving within the cliff. He lies down to see what we will do and we drift offshore, wondering the same thing.

I look over the side of the boat where the sea's surface is freezing and silver shapes glint there, as elaborate as ferns or ostrich plumes. The world's underlying physics is more obvious in the Arctic, where crystals are endlessly made and remade, but never quite the same. The boat fractures the ice-feathers and they sink, spinning into the darkness.

Bears can cross this boundary between liquid and solid more easily than any other animal, swimming through the skin of ice while crystallising water crackles in their ears. Just as the lives of wolves are defined by the way they live in packs, and those of cats by their solitary stealth, polar bears, above all, are the animals that search most relentlessly. It is this place that has made them so, which in a sense has caused them to be. They personify the Arctic's austerity, with its long, cold intervals between astonishing outbursts of life. To know these bears is to know the place that made them.

The sun is higher now. We have been out all night and the bear is still watching us, but it has chosen a hard place to approach and Steinar is not keen to try. He will explain why later.

On the way back to the ship a cloud of Arctic terns rises from an island, calling '*kria!*' High above them are two points of light: a courting pair, spiralling around each other. The water by the boat is as smooth as polished stone and in its darkness all I can see are the bright points of the circling terns.

Bjørne meets us, leaning on the *Havsel*'s rail: 'You can live long on the memory of a night like this.'

f

Steinar says that for years he worked as an expedition leader, taking visitors around Svalbard by ship and using inflatable boats to land on remote shores. On one occasion a group of people in his care were attacked, without warning, by a bear. The situation was quite like today's, with the bear above the group, which was hemmed in between

the shore and a cliff. Steinar fired twelve flares but the bear ignored them and kept coming until, four metres away, he shot it dead.

Like many of Svalbard's bears, it had been darted and measured by biologists some years before. Their records showed that it was twenty-seven years old. By the time it died it had lost most of its teeth and half its weight: it was starving. The police watched a video taken by one of the tourists and told Steinar they had never seen so clear a case of the need to shoot a bear in order to protect lives, but he still agonises over it: 'I don't ever want to do that again.'

At the edge of the pack ice we find two walruses resting on a floe. Bjørne says he once spoke to a man who came here in the 1930s, when it was legal to hunt them. In some years only half the hunters survived the season. The alarmed walruses attacked their boats in herds, knocking the men into the sea and dragging them under. It sounds like a tall tale, they are just large seals after all, but we take him seriously and approach them slowly in the *Buster*. As we come closer their size becomes apparent. They are about three metres (10ft) long, muddy brown and wrinkled, lying face to face with their hind flippers entwined to keep warm, which evidently matters to them more than hygiene. Their smell is eye-watering, like blocked drains in a fish market. Mateo says, 'They must have an amazingly strong urge to reproduce.'

Each walrus has two tusks like curved daggers, the colour of sun-bleached wood. One dozes with its tusk points resting on the ice, propping up its head. They have blunt whiskers as thick as coat hangers to feel for shellfish, which they suck from their shells. Bjørne tells us that some of the males use their powerful suction to kill larger prey, sometimes even other seals, whose brains they can pull right through their skulls.

One evening we anchor near a yacht. It's one of very few to venture this far north and Steinar studies it as the skipper ferries his passengers to the shore. A female walrus and her calf swim nearby, blowing water like small whales. The calf is interested in the yacht's inflatable boat and, when the mother starts to look agitated, Steinar calls the skipper on the radio. He quickly hauls his dinghy out before she can vent her anger on it but the walrus attacks the rudder instead, then tears off a plastic fender, stabbing it repeatedly with her tusks.

The skipper calls Steinar back: 'I owe you a beer for saving the inflat-able ...' but the walrus has finished with the fender and, rearing half her length out of the sea, she brings her tusks down on the suspended boat, ripping a large hole in its side. The skipper is philosophical, saying that it makes a change. His previous dinghy was punctured by bears.

Meanwhile, our own equipment is giving us trouble. My camera uses tapes but Ted's and Mateo's footage is recorded on memory cards and the information has to be downloaded to a hard drive for safe-keeping. The drive makes two copies automatically but something has gone wrong and one of them has been corrupted. There is now a risk that the drive has used the faulty one to replace the only remaining good copy. Ted and Mateo spend hours in the *Havsel*'s hold, studying manuals and making fine adjustments as the ship rolls and yaws.

'It's like working on a roller coaster,' Ted says. 'Perhaps the drives are just seasick.'

He is putting a brave face on it, but the thought that his unique shots of the swimming bears might be lost is gut-wrenching. We have put as much faith in our technology as Andrée had placed in his balloon.

f

I have never seen anything like the pack ice. Floes ride over each other and the pressure has shattered some and hoisted others into gleam-ing spires. In direct sunlight the ice looks white but under clouds it is almost lilac, with blue icebergs embedded in it like ranges of hills. This is the conveyor that brings so many bears to Svalbard, but it will not be easy to find them in all the chaos. Seven-tenths of the sea is covered with ice and Bjørne steers his ship through it from the crow's nest. He travels fast and rams the floes. The bow rises, resting the ship's weight on the ice. It gives way with a crack, allowing the *Havsel* to move on, heel-ing, as Bjørne aims towards open leads. Sometimes the ice is older and harder than it looks and the ship clangs and lurches, leaving red paint on the bobbing rubble and a twenty-degree kink in the wake.

We take turns sitting on the wheelhouse roof to scan for bears. I rest my elbows on the sill and for hours I let the ship point my binocu-lars wherever she is heading. It's a trance-like way to search for minute differences, for the cream of a bear's fur among the cooler shades of the ice, or for movement caused by muscles rather than wind or the ship. It

is essential to have a clear notion of how polar bears look: how sleek and grey they are when they first climb from the sea, or their hummock-hipped shape when they lie stretched out like a dog. These are old skills I'm sure, as old as being human.

In time it works, but the first bear we find is a few kilometres away and it heads in the opposite direction as the *Havsel* grinds closer. We find a few more but they all move away. When we are finally close enough to one to launch the *Buster*, it slips into the water and vanishes. We pass the remains of a bearded seal, just a heap of bones and a streak on the ice, but the bear has gone. After many hours of searching we discover that the easiest way to find them is to stop moving and go to sleep. Within two hours a large male bear has come to us.

The Inuit have a word, *ilira*, for the fear that accompanies awe when you are watching a polar bear. This bear is very close and the *Havsel* is surrounded by ice, so when he stands on his hind legs his head is almost level with my feet. He seems to be looking for a way to climb aboard. While I film him from the bow, with his eyes filling the frame as he stares at the lens, the others launch the *Buster* on the ship's blind side. They are much quicker these days and by the time the bear lowers himself into the water they are ready to film him swimming, with his submerged fur swirling like cream in black coffee. He pulls himself onto another floe, his shoulders working like a weightlifter's, straightens his front legs and pile-drives them into a seal's birthing den, under the ice. The den is empty and he turns back towards the boat.

Miles had hoped to film him underwater with the polecam but the bear is so big and confident that the four-metre pole now feels rather short and the *Buster* soon backs off, switching to the stabilised camera. The boat follows as he swims, filming him searching the floes, ducking under some and snaking his long neck to peer over others. From the wheelhouse roof I can see three more bears in the distance: a female and her two small cubs. The male has found no seals and he easily shakes off the boat, so when I radio the news about the family, Miles decides to switch to filming them. As the boat turns her way the mother starts towards it with her cubs at her heels. When she leaps between floes they hesitate and then bounce across a floating ice bridge, which bobs and

rolls under their weight. When she slips into the sea to cross a larger gap the cubs hurl themselves after her with their legs spread wide, making enormous splashes, then roll in the snow to rub themselves dry. To check where she has gone, one stands on its hind legs with its forepaws crossed, looking impossibly attractive. From the *Havsel*'s wheelhouse roof I can see Jason trying to keep a gap between the mother bear and the boat. He is momentarily blocked by ice and suddenly she is very close. The *Buster* lurches forward and away.

'The best bear of the season,' Jason calls on the radio, and when they climb back aboard the whole team is beaming. Miles says that he and Ted had been watching the bear family so intently on their monitors that they'd lost track of where they were, and even which way the camera was pointing. It was only when he asked Ted to include more in his shot than just the bears' heads that they discovered the lens was already zoomed as wide as it could go. The bears were right behind them, on the edge of the ice a few metres away. The mother was showing every sign of wanting to join them in the boat and Jason moved it just in time.

In the wheelhouse Ted shows us the pictures. His shots of the two running cubs, determined to keep up with their mum, are extraordinarily touching. Miles's gamble with the stabilised camera has paid off handsomely, although we still have no shots of a bear catching anything on the ice or ashore. If we could find seals and a hunting bear here we could try again but now the wind intervenes. Bjørne is worried: 'The ice is closing up. I don't like it at all. We must not be caught between it and the cliffs.'

Like the rest of us he has slept for only two hours in the last two days but the strengthening wind means he must move the *Havsel* immediately. We watch the rest of Ted's shots while holding on to the table and walls, as the *Havsel* smashes a passage away from the lee shore. The ship vibrates so strongly that the fire bell rings on its own.

Jason suggests that we try to reach Kvitøya, the White Island, at Svalbard's most north-eastern point. Sometimes walruses give birth there, he says, and their pups might attract bears, but the ice is so thick this year that no one has been to look.

f

There is fresh snow on the deck when we reach Kvitøya two days later.

The island is almost completely covered by an ice cap, leaving just a few places where we might land a boat. They are small patches of rock and gravel, as cold and barren as Mars. This year there are no walruses on the ice-bound shore, and no bears. A single line of Arctic fox prints is the only sign of life.

In this desolate place, the bodies of Salomon August Andrée and his companions were found, thirty-three years after their balloon disappeared. No one had looked for them so far from the route they had planned to fly. Andrée's diary and Strindberg's camera were recovered. The film had been perfectly preserved by the cold and it still held pictures documenting the end of the expedition. They showed the *Eagle* with its basket upturned and ropes everywhere. Andrée's diary told that for two days they had been blown to and fro, crossing and re-crossing their path, while the balloon leaked hydrogen through its millions of stitch holes, accumulating ice until it grew too heavy to fly and finally settled on the frozen sea. Desperate to stay airborne, they had already jettisoned much of their food, but the men dragged all that remained from the wreck and set off south, walking for almost three months and shooting seals and bears to eat. They sent messages by homing pigeons, supplied by a newspaper. Only one was found and it did them no good because it had been released before the crash. Kvitøya must have seemed an unwelcoming haven but they had reached their limits. By October 1897 all three men were dead. Some of them may have been killed by bears, if not directly then through parasites, caught by eating their undercooked meat.

From here, at just over 80°N, it is easy to work out how much further it is to the pole. Each degree of latitude contains sixty minutes of arc, equivalent to sixty nautical miles, and a nautical mile averages about 1.8km, so the North Pole is just over 1,000km away (600 nautical miles). It's the furthest north I have ever been.

Andrée's diary shows that the *Eagle* crashed at 83°N: 750km (460 miles) short of his goal. His idea of going to the North Pole by air was not entirely fanciful. By the time his remains were found, the airship *Norge* had flown there from Svalbard.

With relief we leave Kvitøya to return to the *Havsel* and head south, travelling down the east side of Spitsbergen among the moving ice.

f

Mateo has some bad news: another hard drive has failed but at least this time we understand why. The *Havsel* generates her own electricity to power everything from the radar to the washing machine, but whenever the ship's heavier equipment is turned on – the crane, for instance, or the compressor in the freezer compartment – the power supply falters. A washing machine's motor can survive this rough treatment but hard drives are more sensitive and a hiccup in the power can corrupt their data. How ironic that here, where we often feel deep-frozen on deck, we risk ruining our footage by opening the freezer door. At least now we know when not to use the drives and, in fact, we have been lucky, because the remaining copies of the footage have survived uncorrupted.

The bears, though, have become no easier to find. By the time we leave the sea ice behind we have filmed no more hunting, but when we land on a small island called Halfmoon we find a family lying together on the shore. The two cubs are resting on their mother. One has its muzzle in the crease between her side and her hind leg. It's a perfect fit and a liberty no one else would dare to take. From time to time she rolls onto her back, raises her head and invites the cubs to suckle, gently putting her paws around their shoulders. She eats nothing herself because there seems to be no food on the island: most of the birds have gone or finished nesting, she cannot hunt seals without ice and there is nothing left to scavenge on the shore. She is lethargic but too wary for us to approach, so the *Havsel* leaves Steinar, Mateo and me on the island, while the others investigate the mainland. With one eye on the family in case they move, we have a look around.

There are bones everywhere. For many years the island's cabin was used by hunters, who killed bears for their skins. A wooden box lying by the door shows how they did it. It once housed a rifle with a piece of meat tied to the trigger. The hunters put up tall poles next to boxes like this, knowing that passing bears would be curious. If they were drawn onto the island and smelled the meat, the bears would put their heads inside the boxes and pull the bait. The rifles were supposed to shoot them in the forehead but sometimes the bears were only maimed. Many were mothers with cubs and the hunters kept the orphans alive, for sale to zoos at the end of the year. In one season on Halfmoon Island, three

men killed more than 150 bears. A string trigger lies undisturbed since the hunting stopped forty years ago, just as our habit of burning fossil fuels began to melt the places where they live.

Some predictions say that by 2050 there will be far less sea ice in the Arctic during the winter and none at all in the summer. Others say that because the melting is speeding up exponentially this may happen within the next few years. What will happen to Svalbard's bears remains to be seen. Some might find enough food on the land to scrape through the leaner times but many of those will go on to die in the winter, too thin to keep warm and lacking the stamina to hunt. Their population is likely to creep downwards until the remaining bears are too scarce to find each other and mate. As we have discovered, some summers are cooler than others, so the polar bears' slide towards extinction in the wild will probably proceed in fits and starts. None of us will see the last of them die but we are surely going to miss these inspiring animals when they have gone.

International travel puts a great deal of carbon dioxide into the fast-warming atmosphere and so do ships like the *Havsel*. Travelling widely in order to film polar animals and their melting homes is a dilemma I am still wrestling with. I hope and believe that the films we make will do more good than harm, or I would not want to be involved.

The *Havsel* returns with the news that they have found two male bears eating the remains of an emaciated female. Perhaps the mother bear on this island is wise to keep a low profile. We leave her in peace, hoping that she will be able to keep her cubs safe in this place, which for so many years was deadly for bears.

Miles and Jason have decided that our last chance to film a bear hunting is to visit the huge seabird colonies on Svalbard's west coast, so the *Havsel* moves on again.

Once, in Yellowstone, I waited for two or three hours in the hope that the sun would light some blowing snow. There was a park ranger with me, to make sure I didn't step into any hot springs. The sun finally appeared just long enough for me to film one shot. It lasted twenty seconds. The ranger said, 'You could kick anyone's ass in a waiting competition.'

When you make wildlife films it is quite common to spend a long time waiting and it is usual for plans to keep changing too, but it is not always easy to be patient, especially if you are suddenly reminded of what's happening in the outside world. Last night a message reached the *Havsel* from my home, where it is school holiday time. My young son has won the photography prize in our village show: *He's so proud*, wrote my wife and I think back to when Rowan and I sat together, looking intently at the patterns of light and shade made by some tall grass, with our heads touching, while he chose which picture to take. I would have liked to be with him when he heard the news. Of course, filming bears in the summer means spending months away from home and it has been fascinating exploring Svalbard like this, but it would be easier to wait patiently if the filming was going better.

When we drop anchor in Hornsund we know it will be our last chance this year to film bears hunting.

f

The fjord is surrounded by peaks the shape of flat irons, set upright to cool: dark knuckles of rock shoved between streaks of white. A snow bunting flits past the dazzling slopes like a piece struck from the land-scape. Ice sculptures float where a glacier meets the sea: some are frosty, others are as clear as glass or weirdly blue and textured like the skin of lemons. They chink together on the rise and fall of the tide and above them is a massive bird cliff. It's half a mountain, cut off sheer by the sea, and the air about it is filled with specks of white, like a blizzard of petals blown from a cherry tree. They are kittiwakes, all calling their name. We pack the camera gear and lower the boat, to investigate the cliff. Halfway along the beach Steinar looks back and shouts, 'There's a bear!'

We have walked right past him, lying on a snow patch just above the shore. He lifts his head and gives us an irritable sideways glance. I can see the whites of his eyes. I don't trust this bear and he doesn't seem keen on us either, but when the adrenaline subsides it's clear that he really wants to sleep, so we set up to film him when he wakes. Crouched by the camera, I wait for him to do something, anything: for days.

f

'Cold coast' is what Svalbard means. One ship's crew, stuck in the Arctic Ocean for the winter, used ice and a walrus skin to make a billiard table. For a while it helped them forget the cold. I rub my hands and look around me at the rocks and seaweed. Making a billiard table seems a bit beyond my means. This is the time to find out just how patient I can be.

I like waiting and it's rare to have as good a reason as this just to be still and do nothing except wait for a bear to wake up, but I do need something to take my mind off the cold, so I slowly sink into the stillness of this place, letting it into me. I listen outwards, finding new sounds, fainter sounds, ever further away. The ice pops and fizzes as it melts into the sea. Bergy seltzer it's called: the sound of gases being reunited, of ancient air escaping from its prison after thousands of years and re-entering the atmosphere. The rocks beside my boots stack vertically like slices of toast, which tap gently when I move my foot. There are tiny aeronautical bones between the flakes of stone, thin struts filled with air: a kit of parts from which you could build a kittiwake. I lie back and watch the living birds circling hundreds of metres above me, like paper planes sailing out and back towards their cliff. Above them the sky is a grey quilt, billowing. Some of the birds are young ones, on their first, breathtaking flights into the abyss of air. They fly straight and level, rowing tentatively with their new wings. I wonder if they feel vertigo. Glaucous gulls are watching them too, and closing in on the most naïve. A young kittiwake panics and screams but the bear doesn't even raise its head. It would be easy to miss these everyday, almost casual acts of violence, among the wheeling kaleidoscope of birds. Behind the clouds the sun turns across the sky. Its light is diffuse and shadowless.

Rain ticks as it hits my coat and the landscape backs away softly behind the drizzle, like the pictures my children once made at school from layers of tissue. I sit with my back to the wind, nursing the camera as well as my hopes that the bear might wake up soon. Below the cliff a little grey ghost of a fox appears, as pale as the rocks and thin as a rake. Run, squat, run: it is constantly moving and dotting its scent onto the landscape. It must smell a quite different place from the one I see and hear. It stops abruptly, aware of something: me, or perhaps the bear? And away it goes, as quickly up the slope as down.

At last the bear is moving. He stands and stretches his back, yawns

massively and then falls as if he has been poleaxed. He lies there, curled up with his head on the snow and his ears filled with the sounds of kittiwakes.

From the fjord comes a long gasp. Smooth white shapes are rising and falling among the ice: they are belugas, a tight pod of whales swimming towards the glacier. Grey youngsters dive flank to flank with their pale mothers. They have no dorsal fins to scrape the cold ceiling of the sea but as they swim they lift their tail flukes, shaped like the ace of spades carved in ivory. What does their ice world sound like? They have been called the canaries of the Arctic and listening to the puffs of their breath I wish I could plunge my head into the water and hear them sing. When the sea freezes the bear may come across these same whales, trapped in shrinking holes in the ice, and with inconceivable strength – belugas weigh twice as much as him – he might haul one out to eat. In summer they are safe and the bear pays them no heed.

I catch myself dozing: it's a dangerous complacency, given the company I am keeping, but the bear does nothing except rearrange his bed. I can see the wind blowing across his back, lifting his fur and showing that underneath, his skin is dark. Every now and then he stretches one leg, like a dog might if it was very relaxed. Most of the time, though, he moves so little that I wonder if in fact he's died.

Days pass. A highlight is when twenty barnacle geese fly over me and then over the bear, looking down at us both. One of their feathers comes to rest by my hand, striped black and white and beaded with moisture. It flickers in the wind, wanting to fly. The muted colours of the geese and their wildness fit this place well, but I also know them from the other end of their migration, in Scotland, where they spend the winter on the Solway Firth. When I see them there next I will think of today and look at them differently, these geese who know bears, but I must leave here before they do. The ship is waiting to take us back to Longyearbyen. We have run out of time.

As we pick up speed and head for the open sea, I look through my binoculars and find his pale shape, still lying there below the cliff. I realise now why the bear had not once gone looking for birds. Instead of hunting he is saving energy and living off his fat. It is only August,

and the sea will not freeze until November, but already he is waiting for winter.

Filming Svalbard's bears has taught me something: wildlife cameramen are not really patient – polar bears are patient.

Central & Mississippi
Migration Flyways
of the
Lesser Snow Goose

Baffin Island

La Pérouse
Bay

Hudson
Bay

CANADA

James
Bay

Atlantic
Ocean

Devil's Lake

Sand Lake

DeSoto

Squaw Creek

UNITED
STATES
of
AMERICA

Breeding areas

Staging areas

Wintering areas

Gulf of
Mexico

MEXICO

Squaw
Creek

Missouri
River

Mississippi River

MISSOURI

A BIG BUNCH
OF GEESE

While polar bears have little choice but to stay put and wait for the ice to restore their freedom to roam, North America's lesser snow geese leave the north before the winter freeze, then migrate back to the Arctic when the spring comes. Their immense flocks are a spectacular sight and a controversial one.

*

Ice has been shunted into ridges on the shore. The holiday houses lining the lakeside are blank-faced, with blinds drawn across their dark windows. In one snowy yard there's a metal lamp post, a sodium-vapour parody of the cosy one in Narnia, lost among the trees. There is no wind or tide to act upon this lake, yet the ice groans and strains, making oddly human sounds where there are no people. Coyote tracks pattern the snow. My hide has been here since yesterday afternoon and its roof is speckled with frost flowers, which I brush to dust as I unzip the canvas. With the help of my colleague Mandi, I must set up the camera inside its stiff cloth walls then start my wait while it's still dark, but the metal feet of the tripod are sliding on the frozen beach. I could melt it by peeing on the shore but perhaps there's a less awkward and quicker fix than that. Should I sacrifice my flask of tea? I'll miss it if I am still in this hide ten hours from now, but the light is coming and we're in a hurry: the tea it is.

Once I am in and perched on a stool I tuck a spare coat across my knees. My fingers and toes will be the coldest now. On the ice nothing stirs. It is still too dark to film. In the distance I can hear the forlorn wail of a train: a sound that defines modern America's Midwest, just as wolf howls did a century ago. The railroad runs beside the Missouri River, which made this lake and then left it behind: an abandoned oxbow in the prairie, surrounded by the plough and stubble of winter cornfields. It must be fun here in the heat of summer, to judge by the boat docks and the sundecks and barbecues of the houses opposite. Their downstairs walls are made of plain concrete and each has a dark line, well above my height, like scum on an old bathtub. There's a similar line on the tree beside my hide, on all the trees in fact, as if someone has obsessively marked the same level everywhere. This lake has changed, left its mark and changed again.

Flood and drought, heat and cold: the Midwest knows all about swings between extremes and so do the birds I have come to film.

*

A few years ago I spent some days in the autumn, filming on the shore of Hudson Bay in Canada. It was warmer there than here, despite being so much further north. On the salt marshes around the bay there were polar bears. It's the furthest south they ever come and they looked out of place in the September sunshine, the more so because those marshes seemed very much like the ones at home, where brent geese had made dark patterns in my childhood skies. There were geese on Hudson Bay too, but these were lesser snow geese. Their gleaming white skeins were a constant backdrop to the bears, as we filmed them testing each other's strength by wrestling. White bears and above them white geese, writing patterns in the sky. These bears, like the ones in Svalbard, were waiting for the sea to freeze but the geese were preparing to leave, feeding up before their long push south. Towards the end of our filming I watched thousands of them smoothly forming their travelling 'V's, with several hundred birds to a side, all heading towards the major river they would follow into the heart of North America.

It was the beginning of one of the world's great natural events – a continent's geese moving from the Arctic to the Gulf of Mexico – and now, from this hide, I am hoping to film the same birds heading north.

This spring migration is a more urgent affair than their autumn journey: every day counts because the Arctic summer is short and they must not waste time getting there. Like America's early explorers and the railroad-builders who came after them, many of the migrating birds follow the course of the Missouri River. Last year's youngsters will be guided north by their parents, as snow goose families have done every spring, time out of mind. In some years they decide to break their journey here and when they do I've heard their flocks can be breathtakingly large. That's what Mandi and I are hoping to film: the way these geese behave when they are in numbers and how their predators react to them, but we cannot tell whether this year's extreme cold will help us or hinder. If they come and I am waiting in the right place, the sight should be spectacular, but if the weather suddenly warms up and the geese hurry north, they may decide not to stop here at all.

The sky is lightening. There are dark shapes scattered through the winter trees, silhouettes, shuffling their feathers against the dawn. They are bald eagles: powerful hunters as well as opportunistic scavengers. They are migrants too but for now they are waiting, like me. One small part of the lake has not frozen and vapour condenses above it in the intense cold. As the sun breaks Missouri's flat horizon its first light gilds the vapour: shifting, twisting shapes of water, taken to the air. Blurred by the distance I can hear voices: people perhaps, or the yelping of dogs.

North America once had another exceptionally well-travelled bird, a migrant named for its willingness to move – it was the passenger pigeon. *Passager* means 'traveller' in French. People spoke in awe about the sound of their passing: of thunder, of canon fire and cavalry. Their numbers were famous too: some flocks darkened the sky for three days and one colony covered 2,000km^2 (500,000 acres). The weight of the nesting pigeons broke branches from the trees and they could be shot, twenty at a time, by firing blindly into the air. No one who saw such abundance imagined it could ever end. Snow geese, they say, are unimaginably numerous too.

The voices resolve themselves, coming closer: they are geese, drawing fine lines across the sky, pencil lines, overlapping. Their voices grow stronger as they come, merging into a clamour. Overhead the lines

waver. The geese are hesitating, considering whether to come down. From their height they must be able to see the larger lake a few miles away, where Mandi is waiting. It is their only alternative but it's completely frozen. Among all the fields this oxbow lake is calling to them with its open water, offering a chance to rest, to wash their feathers and drink.

Is it safe? they are wondering. Their uncertainty shows in the set of their wings and the slow banking turns of the skeins as they look down at the eagles in the trees. *Shall we land?*

It is my question too.

More skeins join the gyre and abruptly they pass a threshold. There are now enough birds willing to take the chance and they begin to spiral down. For each goose the risk of harm is smaller if it is not alone. The eagles watch them come. The geese resolve from specks into family parties flying together. Some are 'blue' snow geese, dark in the wings and body, but many parents are a dazzling white, with black wingtips and coral feet and bills. From below the white birds are lambent against the sky. Most pairs lead two or three greyer youngsters. Down they come, more and more, until it is snowing geese. The open water fills quickly. Latecomers land on the ice alongside. Ten thousand geese? Twenty thousand? More?

The first arrivals start to bathe. They are too buoyant to submerge easily, so they duck their heads, curving their long necks to catch gleaming beads of water on their backs and letting them run away across their wings. They scrub their bills against flanks and splash again. Layer after layer of bathing geese, ghostly in the mist. The front birds are dark by contrast, goose-framing the seething bath behind, where shapes are revealed then hidden as the vapour shifts, making the scene seem timeless and elemental.

They feel safe in these numbers, overwhelming the eagles in their trees and the coyotes hidden beyond. They are confident that the risk to each of them is low enough for some sleep, so they rest on the ice, tucking in their feet and pushing their bills into their back feathers for warmth. They are all facing the same way, in a repeating pattern of bodies outlined in gold. Their voices drop to a deep and constant drone, like hive after hive of bees. One extends its head and calls into its own private cloud of breath. They are oblivious to me. It's a rare chance, made possible by the cold stopping them here and by the open water

that drew them into its gloriously backlit vapour: and also by my sacrificed tea. I film them with my heart hammering, afraid the spectacle might end too soon, ecstatic at the shafts of light falling on goose shapes in the golden mist, at their blue shadows on the ice.

And then an eagle flies. The flock wakes with a joint intake of breath. Every head rises. A vast ripple spreads as each goose stretches its neck to see beyond its neighbour. The birds on the ice are rigid. They can see the eagle coming. They can see its deep wingbeats and the purpose in its flight. It will pass directly overhead and they can wait no longer. They crouch and spring, clawing upwards. Another wave sweeps across the ice, a wave of thrashing wings and violent air. Between my heartbeats thousands of geese are up and going and as they go a gale hits the hide. Ice, dead leaves and water explode away from the pounding wings. The smell of birds, of barnyards and duck ponds, fills the wind and with it comes a chaotic sound: the panic of families calling to each other, trying to rise together through the churning air and the mass of bodies. The air is so dense with geese that I cannot see beyond them. Dazzled, the eagle veers away. It crosses into the clear air at the edge of the flock, with its head and curved beak facing downwards. It is searching for weakness.

A goose crashes down, broken by an impact as it rose and crushed now by the ice. It seems that snow geese find safety in numbers from every threat except themselves. The eagle turns, stalls, and as it lands the others launch from their trees.

The flock rises clear of the treetops, re-forming its lines against the sky. The geese in each skein space themselves evenly, feeling their way into the exact place where the moving air from the beating wings of the bird in front will save them energy as they fly. I watch them go, trying to judge from their direction and height whether they are leaving for the north or just moving to the larger lake.

I film the eagles squabbling over the dead goose but my heart has gone with the others. Something extraordinary happened when they took off: beautiful individuals were transformed into a flock with its own means of deciding how to move, like a collective mind. It took possession of the space above me and made undreamed of patterns in the sky. Now I yearn to film a really big flock, but what is a really big flock of snow geese?

f

Standing on a sea wall when I was a child, I once tried to count my local brent geese as they flew towards me, quickly totting up ten birds then scaling them up ten times to the space 100 would fill and mentally pasting that many, in blocks, across the flock. I rarely needed to make the next jump, to 1,000 birds, because only 5,000–6,000 ever spent the winter in Langstone Harbour, but the spectacle of them flying always made me pause.

The snow goose population in the central part of North America has changed as wildly as the level of the Missouri River and arguments about how many there are have ebbed and flowed too. No one disagrees that there are more geese now than there have been for at least a century, but that doesn't make them any easier to count. One way to do it is from aerial photographs, taken when they are evenly spaced and conspicuous, sitting on their nests on the Arctic tundra. Computers have replaced people at counting the dots but snow cover confuses them both. Estimates made like this and by counting the birds in their winter flocks suggest that about 3 million adult geese fly up and down the centre of the continent each year. The numbers are hard to check and the most reliable figures probably do not come from counting geese at all. Instead scientists put rings on the legs or necks of a known number of them, then wait to see what proportion of these ringed birds are reported by hunters. This statistical method has shown that regular counts grossly underestimate how many geese there are in the largest flocks. Ringing returns suggest that in recent years as many as 20 million adult lesser snow geese and 5 million youngsters may have headed south from their Arctic breeding grounds.

f

Mandi sends me a text to say that masses of geese are now circling over her. She's coming to collect me. It's time to abandon the hide.

She has been watching from a National Wildlife Refuge, one of more than 550 across the country. The first was set up in 1903 and they now cover more than 500,000km^2 (more than 120 million acres) of the United States. This one is a patchwork of large, shallow lakes, fringed by cattail marshes and trees and ringed by a dirt road. From the high perspective of a migrating goose, seeing so much water must be very tempting, even when most of it is frozen. Driving there we pass fields

of geese by the roadside. They are made of white plastic and stand on sticks among the stubble. Other battery-powered decoys whirl in tight circles to mimic landing birds joining the flocks. Men wearing camo and baseball caps walk among them, picking up the real geese they have lured down and shot. The gas stations and fast-food places in town are full of trucks, full of hunters. *Putting them on their backs since 1990*, reads the slogan on one man's shirt.

In 1916 a treaty was signed on behalf of Canada and the USA, to protect snow geese from hunting in the spring, in particular from the 'indiscriminate slaughter' of the unregulated market hunters who had driven the passenger pigeon to extinction two years earlier. The realisation that America's most numerous birds were all gone had come as a tremendous shock. Only fifty years earlier there had been billions of passenger pigeons. The snow geese benefited: relieved of the spring hunt and protected by the new refuge system during their autumn migration, they started to recover.

When we pull up by the lake on the refuge, the wind has strengthened from the south. It's a warm wind, full of geese. There are lines of them as far as I can see, looking so much like oncoming aircraft that it feels like an invasion. The birds I filmed earlier were just an advance guard and now flock after flock of that size or more come spiralling down in front of us. Many land on the unyielding ice. Solid water is not their ally if an eagle comes, but the ice has started to melt and the open water is growing. Many geese settle on it and drift towards the bank. For the first time I can really see them as individuals. They have dark cutting edges to their bills and subtle whorls of feathers make ridges on their necks. I can see the small differences between the sexes: the greater heft of the ganders, with their larger beaks, and the gentler rounded heads of their mates. The lake is filling with so many geese that it feels as if we have the entire population of a city laid out in clear view, with every aspect of life going on. Young birds peck optimistically at the dead stems of last year's plants and the large seed heads of lilies, protruding from the lake. Others preen, sorting out their feathers. A few young-sters and adults fly above the rest, calling for the families they have lost in the chaos of taking off. I watch one bird almost out of sight, then see

it turn and come back, still calling. It's astonishing that among so many they have any chance of finding each other by the sound of just one voice. Illness, old age and accident are here as well. Some geese seem too tired to carry on. One is unable to raise its neck and its head lolls in the water until it drowns. I imagine the eagles will come to take the sick and injured but for now they seem cowed by the sheer size of this flock. When two fly over they stay high, like airliners routed over a city, and the geese eye them without concern.

The news has gone out on Facebook – 'The geese are here' – and the hunters arrive to take photographs and make jokes, while they wait for the birds to leave the refuge:

'We haven't brought enough shells. Who did the math? Fifty each is way too few.'

It dawns on me that perhaps they are not jokes.

Some people try to scare the birds into the air by running and waving their arms, holding their cameras ready, but the geese just swim a little further from the shore. Elderly couples, outnumbered by the hunters, stay just long enough to photograph each other with the white lake behind. 'Have you tried to count them?' they ask. 'I got to a hundred and lost my place. Had to start again.'

The friendly refuge manager stops to chat and I ask him if he knows how many geese there are: 'Must be close to a million by now,' he says. 'We count them each week and today's the day.' He photographs the flock on his phone to show his wife.

f

Until about fifty years ago America's 'mid-continent' snow geese spent the winter on the coast of the Gulf of Mexico, feeding on salt-marsh plants as they still do in the north, but then came a dramatic change in their fortunes. Many marshes were being drained or converted into oil terminals and refineries, which displaced the geese inland where they discovered that the prairie grasslands were changing too. They were being irrigated and used to farm rice and corn instead of cattle. Farmers increasingly used artificial fertiliser to guarantee a good crop and the grain they spilled at harvest time made ideal goose food. As a result more of the birds survived the winter and in twenty years from the 1970s their numbers quadrupled.

The natural world and ours are inseparable. Changes in the fields of Texas and Louisiana began to make a difference as far away as the Arctic, where the large numbers of geese were damaging plants at the other end of their migration, around Hudson Bay.

All afternoon the geese float down like snowflakes, filling the lake until the flock spreads almost to where we are standing, with the tripod and camera partly shielded by the car. Through the lens I can see a white field of heads stretching to the far shore. It's a dreamlike landscape where clouds of birds drift to and fro, punctuated by puffs of white dust, the distant jets of geese startled into flight by each other's shadows or a glimpse of a coyote in the reeds. They settle again quickly and whole families sleep, confident in their vast numbers. There are sixty or so bald eagles watching them but they stay in their trees or on the fringes of the ice, waiting to see what will happen when the geese fly.

I have never seen so many birds, or any other animal. The largest sporting stadiums in the world could accommodate less than a tenth of this number of people. A passer-by tells us that so many geese weigh thousands of tons and they may soon submerge or break the ice: especially now it's melting. He starts to do the sums: 'Six pounds per goose, times ... how many do you think?'

That's the question everyone is asking: 'How many geese?'

It is overwhelming to see so much life in one place, to know that some wild animals are booming rather than following the passenger pigeon, but the rise of the snow geese would have brought fewer problems if the animals preying on them had increased in parallel. Instead, most Arctic predators have to struggle through the bitter winter, while the geese are far away in the south, finding plenty of food in the fields. That's why the birds make their enormous spring journeys, to nest in the north, where the winter strictly limits how many of their predators can survive. It's been a winning formula so far.

Two state conservation agents arrive: smart in their crisp uniforms, with their badges, black belts and holstered guns. Their job is to check hunters' permits. Both of them photograph the geese with their phones. I ask them how many were left when they were first protected from the market hunters. They do not know.

'They're invasive,' says one agent. 'We conserved them and now there's too many and we can't get the numbers down. They're destroying the tundra for other birds.'

I ask him which other birds but he's not sure.

'How are they counted?'

'They do it by area,' says one. 'They know the area of this lake, work out how much of it is covered by geese and multiply that by one and a half geese per square yard.'

'Isn't it two and a half?' says the other.

'Yeah, maybe, one or the other.'

'So how many would you think are here now?'

'Well, there's sure a load,' says one.

'Yeah, there's a bunch,' says the other.

They are keen to move on to more certain ground.

'It's going to snow again tomorrow.' He checks his phone. 'One tenth of an inch.'

f

The refuge manager told us later that the official snow goose count for the day was 1,196,267: a number, I'm sure he would agree, which is as unfeasibly accurate as forecasting a tenth of an inch of snow.

We like our numbers to be precise: they are our only means of grasping the unimaginable scale of gatherings like this, of labelling them and making them safe, but there is no safety in these vast numbers for the geese. Through the 1990s their population kept on climbing until it crossed an invisible line, beyond which it was apparently up to people rather than nature to decide how many geese there should be. This happened to the geese because we had changed their world. They had benefited from our conversion of the prairies into grain fields and now they were to be killed for seizing that chance to thrive. In 1999 their protection was removed, allowing snow geese to be hunted in the spring, with the aim of halving their population in six years. Lures and higher capacity weapons were permitted, without any daily bag limit. Twice as many geese were shot as a result but the growth of their population has hardly faltered. The sums had been based on the underestimates made when counting massive flocks by eye and from photographs. Even shooting a million birds a year has not made enough

difference and the latest figures suggest that the geese have now escaped from ever being controlled by American and Canadian hunters shooting them. The next step might be to kill them at their nests or break their eggs but reaching their Arctic colonies to do this would be very expensive. Otherwise shooting them at night, using devices akin to landmines or perhaps even poisons, which could kill tens of thousands at once, have been mentioned as last resorts.

I cannot look at the geese and stomach the idea of killing them in such vast numbers but these are complicated issues: in time they will probably colonise every suitable nesting place and then their numbers will stabilise and perhaps start to fall, but before then they will have damaged some of the tundra and the plants of the salt marshes and pools of Hudson Bay, and perhaps further north. When I was filming up there it was clear that the fragile Arctic vegetation takes many decades to recover. Sometimes the damage will be at the expense of rarer birds. Perhaps, though, the geese have simply recovered to their previous numbers, before they were hunted so intensively. No one knows.

At present predators don't make much difference to the geese but as the world warms the Arctic itself is changing. Hudson Bay is freezing later each year, giving its polar bears less time to hunt seals. In the summer the hungry bears are likely to find the expanding goose colonies appealing, and to spend more time searching for eggs, as the bears do in Svalbard.

It is clear that what once seemed to be the right solution to the snow goose problem is not working. We have caused this problem and we should take responsibility for solving it, without killing millions of geese. We could consider the one solution no one mentions: farming differently, so that less spilled grain is available to them in the first place.

✝

Under a bright sun and the warm wind, the ice is thawing. It will all be gone in a few days but I doubt the snow geese will be here to see it. To them melting ice means it's time to go. The sound of more than a million goose conversations is very loud, so when the hush falls it's as if the lake is holding its breath. All their necks come up. Every goose is alert. Then comes a sound like a demolition charge, a sharp crump, muffled by the distance, then a tower block thundering down in ruin. The geese

are taking flight. Away to the right a roar builds like surf pounding a beach, a jet engine spinning up and gaining power, the passion of a football crowd: all of these, merged into an overwhelming noise, white noise, which drowns the thunder of a 10,000-ton train on the railroad beyond the lake. I feel my ears clamping down in self-defence. Do I speak? If so, I cannot hear my voice.

A wedge of black and white drives from the edge of the flock into its heart, a reverse blizzard rises from the ice: more and more and more geese rising. Others catch their panic and spiral upwards in a vortex, a tornado of bodies, of individuals subsumed by the flock. A force of nature, the goose wind, is beaten down by their wings, under a dark goose ceiling. They live in that wind and sometimes they die in it too.

The sky turns, revolving towards us and over us: a dark granular sky, a fluid sky of particles pulsing and flowing, joining and parting. Frozen, they would look like an Escher woodcut of black and white shapes fitting into each other's outlines, but in motion they become a flickering pixelated mass, as meaningless as static on a screen.

I wish it would stop.

I wish it would go on for ever.

The flock turns away. Ranks of shadows spin across the tilted screen of the ice, across our astonished upturned faces and our open mouths.

I cannot see what made them go. Not even an eagle would dare to fly through such a sky, so perhaps it was just the need to do as the others do, to belong and not be left behind: the urge to seek safety in numbers. Scattered across the lake they leave behind sad bundles of feathers, whipped by the wind. The gunfire begins as the geese cross the refuge boundary. White birds fold and fall from their constellations like spent stars. As the clamour of the survivors recedes into the north a single injured goose runs after them across the empty ice.

Snow geese are one of the few reminders of what wild America was once like. They prove that this continent can still support an unimaginable abundance of animals, beside ourselves. I am glad I did not fritter away my time with the most astounding assemblage of life I have ever seen by trying to count them.

f

1. The natural world is full of surprises. Whenever these gentoo penguins left their Falkland Island colony to fish, they ran the risk of being caught by the male sea lion hiding in the waves. Every evening, when the penguins came home, there was nail-biting drama as they were pursued through the surf.

2. Emperor penguin chicks experience the most extreme conditions of any bird. They need to be fat and fluffy to survive the Antarctic winter, in temperatures ranging from -60 to -25°C.

3. The Antarctic peninsula is warming more rapidly than anywhere else on Earth and now it's sometimes warm enough for rain to fall. Penguin chicks are not well adapted to being wet or muddy: these bedraggled chinstrap youngsters may die of exposure.

4. Antarctic warming is also affecting the most ice-dependent of all birds – the Adélie penguin. Sea ice is a vital breeding ground for krill, their staple food. As the ice melts they may have to move even further south but their options to do so are limited. As a result the Adélie penguin may become an early casualty of climate change.

5. I spend much of my time filming from this canvas hide. Most animals ignore it but it was a different story in Svalbard, in the Norwegian Arctic. The hide proved irresistible to a polar bear, which first sniffed inside it, then squashed it flat.

6. While filming the polar bears in Svalbard Steinar Aksnes and I stayed in this hut, once used by hunters and fur trappers. When bears approached they would splash through the stream by our door, providing some powerful images of the summer thaw.

7. Filming polar bears swimming among the pack ice is quite a challenge. Cameraman Ted Giffords modified Jason Robert's boat to carry a stabilised camera with a long lens. The results were stunning, giving the viewer an intimate sense of swimming next to the bears, while keeping the boat at a safe distance.

8. Wildlife filmmakers rarely travel light but spending three weeks filming in the Ross Sea required even more kit than usual. Flashmobs of curious penguins gathered to watch us setting up camp. They were especially fond of the divers' air bottles.

9. Much of the island of Nordaustlandet, in Svalbard, is covered by an icecap. During the summer, melted snow cascades over its edge and into the sea. While filming these waterfalls we came across a swimming polar bear. It must have swum a long way – the ice cliffs run unbroken for around 180km.

10. Polar bears are well insulated and they are excellent swimmers but this one was cold and tired. It eventually climbed onto the only piece of floating ice it could find and lay there, shivering.

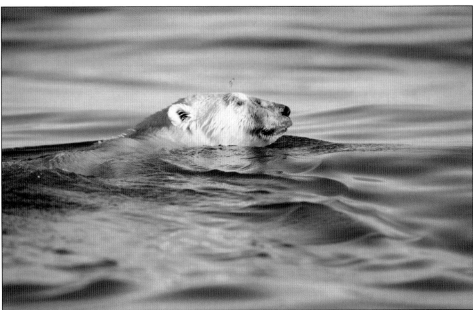

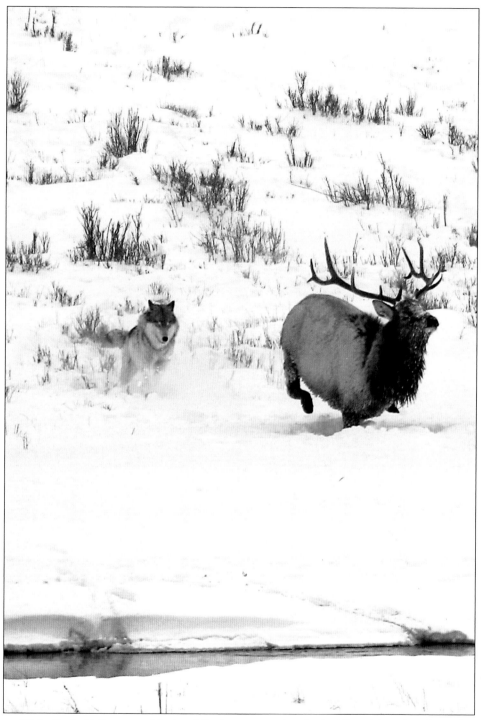

11. This elk, in Yellowstone National Park, was running for its life, with wolves from the Druid Peak pack at its heels. The only way to keep them at bay was to stand up to its belly in a river. The alpha female of the pack was content to play a long game, leaving the elk to chill in the water while the wolves rested. The tactics of these reintroduced predators and their prey were fascinating to watch and to film.

12. Around the Aleutian Islands, in Alaska, there is a summer gathering of more seabirds than are found in any other place on Earth. Many are short-tailed shearwaters, which fly here from Australia. Humpback whales swim from the tropics to join the feast. They come to gorge on plankton.

13. Bandhavgarh National Park, in India seems to be a remote wilderness. Here tigers appear to live completely natural lives – an impression often reinforced by wildlife films – while this young tiger is actually surrounded, not just the park's many visitors but also the farmers who were displaced to create the reserve. This tiger and his brother were taken into captivity some time after our filming because they were suspected of killing a forest guard.

14. Conserving wild places and their precious animals is vital but balancing so many conflicting interests is not easy.

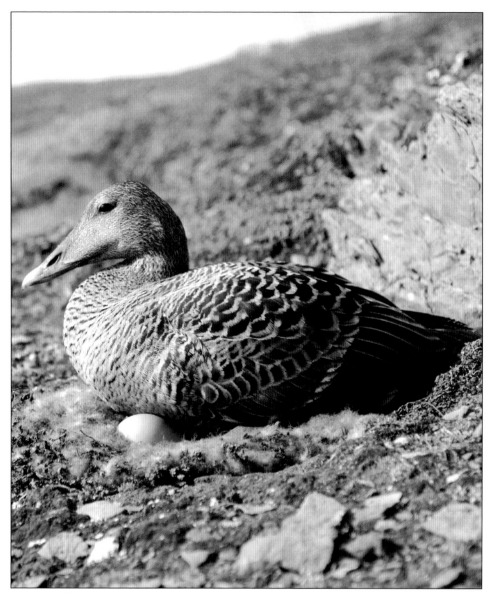

15. Can a duck outwit a bear? It seemed unlikely that this eider could stay undetected on her nest for a month, while polar bears searched the area every few days, hoping to find her eggs, yet this mother managed to bring her ducklings safely through.

16 (opposite top). During the summer months many polar bears can be short of food, especially mothers with cubs to feed. In order to film this family Ted needed to put his head inside a hood and peer at a monitor. The mother bear was hungry, curious and much closer than Ted realized. Jason took this picture just before moving the boat out of range.

17 (opposite bottom). This large male bear looked up at me as I filmed him from the bow of our ship, the *Havsel*. Polar bears are the only animals that frequently stalk people and his intense scrutiny was quite unnerving.

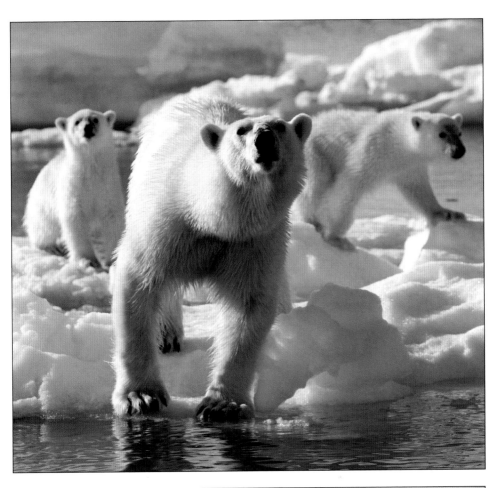

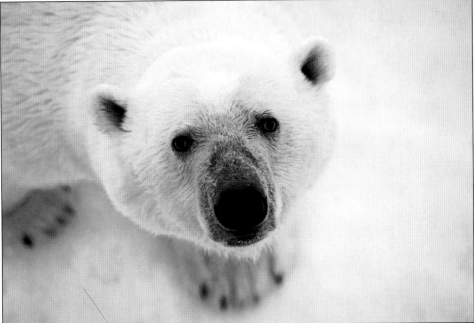

18. All cats have acute senses and are often secretive, but filming in the forests of the Yukon Territory in Canada, showed that lynx have vanishing down to an art. After a month of searching we managed to film only a handful of shots and to take this photograph.

19. In China I tried to film another secretive and wary animal. Finding this moulted feather seemed the closest I was likely to come to a Siberian crane. Beads of water, acting as tiny lenses, magnified the details of one of nature's most remarkable structures.

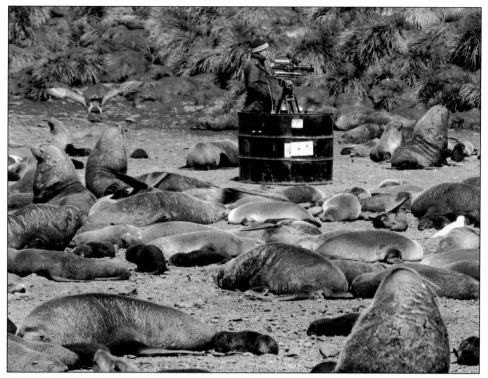

20. Crouching among the battling fur seals of Bird Island, in the South Atlantic, is not for the faint-hearted. The males are powerful, aggressive and armed with self-sharpening teeth that they sometimes use on visitors as well as each other. A portable fort, built from old oil drums, made it possible to concentrate on filming without being bitten.

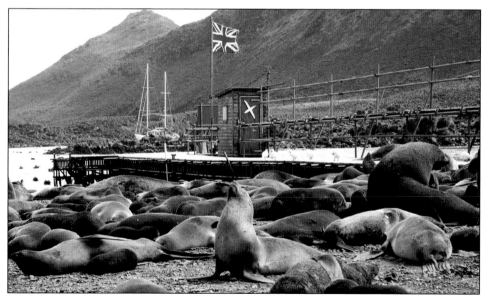

21. Bird Island's small population of scientists sometimes need access to their pier, despite the mass of breeding fur seals blocking the way. One reason to make the tricky journey is to pay a visit to the island's original toilet, in the small hut by the flagpole.

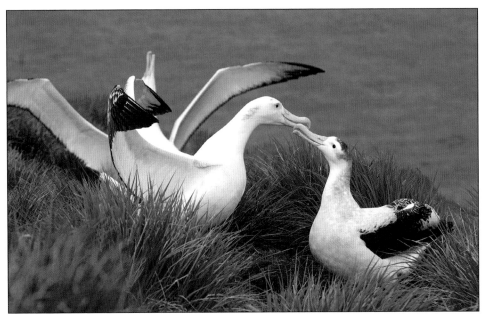

22. After spending their first five years or so at sea, wandering albatrosses return to their colony to find a mate. The males call and tap bills with each visiting female (right) while showing off their enormous wings, the longest of any bird. Some of these albatrosses are considerably older than me and many pairs will stay together for the rest of their lives.

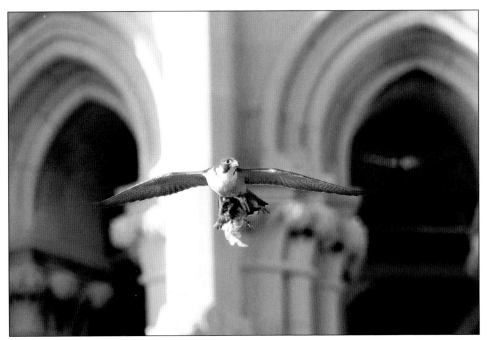

23. During the 1960s and early '70s peregrine falcons were wiped out in the US, east of the Mississippi river. The birds' spectacular recovery, to the point that seventeen pairs now breed in New York, is an encouraging sign that conservation can work. This bird nests on a church tower near the Hudson River.

24. The seabirds of French Frigate Shoals, in the Pacific Ocean, see very few people and they are exceptionally tame. The camera was the highest point around, which made it an irresistible perch for this booby. Some of my filming of tiger sharks trying to ambush young albatrosses leaving their island for the first time was done with birds balancing on my head.

25. Nothing matters more than not disturbing or harming the animals you are photographing. My son Rowan lay for ages in the cold sea in order not to wake this mother otter and her well-grown cub. As a result he saw much more of their natural behavior – and he made his father proud.

Just one thing remains to complete our filming: we need a shot of a bald eagle taking off from a tree, which is not as easy as it sounds. There are still many eagles on the refuge but they are reluctant to fly without a good reason and it is against the law to disturb them, even if we wanted to.

We drive the dirt road until we find a loose group perched in a copse and pull up, so I can slip out on the blind side of the car. I set up the tripod in the road, hoping there will be less traffic now the geese have gone, then Mandi eases the car back until I can frame two of the eagles, perched side by side. They look back at me, eagle-eyed. They can probably make out the serial number on the lens so I do everything I can to avoid disturbing them: gloves cover the paleness of my hands and for fifteen minutes I barely move the camera, just kneeling there, as still as I can be. The eagles relax a bit too much: they are showing no sign of wanting to fly. One preens the feathers on its side while the other dozes.

I have begun to think that for once I could do with someone disturbing the birds I'm filming when a car pulls up beside me. The window opens and over the roar of the engine a photographer yells:

'Good of them to give you two! What lens are you using?'

I shout-whisper back, as tersely as I can: 'Great, aren't they?' trying to be polite without starting a conversation, while keeping my eye to the viewfinder in case they should go, but both eagles are asleep. The photographer yells again:

'Oh, there's another. There's a bunch of them!'

In the trees ahead of us there are four more eagles, but that's not a bunch. I know what a bunch is. I've seen a bunch of geese.

THE ELUSIVE LYNX

Compared to filming a million snow geese in the open spaces of Missouri, the forests of north-west Canada pose a very different challenge. After weeks of trying, it would be encouraging to have caught even a glimpse of the cats we've come here to film, but for the moment all we can see are ravens.

Four of them have landed in the middle of a frozen river and they are bathing in the snow. It's the first time I have seen them do this. They open their wings and kick their feet in the air, rolling upside down to clean their feathers. Among so many trees there is a sense that you are always being watched by invisible eyes, which is perhaps why the ravens feel relaxed enough to snow-bathe only in the open expanse of the river. They are too far away to film but lovely to see: it's a bonus of spending time in one place, just looking.

From the hill we can see far across the Dezadeash River, over the aspens and willows on its banks, to the blue spruce forest and the mountains beyond. In the snow in front of me there is a perfect footprint, as if a small child has stood here, barefoot. I can see the splayed toes and the impression of a heel. It was made by a hare. The enormous hind feet of snowshoe hares spread their weight, allowing them to run astonishingly quickly across soft snow. This one took such long strides that its hind feet left their prints ahead of its smaller front paws. It could still be close by but unless I can spot the black tips of its ears or the pupils of its eyes, its pure white fur will keep it hidden.

The lynx we are looking for are almost invisible too. These cats are wary, with superb senses of sight, smell and hearing and they spend most of their time in the forest, so it's no surprise that they are rarely seen. Adam, the producer, and I are hoping to film them with the help of a local tracker called Lance, but after ten days of trying, our chances of even seeing one seem as bleak as the landscape. We do have one thing on our side: the lynxes' fortunes depend on how well their prey are doing and last year the snowshoe hares had a bumper season, so this should be a good year for lynx.

f

Lance has a network of friends who are helping our search. One drives a snowplough and she called this morning to say she'd seen a lynx family by the roadside. As we drive to meet her I stare at the trees lining the route but I cannot picture how a lynx moves or what shadows it might cast. We are more likely to find their footprints in the snow than to see the cats themselves through the tree trunks, but at forty miles an hour I can barely separate their tracks from moose or coyotes'. Somehow, as he drives, Lance manages to scan for footprints and remember which ones were there yesterday, as well as noticing which are fresh. When we reach the snowplough driver's spot the only signs that the lynx family was ever there are the tracks they've left in the snow. Lance shows us how to test whether they are fresh by sliding your foot across the edges. If you feel an icy ridge they are more than ten minutes old. These lynx are long gone.

We follow another set of tracks along a quiet road. A lynx walked here this morning as it was growing light. Its footprints are strikingly round and as large as my palm. I can see its toes but no claws because lynx can withdraw them, like almost all cats. The footprints start out well spaced but then the lynx abruptly changed gait, taking extremely small steps and placing its toes almost on top of the heel in front. Lance calls this 'pussy footing'. The cat was hunting. Its prints end abruptly where it left the road and leapt more than two metres into the deeper snow, then again and then to a tree, where it caught a squirrel. The squirrel's prints are paired and very shallow where it bounded towards the tree. The lynx must have intercepted it there because the squirrel's tail is lying in the snow. That's all that's left, just the tail.

It is tantalising to know that the lynx was here earlier but that

we've missed it. I look at the silent trees and wonder how many lynx have seen us as we have been looking for them.

Overhead a band of light pulsates, pale light without colour. It becomes a pyramid, flickering and dancing, the wisps of light drifting like curtains. I should be shivering, watching the Northern Lights under a clear sky in March, but this morning it's only just below freezing. This time last year the temperature was −45°C (−49°F). The unseasonal warmth is melting the snow and taking the lynx tracks with it, making our task much harder.

A pattern of stars stands out in the sky before dawn. It's Orion. I often saw him from my bedroom window in winter when I was a child. Orion is the hunter's constellation, and now, after years of starting early to go filming while he is still in the sky, I think of him as the wildlife cameraman's too. Perhaps he is a good sign. We have ten days left but we have not yet found a way to anticipate a lynx, to know where it's going before it does.

Lance has tried every trick he can think of: he has hung sparkling CDs on strings to make the cats curious, he's tried to lure them into the open with hares found dead on the road, he's even smeared smelly stuff on twigs – castoreum from the anal glands of beavers and a special mixture called Cat Passion. He says some males are so fond of these substances that they will rub their faces in them. Cat Passion looks like Marmite, but woe betide you if you spread it on your toast. So far nothing has worked.

We have walked for an hour through the quiet woods, between grey aspens, with snow falling gently all the time. There's a house nearby, where for the last few days the owners have watched a lynx family from their windows. It would be a perfect place to film them but so far we have drawn a blank. Now Lance has found their tracks: a mother and three or four kittens have walked recently among these trees. Judging by the youngsters' prints they are almost as large as she is.

We walk in a long curve, pulling the camera kit behind us on a sledge and drawing a circle with our tracks around theirs, so we can

be sure the family is still somewhere to our right once we come back to the road. There we are disappointed again: they have crossed the road already and the area we have circled is empty. The family is at least an hour ahead of us and we will not be able to catch up in the dense spruce forest and boggy ground they've entered. Lance explains that lynx travel in large circuits: they will be back but we don't know when. He says families often separate and come together as they move, calling to each other to keep in touch, so our best bet now is to find somewhere high and listen for their strange cat sounds. The males call too, to mark their territories, and if we hear one Lance may be able to call him in. He cups his hands and demonstrates a deep, two-note sound, unlike any cat I have ever heard. It would certainly draw my attention if I were a lynx.

The hill overlooking the river seems a good place to wait, with its hares among the willows. The cats will find walking easier along the riverbanks. Lance lights a small fire to thaw out his drinking water while, above us, courting ravens fly upside down, plunging inverted then rolling upright by shooting out their wings, like unfurling umbrellas.

Three weeks feels like a long time when every day brings another failure. Now it's important to remember other times that seemed just as hard and that paid off eventually, times when the filming would not have worked if we had given up towards the end. To raise our morale Adam suggests a new policy. He will give a bonus of fifty Canadian dollars to the first person to see a filmable lynx. Lance says one hundred dollars and Adam agrees. I am the only one facing the river at that moment, just as a lynx walks out from among the willows on the far bank. He's a burly male, long in the body, bow-legged and heavily furred: a powerful, muscular cat who looks completely at home. I tell the others I can see a lynx and, of course, they don't believe me.

Lance cups his hands and calls. The lynx stops instantly, takes a few strides towards us and listens. Although he is far away, through the lens I can see his tufted ears and bobtail. Lance calls to him again. The lynx must sense that there's something odd about the sound or where it is coming from because he turns back to his path and, without seeming to hurry, he vanishes into the willows. We have filmed a lynx at last, but on their own these shots will not be enough. We share the bonus to buy some beer and try to decide what to do next. So far tracking has failed, waiting and hoping has failed and even the Cat Passion has failed: poor Lance. He has another job to go to soon but he has a final suggestion. His friend

Peter could tow me through the spruce forest behind a skidoo. If we cross a lynx trail we could follow it on snowshoes. It seems worth a try.

ƒ

Where I wait for Peter the spruce trees are tall and pencil-thin. They muffle sound and no snow lies in their shade. A squirrel rattles an alarm and a grey jay flies past, as round-winged and silent as a moth. Overnight the temperature has dropped and minute rosettes of ice have sprouted from the tips of the needles, each with six crystal petals like a rose. There is one on every needle, on every tree: millions of beautiful ice flowers, almost too small to notice. A dusting of fresh snow has fallen too. It is the first snowfall in days and for tracking a lynx it might make all the difference.

Peter roars up, towing a wooden dog sled behind his skidoo. We strap the camera kit on top and I stand behind, balancing on the last few inches of sledge runner, protecting my eyes as I duck under branches and shifting my weight on the corners to stay aboard. It's exhilarating and we cover plenty of ground. When we find our first set of tracks Peter and I head off through the trees on foot. The lynx is slim enough to have slipped through gaps too narrow for us. Its tracks cross a log, then the thin ice on a pond. We crash along behind, breaking through the crisp surface of the snow despite our snowshoes, then, beneath a tree where there is no snow, the track disappears. We circle it twice: lynx tracks go in but only a snowshoe hare's tracks come out. We circle again, convincing ourselves that no lynx footprints leave. Peter says the cats sometimes climb into trees and jump between them, chasing squirrels, then drop to the ground twenty metres away, so we walk in a spiral, working outwards from the tree until we find a single print beside the hare's trail. The lynx has saved energy by walking on the compacted snow of the hare's footprints, placing its paws exactly on top of them. The prints lead us to another tree and when the snow runs out they disappear again. As Peter and I stand there, wondering what to do, a goshawk passes us, as silent as a ghost and just as pale.

A National Park ranger once told me: 'If you follow tracks for long enough you are bound, eventually, to walk into the back end of whatever made them,' and I believed him until now, but we are so slow and so noisy that, unless the lynx was deaf, our chance of finding and filming one like this seems vanishingly small.

f

With just a couple of days left, Peter takes us to meet his friend called Thomas Joe, a Southern Tshwane Indian. They often hunt together in the autumn and Thomas Joe has paid Peter the great compliment of calling him by his own elder brother's name. In the village the local kids respectfully call Peter 'Uncle'.

We find Thomas Joe on the steps of his cabin, looking out across a frozen lake, named after the huge pike he says live there. His family have been here for generations. He has high cheekbones in a face like mahogany and deep-set, thoughtful eyes. The crinkles around them are exactly as I remember my grandfather's. I like him immediately but he is seventy-two years old and diabetic, so I feel sure he would prefer to stay at home in the warm. I tell him what we have been trying to do and how hard it has been.

'You going to catch a bird, Monday?'

'A plane? Yes, we are almost out of time.'

Thomas Joe rubs his chin and says the smell of 'split pike' might attract a lynx – he says 'link' – and he goes to fetch a sack of dried fish. I realise then how lucky we've been: he has decided to help us. We drive to a crossroads of two skidoo trails where Thomas Joe fixes the sack to a tree trunk. He suggests that I follow him on foot along one of the trails, saving energy by walking on the compacted snow like a lynx, moving quietly and looking for tracks.

'Link hunt 'bout four o'clock,' he says, explaining that in the afternoon the softer snow makes less noise: 'Harder for rabbit to hear him coming. Link don't like wind. Good now, good for listening. We'll get you link today,' and despite our many setbacks I already half believe him. Thomas Joe goes first and I follow, walking in his footsteps, matching mine to his to minimise the noise. I put the heavy tripod and camera on my shoulder, which I know will hurt before we have gone far, but this way there is no loud sledge to pull. He wears a thin quilted coat and carries a flask of tea. It is overcast and the light reflecting from the snow fills the shadows under the trees and lights Thomas Joe from underneath, making his eyes pale and exotic, as if he were a photograph in a magazine. He is proud of his strength: 'Not many people my age walk so many miles.'

We point rather than break the silence. He shows me wolf prints

almost as large as my hand, pacing the whole length of the two-mile trail. He notices the swoop of a snowshoe hare, which had run from the trees and crossed our path, and the bear-like prints of a wolverine, ploughing its own trench, indifferent to the effort it could have saved by walking on the track. It was dragging something edible, dropping titbits gleaned by ravens and jays, which have barely dented the surface with their stick-arrow feet and the sweep of their pinions as they flew away. A different set of footprints straddles a narrower drag mark, as if a stumpy predator had pulled a body towards a spruce tree.

'Porcupine,' says Thomas Joe and smiles as he waits for me to realise that it had been dragging its own heavy tail. 'Wolverine eat them. Don't get quills, turn 'em over. Split 'em,' he says and we walk on again, in a comfortable silence, to where some blunt heart-shaped prints have been stamped deep into the snow.

'Moose,' he says, 'looking for mushrooms in the trees.' Squirrels had carried the fungi into the branches in the autumn, to dry, and the moose has come to sniff out this overhead larder. He shows me one shrivelled mushroom it has missed.

'Squirrels, they smart for little guys,' says Thomas Joe.

Their tracks are everywhere among the trees, so many that in places their toe prints dimple the snow to the texture of a golf ball. He shows me their middens, heaps of cones as big around as both his arms can encompass.

'Link hunt here. Easy to catch squirrel.'

We come to our first lynx tracks and Thomas Joe examines them closely, scraping the edges with his finger, feeling for ice. They are old. The toe pads are neat and round, spaced like the petals on a pansy, with the largest at the base. The fur covers much more space than the paws, spreading the load and muffling the sound. He points out where the lynx left the skidoo tracks. I push my finger into the snow to see how much pressure it takes to break the crust: it's almost none. Lynx step very lightly indeed.

We have come full circle and Thomas Joe tells me to set up the camera near the smelly bag of pike, looking back down the skidoo trail. It is just past three o'clock. He takes off one glove and kneels on it, watching me

sideways to assess my stillness. Apparently I pass and we wait quietly among the silent trees.

An hour goes by, then a squirrel calls. Something grey is coming along the trail. I try to point it out to Thomas Joe, my angle is slightly better than his, but it has stopped behind the willows. It moves again and I start to film. It's a lynx and now he has seen it too. Through the out of focus willow stems, a slender, self-confident cat comes striding towards us: a female. There are dark tufts on the tips of her ears, her face is patterned and, as busy as I am with the camera, the bold white markings around her pale eyes strike me as breathtakingly beautiful. Thomas Joe whistles to her, a kitten's call perhaps, and she trots forward, then stops at the sight of two people crouching where she'd expected another lynx. She stares at us quizzically, quite unafraid, and calmly detours, stepping tall through the deeper snow as carefully as a house cat. On the other trail she walks away without a backward glance, her trim behind and short tail swaying, her huge feet silent on the softer snow of the afternoon: a little after four o'clock, as Thomas Joe predicted. He shakes my hand and smiles, then we walk away, quietly, in single file.

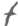

After a month of looking for the lynx we have had to leave with our film only half finished. In such an ideal year, with so many hares for them to hunt, Adam had hoped we would eventually find the mother lynx and her kittens, but we missed them by a whisker. When the family completed their circuit of the forest and its frozen rivers, they came back to the house in the woods and spent two days there, hunting and playing together. We had left the day before.

For twenty years I have dipped into many places, filmed for a month or two then moved on. It has been endlessly fascinating but there have also been times like this, when people rightly say, 'It happened as soon as you had gone,' or, 'You should have been here yesterday.' Thomas Joe has lived a very different life. He proves that immersing yourself in the area around your home is the best way to know its animals intimately well. There is no substitute for spending time.

AN UPDATE ON LYNX

*T*he natural fluctuations in the numbers of lynx, which mirror the cyclical change of the snowshoe hare population, have been happening since at least the early nineteenth century, when this pattern was discovered in the numbers of their skins traded by the Hudson's Bay Company. Despite lynx still being trapped for their fur in western Canada and in Alaska, where there are still large areas of forest, these cats are doing much better than Asia's tigers. Where forests have been fragmented, in eastern Canada and the lower forty-eight states of the USA, lynx have become rare. They are classed as 'threatened' in the contiguous US and in 2008 more than 40,000 square miles of public land were designated as critical to their survival.

Europe has lynx too, perhaps 30,000 of them in the conifer forests of southern Siberia and in Scandinavia (with a smaller and very rare species clinging on in Spain). They have been reintroduced to several European countries, including Switzerland, Germany and France, with some conservationists lobbying for the same thing to happen in Britain, where they might help control the rising number of roe deer.

Eider Farm
- Svalbard -

GREEN-
LAND

SVALBARD

Arctic Circle

ICELAND

Louis's
cabin

eider's nest
taken by
the bear

tern colony

filming
hide

EIDERDOWNS AND POLAR BEARS

The lagoon in front of me is fringed with islands and beyond them rise the snow-covered mountains of Svalbard: it's a place alive with birds. After our failure last summer, Miles has decided to try again to film polar bears searching for nests, but this time we will wait on one of the islands and hope that a bear comes to us.

This is a productive, sheltered place, which is one reason that so many birds have come here to breed. Above us dark skuas chase Arctic terns, as if the birds were being robbed by their own shadows. On the water there are black guillemots and all the way along the shore spin twittering groups of phalaropes, so delicate you would never imagine they had spent the winter at sea. Miles has chosen this particular island because eider ducks nest here too, and when their eggs are about to hatch the bears sometimes come looking for them.

Instead of last year's flimsy shack we are staying in a robust cabin, which was built here because of the eiders by a man called Louis. This is the only house on the island and inside it is very quiet. The terns' screams are muted by triple-glazed windows. There is no ticking clock and no running water. No tap drips. There is no radio and no aeroplanes pass over. On its walls are two pairs of walrus tusks as long as my forearm. There are Arctic fox furs, a flare pistol and a hunting rifle, hanging by its strap from a peg. Louis is ingenious and mischievous: the peg is the penis bone of a walrus. I've sat in a chair he made from a whale vertebra and laughed at the signs on the toilet's double doors:

one has a male arrow, the other a female cross. Both open into the same small room but on the gents' side there is a note saying: *Out of order, use the beach.*

All this is in the upper half of the cabin, where Louis lives, but in the basement there's a small fortune. A metal door protects a storeroom stuffed to the ceiling with large cotton sacks. When I press them they feel soft but elastic. Each one weighs 10kg (22lb) and their contents are worth £650/kg (about $550/lb).

f

Today the air is cold, with just a light breeze ruffling the leaves of the willow trees. Not one of them reaches higher than my boots, none of the plants here do, but tucked into this dwarf forest is an eider. I have been watching her from a distance for several days. The duck has made her nest in a hollow, surrounded by purple saxifrage flowers. Her feathers are subtly beautiful, with pale edges and dark centres, dappled in cinnamon, black and ash brown. When she moves they slide over each other like tiles. On her face they shrink to dark and light stipples and above them a pale brow gives her a gentle look. She is an exact match for the rocks and soil between the flowers, and she needs to be hard to spot because sitting ducks like her are a powerful draw for bears. Five or six of them visit Louis's island and he knows the character and foibles of each one. I would rather not meet them while I'm sitting in a hide, especially the bear Louis says he really doesn't trust – he calls it the Telephone Bear.

Miles is outside making a phone call: we can hear the murmur of his conversation with the production office in Bristol, as Louis tells me how the bear came by its name. The phone mast that makes the call possible was installed a few years ago to serve a coal mine, far away at the head of the fjord. The signal is weak by the time it reaches the cabin, so cell phones only work on the top step outside the front door. From there the cabin blocks the view to the rear. Last summer a friend of Louis's was standing where Miles is now, making a call from the top step. The first sign that he had met the Telephone Bear was a very loud bang. When Louis ran to the window his friend had vanished. Instead the bear was standing there, upright and taller than the door it was battering with its paws. It had heard the conversation, crept to the corner

of the building, then rushed the last few feet. Louis scrambled for his rifle, ran to the porch and found his friend lying on his back with his feet braced against the juddering door, still on the phone and saying, 'No, dear, no, it's nothing, it's just a bear,' all the while gesturing furiously at Louis and hissing, 'It's my wife! Don't shoot or she'll never let me come back.'

'Louis,' I said, 'don't you think we should tell Miles?'

Although bears are frequent visitors to the cabin they rarely come as close as that to breaking in, but one August Louis came home to find that a family of bears had succeeded. The mother had chewed one of his windowsills until it splintered, then slid her claws behind it and torn out the glass before climbing inside with her cubs. They had spent several days trying to reach the food, which Louis keeps in a reinforced cupboard. He showed me photographs of the knee-deep debris in his home: smashed furniture, glasses and crockery. He says it was a shame the bears hadn't managed to open the food cupboard because they might have left sooner and done less damage.

He rebuilt the cabin and this time he armoured the walls using timber cladding three inches thick and recessed bolts, with locking metal shutters across the downstairs windows. He has fixed strips of wood, with nails protruding like claws, to the edges of the roof and every climbable surface, but Louis, who is so fastidious in everything he does, has left the bears' claw marks on his living room walls. Perhaps they remind him never to be complacent.

With this in mind, when I go outside to wash, I carry a flare gun and take no chances. It is a bit like crossing the road: looking right, left, then right again. There is no sign of the Telephone Bear but I am immediately attacked none the less. The Arctic terns' colony on the island is large and close to the cabin and the terns are defensive of their eggs and chicks. It is not the most peaceful way to clean myself, with screaming terns hitting my head, so I set my bowl on a driftwood log and wash as quickly as I can, scanning for bears and wondering how long the water will take to freeze.

The terns' deterrent is effective but it does advertise where they are nesting. Eiders have the opposite strategy: they stay still, trusting their

camouflage and, just as importantly, their lack of smell. By nesting close to the terns they may even gain some aerial protection but there is no escaping the fact that to succeed they must lay their eggs on the ground and somehow, for a month, ensure that they are not found by bears. For the next couple of weeks I will be there with them, sitting in my canvas hide, which has a very limited view and offers no protection at all, trying to film what happens when the eider ducks think that no one is watching them. The thought will never be far from my mind that the Telephone Bear might be watching me too.

*

There are eiders nesting all over the island, there's even one directly below the cabin window, but it has been hard to choose which of them to film because we have no way of knowing when their eggs will hatch. Last night this changed when Miles visited the saxifrage eider and noticed a tiny crack in one of her eggs, so now the three of us – Miles, Steinar and I – are walking slowly towards her. She crouches with her head among the flowers, stretching her neck and flattening her body. We take our time and I talk to her as we approach: 'Hello, hello there, don't worry about us, we won't harm you, you just stay put, good girl, good girl …' on and on, as if she were a fretful child.

Filming nesting birds is a matter of life and death. Her babies are about to be born into this cold, dangerous place and she wants nothing more than to be left alone, but to film what happens I will need to spend many hours just a few metres away. If I scare her from her nest the eggs will quickly chill and her ducklings will die. That's why I am trying so hard to make no difference to the outcome. It's only television after all.

I have two reasons to think this will work: eiders are famously confiding because they put such faith in their camouflage, and I can use my hide, which most animals ignore. We set up the metal poles first then cover them with the canvas, faded now by years of sunshine and wind, but still able to make me disappear. I squeeze inside and Steinar passes me the tripod, the camera and a walkie-talkie. He zips me up, then he and Miles walk away. Through the opening, obscured by layers of net, I can see the duck lying flat on her nest. It must take a great effort of will not to seek safety at the expense of her eggs and I

thank her quietly for staying, hoping she is convinced that I have left with the others.

The sun burnishes her back and streams in through the mesh of the hide, casting patterns like a reptile's scales onto the walls. I sit completely still, watching her. She casts no tell-tale shadows because her wings and tail droop smoothly to join the ground. Everything about her is cryptic and matte, except where the sun sparkles in her liquid eye. Fifteen minutes pass before she relaxes enough to raise her head.

Eiders spend most of their lives at sea or on wild northern shores like this, where calm days in summer are a treat to be savoured. I first filmed them with my fiancée, Mary-Lou, twenty years ago in Scotland. We watched groups of the gorgeous males throwing back their heads and cooing, and became so fond of them that, as an engagement present, I gave her a ring with a male eider engraved on it, rising from the water to flap his wings.

The ducks finished their courtship here a month ago and this female has been sitting on her eggs among the flowers ever since. In that time she will have seen more polar bears than people. One of them was here yesterday, leaving its footprints on the shore; and where the last of the winter ice joins the island it found a handy place to scratch its backside. The strands of hair it left behind are long and curiously colourless, transparent rather than white.

An unfamiliar sound startles me – the clicking of stones – and I listen hard. Perhaps the waves on the shore are echoing from the rocks, but was that a huff of breath or just the wind? Steinar is lying out of sight somewhere above me on the hill, keeping watch for bears. I tell myself it's nothing and concentrate on the eider, through the lens. She is confident that there are no bears and stands to turn her eggs, a clutch of khaki domes.

Eggs are a brilliant solution to the problem faced by nearly every female bird: if their young grew inside their bodies, the mothers would become too heavy to fly, but by encasing their babies in shells they can put them in a nest. The snag is that the chicks will only develop if they are kept warm, and that's especially difficult for birds nesting in the

Arctic. Even in July this duck could find that she and her nest are buried under eight inches of snow. The eiders' solution to this problem is the reason that Louis built his cabin here, it's why he has those valuable sacks in his basement and why the cosiest of all bedclothes, the eiderdown, takes its name from a duck.

f

As a boy I could hardly believe my ears when I first heard that quilts were filled with feathers, which had been plucked by wild ducks from their own breasts, then collected by eider farmers: it sounded fascinating but unlikely. Years later, when I was filming those courting eiders in Scotland, I saw the first stage for myself. A duck had scraped a bare nest among the heather, laid her eggs in it, and now she needed to protect them from the cold. She stretched her neck very tall, tipped her bill until it rested on her front and rubbed it upwards against the grain, as if she was stropping an old-fashioned razor. Easily, miraculously, clouds of down bubbled up from between the feathers. It seemed to weigh almost nothing. She worked each plume to a head as fluffy as meringue, took it in her bill and carefully tucked it under her. After an hour she had filled her nest and had enough down left over to cover the eggs.

Eider down is the best insulator in nature. A teaspoonful, fluffed up, would fill a cup and the warm air trapped inside it is just as effective at protecting eggs in a nest or a person snuggled under a duvet. Warmth like that is worth paying for and in Japan the best eiderdown quilts sell for $30,000. Louis is an eider farmer but the birds on his island are wild and free to nest wherever they like. He only takes their surplus down, which the ducks replace, and he protects them from predators. Since he came here the colony has doubled, to more than 3,000 nests.

People first protected eiders more than 1,000 years ago, when the Northumbrian Saint Cuthbert made what may have been the first conservation law anywhere in the world. Perhaps he too was kept warm by their down at night.

⩜

The duck shuffles round to face the other way. Perhaps she's feeling the

small movements of her chicks through their shells. If so she is keeping her secrets close to her chest, but just as she settles I glimpse a hole in one egg, smaller than my little fingernail. It's one chick's first window onto the endless light and brisk air of Svalbard's summer. She calls to them, '*kuk-kuk-kuk*', and from inside their shells the ducklings answer with the faintest peeps, almost too quiet to hear. They just carry to my hide.

I remember the anxious hours in delivery rooms, the uncertainty and pain and the many years of dependency after our children were born. These young eiders must grow up far more quickly. Rather than lingering on the shore, they must run as soon as they can, and swim and dive and feed themselves too. At least it's a good day to hatch: the wind has dropped and the island is quiet now, apart from the calls of the terns around Louis's cabin. There are still no signs of bears. I rest my back against the hide wall. I will be here for many more hours but this is nothing compared to the duck's wait, of course. She has not eaten for four weeks and will have left her nest for only a few minutes every couple of days, after carefully covering her eggs, staying away just long enough to swallow some snow.

In my pocket there's a clump of down. I took it from an abandoned nest this morning. I feel the warmth almost as soon as I wrap it around my hand: it's my own warmth, held close. I rub the down and my fingers glide as if I were smoothing cream. Louis is the only man I know who has used an electron microscope to study what makes eider down so special. He says it has virtually no quills but that each fibre has bumps along its length, which are too small to see. To demonstrate its extraordinary elasticity he interlocked his fingers and moved his hands, while preventing his knuckles from sliding past each other. I can feel this happening when I tease the down apart. It resists at first, stretching, then rips with a minute tearing sound, like Velcro letting go.

Within the feathers I can feel tiny imperfections. I roll one to the surface with my fingertips and a saxifrage seed head appears, as if through mist. Teasing out seeds and twigs is a strangely calming way to pass the time and twenty minutes later I'm still finding ever-smaller bits, like the princess who felt a single pea under her many mattresses. No doubt she slept under an eiderdown too.

f

I am losing track of time, but when the sun has moved across a quarter of the sky the duck grows restless, flicking her wings with the rustle of expensive paper. She stands and settles again quickly, with a crunch. Perhaps she is helping her chicks escape. Her sides twitch as my wife's did when the babies kicked. Two tiny dark heads appear, bristly and wobbly necked, then tumble back into the nest. She hunches over them, making a tent with her wings, and dozes uncomfortably while her youngsters explore their freedom to move. She knows they are not yet ready to go.

I open my eyes, see the duck and realise that I've dozed off. This is a bad idea when there might be bears around, but between sleeping and waking nothing has changed, literally nothing: I had been seeing the duck with my eyes closed too. A skua flies low overhead and she freezes. It could swallow the ducklings in a minute but her camouflage works and it flies on, unaware.

Hours later a duckling climbs from under her tail, stumbles half-way around the nest and disappears under a wing. She stands and four well-fluffed little ducks stand too, swaying on their minute black webs. They are well coordinated now, pecking at the flowers, climbing onto her back and sliding off, flapping their very small wings. She sits back on top of them. It is colder now and becoming foggy. I talk, quietly, by radio to Miles and Steinar. They say we have been here for fourteen hours and, as the ducks have settled down to sleep, we decide to take a short break to eat something hot. When Steinar unzips the hide I topple backwards onto the ground. Miles says I look like a beetle.

When we return to the hide we are met by a wall of fog. It is hard to see more than grey shapes but something is moving by the nest. Miles calls, 'They're coming,' but it is too late and too foggy to film the duck and her ducklings as they run down the shore to the sea. There are five ducklings. One egg must have been late hatching: no wonder she has waited so long.

Disappointment mingles with relief: I had so wanted them to do well, despite my being there, but now we'll have to try again to film a different eider family's journey to the sea.

ƒ

With every passing day there are fewer occupied nests, so searching for another sitting eider takes us some time. As soon as we have found a suitable one and set up the hide, the Telephone Bear comes calling.

He climbs out of the sea with his hair plastered to his sides and shakes like a dog. His nose comes up and points straight at the hide, but by now we are watching him from a distance because Steinar saw him swimming in and radioed just beforehand: 'Quick, quick, get out! There's a bear,' and together we scuttled back to the cabin.

The bear shows an unhealthy interest in my hide. He creeps up behind it and pushes his muzzle under the zip.

'That would be an interesting moment if you were still in there.'

He inspects it from all sides, then stands on his hind legs and leans on the top with both front feet. The hide collapses as if it was made of paper.

This bear has been moving from island to island, systematically searching them for nests. After he flattens my hide I film him in the tern colony with the birds in uproar. He flinches when they draw blood from his muzzle but otherwise ignores them, stamping on their chicks, then stooping to eat the tiny bundles of fluff. As he approaches the eider's nest I hold my breath. She is almost impossible to see but bears have extraordinary noses.

Should we scare him away? Steinar has the flare pistol ready but would it be right to interfere? It's a question as old as wildlife film-making. If we had made things worse for the eiders by being here it might have been right to redress the balance, but we haven't and the bear needs to eat, so we must let the scene play out.

He raises his head and sways to and fro to test the wind, then starts forward and the duck explodes from her nest in a clatter of brown feathers. He opens the down gently with his claws and lifts out an egg. It cracks open and a duckling drops onto the beach. The bear eats it and does the same to the others. The eider watches from the shore: in this moment she has lost a month's effort and a whole year in which she'll have no young. If the bear had come a day later they might have survived.

He moves on through the nesting terns towards the cabin. The last eider's nest is the one below the window. I can see her crouching there. Her heart must be hammering but she is as still as the rocks. I wish I could help but I must film the bear. His feet fill the frame and then his

muzzle. It is the closest I have ever been, filming his feet thumping down, coming straight towards us and the sitting eider.

Steinar doesn't deal in filmmakers' niceties about whether we should affect what happens. He is in charge of keeping us safe and abruptly he decides that the Telephone Bear must not come any closer. He aims his flare pistol out to sea and fires to let him know we are here. The flare explodes with such a loud bang that I jerk the camera and the bear jumps too. He turns and hurries back the way he came. The duck has stayed put.

f

Tonight a boat will come to take us away, so the eider nesting by the cabin is our last hope, but we have no idea when her eggs will hatch. We retreat inside and I watch her from the window. She is hunched, as the other duck was when her eggs were cracking. Then from under her wing pops a duckling – two of them. They are already dry and fluffy so, with four hours left, Miles and I straighten out the flattened hide and start again. I wait and watch the nest, while he and Steinar pack the rest of the equipment and move the cases to the shore. The duck may be shy of leading her family away while there is so much activity around the cabin but at least it means the bear is unlikely to come back. For hours she bumps up and down as her ducklings squirm under her, then she seems to make up her mind. She takes two steps from the nest, checks they are following and sets off, weaving between rocks and scrambling over others, with the ducklings running in a string behind her, almost stepping on each other's heels. A few minutes later they reach the water's edge and she pauses to take a sip, then leads them in. The ducklings float immediately and as their mother shakes food from a clump of algae, her family starts to feed.

It is the last piece of the story Miles wanted to film, the story of the Arctic in summer, when even the world's most powerful land predators become desperate for food and where the dedication of a most unlikely hero, a mother duck, has brought her youngsters safely through.

AN UPDATE ON THE POLAR BEARS' APPETITE FOR EGGS

*L*ouis *has retired from farming eider down since we filmed the nesting eiders and the Telephone Bear. It is hard to prove that Svalbard's bears are taking more eggs or young birds – their adaptability and their willingness to eat almost anything mean they have probably always done so – but in these times of dwindling sea ice, the energy neatly packaged in a clutch of eggs must be especially welcome.*

In recent years Canadian researchers have recorded polar bears coming ashore earlier, as the ice melts and breaks up in Hudson Bay, which brings them into contact with nesting snow geese. In four days a single bear was seen eating more than a thousand eggs: equivalent to about a quarter of a million calories. Just eighty-eight goose eggs would have the same energetic value as eating a seal. They eat the birds too. In one colony the scientists watched several polar bears hunting flightless goslings.

It is too early to say whether the bears' increasing overlap with the geese during their most vulnerable time will reduce the burgeoning goose population. The researchers are careful to point out that while the extra food could benefit some hungry bears it can be no substitute for the long-term loss of sea ice and, with it, the lost opportunities to hunt seals.

Scale (km)

0 10 20 30

Akutan
Peak
▲
1303m
4275 ft

AKUTAN

Akutan
settlement

AKUN

ROOTOK AVATANAK

Dutch
Harbour

CUNALAGA

UNALASKA

Route of *Miss Alyssa*

SEDANKA

The
Aleutian Islands
- Alaska -

RUSSIA Arctic Circle USA

Siberia Alaska

Bering Sea

Aleutian Islands AREA OF
MAIN MAP

A STORM OF BIRDS AND WHALES

While many of Svalbard's polar bears struggle to find enough to eat on land, some parts of the northern seas become fabulously productive during the Arctic summer. The waters around the Aleutian Islands attract some of the largest gatherings of animals anywhere on Earth. These feeding frenzies cover such large areas that you'd think they would be easy to find, but they happen far from the shore and in one of the world's wildest places, so trying to film them for *Frozen Planet* is one of the hardest things I have ever done.

f

Our skipper's name is painted on his coffee mug. It says: *Jimmer – American Viking*. His ancestors were Danes and Icelanders but also Aleuts, Russians, Irish and Scots. He is a one-man history of these islands and wave after wave of explorers.

The Aleutian Island chain stretches almost 2,000km (about 1,200 miles), from Alaska all the way to Russia. The islands are famous for their fickle tides, their fog and above all their storms. They are less well known for hosting one of nature's most spectacular banquets, which happens here because this is a meeting place between warm and cold seas. When currents from the Pacific Ocean meet water from the Arctic they stir up nutrients and encourage plankton to grow, which in turn feeds many animals, including humpback whales. These ocean

currents, and the masses of air moving above them, brew the frequent storms, which travel east along the chain from Russia. People came that way too – the island communities still have Russian Orthodox churches, with distinctive, onion-shaped spires. The Russians were lured by the promise of sea otters whose fur was so thick that it was impossible to push your fingers through it to touch the skin. At home the furs were worth a fortune but the Russians did not catch the otters themselves, the native Aleuts did that. They had lived here for millennia and were skilled at hunting from skin kayaks called baidarkas, wearing water-proof coats made of seal intestines.

All the enterprising people who made the risky journey to these islands faced the same problem, whether they were the Aleuts' ancestors, who island-hopped from Asia to America, or Vitus Bering, the Dane who explored the Aleutians on behalf of imperial Russia: they all came without being sure of what was over the horizon or hidden in the fog. It is also the humpback whales' problem and it's our problem too.

f

Bering named two of his ships after saints but these days all the smaller boats in the Aleutians' main town, Dutch Harbor, take their names from sweethearts. Jimmer's is called *Miss Alyssa*. He tells us that he proposed to the original Miss Alyssa by writing on a slate during a scuba dive. It had an engagement ring attached to it by a zip-tie. After reading his question she turned to find Jimmer kneeling on the seabed. Her namesake is a 13-metre (43ft) fishing boat, only slightly smaller than a humpback whale.

I have seen fishermen like Jimmer on television, hauling gigantic king crabs out of the Bering Sea in winter. The crab boats are tied up now and rows of their pots, the size of washing machines, are piled on the quay, but Dutch Harbor is also home to boats that land huge quantities of pollock, year round – it is the largest fishery in the USA. In the winter fishing boats sometimes capsize under the weight of ice, and men slip and vanish overboard. Jimmer's brother-in-law was among them.

This is a wild frontier, where making a living sometimes means taking great risks. If you are in the right place at the right moment the rewards can be enormous too. That's what we are hoping will happen when we go to sea.

We have already spent several days modifying Jimmer's boat and *Miss Alyssa* now has a stabilised camera fitted to her bow. Jimmer asked us not to drill holes to bolt it down, so the camera, worth over £300,000 ($500,000) has been stuck to the deck instead. Dave, who owns and will operate it, has paid close attention to the glue. How long it will stay put in such rough seas remains to be seen. A stabilised tripod head has also been fixed to the wheelhouse roof for my camera. It can be moved into the specially strengthened inflatable tender if we ever find ourselves surrounded by whales. This has all taken longer than we had hoped but it has made no real difference because all flights to Dutch Harbor have been grounded by fog, leaving much of our equipment stuck in Anchorage.

When the sky clears and the planes are flying again, I go to the tiny airport with our assistant, Tom, to collect the missing cases and the last two members of the crew: a whale biologist called Steve, and Jess, an observer who monitors the pollock fishing boats and who is going to be a spotter for us in her spare time.

The town is full of fishermen and most of the processing plant workers are men as well. Jess tells us about being the only woman on boats with macho names like *Seawolf* and *Intrepid*. On one trip a captain offered her the kind of dating advice only a fisherman could: 'Change your bait and try a different ground.' Life at sea is full of surprises: she describes coming across a fulmar lying on the deck of another boat, flash-frozen like the fish in the hold. It was still alive after the ice had been chipped away.

Chadden is the assistant producer from the BBC who is in charge of this shoot. He has decided that Dave and his stabilised camera will transfer to a helicopter once he's filmed enough from the boat. We can all see that this plan is ambitious, given that the helicopter will have to fly here from the mainland, despite its pilot not being allowed to cross water hidden by fog. We don't know where the whales will gather either, but we have a month to find them.

To celebrate finally being ready to start filming we have a Chinese meal and finish it off with fortune cookies. The note inside mine says:

Watch your expenditure, frugality is good, so I give it to Chadden for a joke and in return he gives me his, which says: *Next week your lucky colour will be green*. Perhaps not, as the radio is forecasting strong winds and five-metre waves. The inflatable boat from which I'm supposed to be filming is barely that long. We are hoping to film a storm in the Aleutian Island but ours is of a different kind: a living hurricane made of whales and birds.

f

When Jimmer takes us out in *Miss Alyssa* to look for whales, he says the Bering Sea has only two states: he calls them FAC and DFS: Flat-Assed Calm and Dead for Sure. We discover what he means when we leave the land behind and find the open sea filled with restless energy: it seems that Jimmer's FAC is hypothetical. Fog is gathering too, erasing the horizon.

Bering had the same problem in the 1740s. He sailed past whole islands, blinded by the fog. The expedition's naturalist, Georg Steller, recognised birds he knew would never stray far from land and deduced that islands must be hidden nearby, but by then Bering was very ill and the Russian sailors ignored Steller's advice. What could a naturalist teach them about navigation? In time the ships did find land and Steller, aged just thirty-three, became the first scientist ever to set foot in Alaska. He wrote: I have fallen in love with nature. Several of the animals he found were new to science and to this day they carry his name.

Our own expedition's biologist, Steve, is also in love with nature. He is a superb whale spotter and often stands in the bow, bearded and alert, clutching a crossbow like a modern-day Captain Ahab, except that he intends to use this weapon to help the whales. He has a special permit to approach them and will work closely with Jimmer to ensure they're not disturbed by the boat. Steve is also licensed to collect small skin samples, using hollow crossbow bolts, and he will photograph the distinctive patterns on the whales' tails as they dive.

Humpbacks can live for 100 years but they were almost wiped out by whaling: there were only 1,400 of them left in the Pacific by the time it was banned in the 1960s. They reproduce very slowly but their numbers are gradually recovering. There are about 20,000 now and more than a third can be recognised from their tail ID photos. Matching the pictures taken at either end of their migration has shown that most Alaskan whales swim to Hawaii for the winter, to have their young.

Some have even turned up there towing crab-fishing gear from Alaska (one of Steve's jobs is to cut whales free when they become entangled), but the Aleutians' humpbacks are different – most of them just disappear during the winter – and Steve hopes that by collecting skin samples on this trip he might help track down their wintering grounds, somewhere in the vastness of the north-east Pacific.

By comparison to that, the area we are searching is tiny, but even here the whales are hard to find and we spend our time at sea trying to predict where they are.

Jimmer stares intently at the echo-sounder, which is plotting the bottom fifty fathoms down. Dave and Chadden have installed themselves behind their screens in the wheelhouse. My station is with the other camera on the roof, where Steve, Jess and Tom will spot for whales and crew the inflatable boat if we need it. For the moment there is very little to see because we are in a bank of fog so dense that it's hard even to tell that we're moving. Jimmer's instruments show that *Miss Alyssa* is following the edge of a shallow bank. It ought to make the water well up, bringing food with it. The bank is in a busy shipping lane and a container ship looms on the radar, huge and close and bound for Asia at twenty knots. In the fog we don't even see it pass. As we roll in its wake Jimmer spots a line of flotsam by the boat: 'That's a kind of indicator of the edge of the tide,' he says.

Currents are meeting here. It's a good sign: they might concentrate the krill. The water is shot through with a subtle grain, like flecks of mica in a rock. The sea begins to simmer. There are massive numbers of krill swimming beneath us. We rush to launch the inflatable, struggling to transfer the camera across the gap. It is slippery in its waterproof cover.

Tom asks, 'How much is this worth, before we drop it in?'

'You don't want to know.'

The stabilised tripod head comes to life, making weird robotic sounds: a grumbling monologue about the state of the sea. The *Miss Alyssa* backs slowly away. I peer into the water and creatures like pink grains of rice peer back. They swim in circles with quick flicks, biased by their round black eyes. How odd to think that the largest animals on Earth are fuelled by these tiny krill. Their numbers make up for their size: krill are counted not as individuals, but in hundreds of millions of

tons. There might be 60,000 of them in every cubic metre of the water around the boat.

The surface boils. The sound is like hail striking the sea. It's herring: more fish than I have ever seen in one place. The water flashes silver and bronze as they rise to snatch the krill, changing the texture of the sea with their bodies and covering a huge area, all of them feeding. There are so many that we can smell them.

An unearthly patch of neon green appears below our little boat. It's a whale's pectoral fin, growing larger, rising through the water. The whale surfaces beside us like a dark island. Its two nostrils open, quivering, each the size of my head. Spray shoots far above the boat and an oily mist blows into our faces: it is whale breath. The smell is shocking. Others surface until there are twenty humpbacks feeding around us, quite undisturbed, whales with the girth of submarines and so deep-keeled that they're hardly affected by the waves. They are the largest animals I have ever seen this close. Their tails are wider than our inflatable is long and each one weighs thirty or forty tons. One raises its immensely long pectoral fin higher than our heads.

'Can you spin the boat a bit, Steve?'

The camera is blocking my view to one side and as Steve steers, Tom directs me. He too is used to working around whales: 'Two off the bow, three close astern, round to the right.'

I hope they know we are here. The whales rise and roll back under before I can frame them, but then one lunges straight at us, open-mouthed. I film right down its throat, looking uneasily into that watery cave as its mouth wobbles and expands, filling with three tons of water. Pleated grooves appear: white lines on the dark skin, echoing the pattern of the snow runnels on the volcano behind. The roof of the whale's mouth is startlingly pink. Stiff fringes of baleen close the gap and tighten, as it forces the water through them with its tongue: filter feeding, keeping back the krill and herring. There is a rising curve of a back, an impression of rubbery bumps and the white stars of barnacles passing by. A knobbly spine flexes and the tail comes up, like a dark wine glass above the sea.

The humpbacks do not feed in their tropical breeding grounds, so what they eat here has to last them a whole year. They make the long journey back in the faith that these seas will be full of food, especially krill. Krill live in all the world's oceans but they reach their most astounding numbers towards the poles in summer, when the long hours of daylight drive

the blooms of phytoplankton on which they feed. At their peak the most numerous krill species alone weighs more than the entire human race.

Like the whales, we have come a long way to be here, but none of us has travelled the furthest to this feast. That distinction belongs to seabirds called short-tailed shearwaters. Streams of them are passing the boat, all going the same way. They have slim bills and charcoal-coloured, bullet-shaped bodies. They hold their wings stiffly, rising and falling like crosses against the sky, in dark mimicry of the waves. They are searching for krill and to film them feasting we have to work out where they're going. You'd think it would be easy to find half a million birds, and so it would if it wasn't for the fog. They are much faster than us and we quickly lose them in the greyness.

f

After spending a few more days offshore from Dutch Harbor we realise that we do not know enough about where and when the krill will swarm, so we cannot predict where the whales and birds will gather to feed. Chadden decides we should base ourselves further east, where Jimmer has seen many shearwaters in the past, around the small island of Akutan. If we catch the right tide it will be a five-hour journey and, as usual, it is not FAC. Waiting for better weather would mean missing the tide and prolonging the journey by travelling against the wind and into an eight-knot current, so we grit our teeth and set out. Blue-green water blocks the horizon each time we sink into the wave troughs and groups of tiny whiskered auklets burst from the surface above our heads, with their wings already whirring, as if they have not noticed the transition from water into air. During the whole journey we see only one whale.

The only village on Akutan has wooden walkways instead of roads and quad bikes instead of cars. Seventy-five people live here in brightly painted houses but the village is very quiet. It seems that everyone is working in the fish-packing plant, a converted whaling station smelling of pollock. Closer to the houses the smell is of smoking salmon. There is nowhere to stay but the school is in recess and the head teacher says to make ourselves at home. I unroll my sleeping bag on a crash mat in the gym, surrounded by exercise machines and dumbbells, where I have the benefit of an inspirational poster on the wall: *Attitude is your mind's paintbrush, it colors every situation.*

In the corridor, other paintbrushes have been at work: the children have made a big picture of their island and added neat labels. In the centre there's a volcano with glaciers down its sides and in the sea they have labelled icebergs. All around, in the water, they've painted whales.

*

We set off early the next morning and soon pass a gang of Steller's sea lions, crammed onto a rock. From the boat we can see a scar on the hillside, formed twenty years ago when lava from Akutan's volcano flowed into the sea. There are nearly sixty volcanoes in the Aleutians and almost half of them are active. People in the village rarely give it much thought but this morning was different: I wonder whether the sea lions felt their small island shaking, as we did on Akutan. There were two big shocks, as if a truck had backed into a wall or someone heavy had jumped, twice, onto the floor. The school banged around us, with its doors and gym weights rattling, but thankfully it was only an earthquake not an eruption. We ran outside and checked on Jimmer. He had stayed aboard his boat and the earthquake struck while he was peeing over the side. For once, he said, the land had moved up and down while the sea stayed still.

This time we travel far offshore. In the west the clouds meet the water and the sea is dented all over like a pewter tray. The echo-sounder shows that we are over another shallow area. A sleeping fur seal, smaller and slimmer than the sea lions, floats in a curve to keep its toes and muzzle out of the water. It wakes with a start, its ears sticking out sideways like pencil stubs. In the water around it, herring scales tumble as if they were snowflakes. We have just missed something big.

Pancake marks appear on the sea, first on one side of the boat, then the other, made by a whale's flukes passing under us as it dives deep. It seems a krill swarm rose to the surface with the herring hitting them from below and the whales following, only to sink back into the depths. There are shearwaters here, floating on the sea and pecking like hens, delicately picking up the last of the krill with bills as thin as twigs. They chatter quietly to each other and wait to fly until the boat is almost on top of them, pattering away with the sound of bubbles popping. Some are so full that before they can take off they have to regurgitate, with little high-pitched pukes.

After shearing the first wave they climb, by converting the wind's energy into height, then turn downwind to trade it for speed, which

carries them to the next wave, where they start again. It's as if they are sailing, and with the same pros and cons: like a yacht they cannot always take the most direct course but they can travel almost for free. This is how the shearwaters make one of the world's greatest migrations, from one end of the Pacific to the other, by mimicking the shape, the motion and the rhythm of the waves. Chadden says their gatherings around the Aleutians bring together more seabirds than anywhere else in the world but that each lasts only as long as there are krill near the surface. When the krill surface next they could be many miles away. The shearwaters and humpback whales need to work out where, and so do we.

Two whales rise, blowing columns of spray like pale trees. They are a mother and calf. The mother breathes out with the reedy note of a massive bassoon, then inhales with a deep, elephantine squeal. Going under, she streams water from her sides like a slate hillside in the rain. The calf's inhalation is higher pitched, a hurried, 'Wait for me!' Steve photographs their flukes as they dive: adding two more pictures to the database of whales.

The wind is picking up, wrinkling the sea surface like soaked skin. There are more whales around us now and giant pectoral fins beat the sea to a froth. A tail slaps like a gunshot and then a humpback breaches. For a frozen moment the huge whale hangs in the air, astonishingly large, then it twists and topples back in. The impact makes a crater in the sea, which caves in with a muffled thunderclap. Waves surge outwards, then the surface erupts again with the whale's own volume of displaced water. An aquamarine wound marks the place where air has been forced deep, in a patch of water shocked to stillness. I am glad we are not in the inflatable boat.

'They'll do this for about an hour after the sea gets that rough texture,' says Steve. 'No one knows why.'

By the time the whales stop breaching I have filmed some enormous splashes. One leap haunts me: the whale came so close to the boat that it filled the camera's frame, but the shot was obscured by the mast. It's the one that got away: a fisherman's tale to tell with my arms stretched as wide as they can go: 'It was *this* big!'

Jess tells us that her boyfriend, who works on one of Dutch Harbor's trawlers, was on watch one day when a humpback flew past his bridge window, immense and utterly unexpected. 'Awesome,' she says, and about humpback whales the word is exactly right.

To everyone's relief, especially Dave's, the glue has lasted the course. He has filmed plenty of whales and it's time to take his stabilised camera ashore and into the air, if the helicopter can cross the fog and reach him in Dutch Harbor. So far the rough seas have been making it hard for me to use the other camera. The tripod's gyros compensate for the wave motion and keep it upright, but when *Miss Alyssa* crosses the bigger swells the boat seems to dance around the fixed camera, which often smacks me in the eye. It is impossible to film a whale or a flying shearwater with the long lens unless I can anticipate the sea's movement and if we do find a big gathering there will only be one chance to get it right. I know I will miss it unless I can respond automatically to the boat's gyrations and fit my body snuggly beside the rigid camera so I practise as we travel, bending my knees and swaying at the hips while looking through the viewfinder, touching the tripod just enough to pan and tilt without gripping it too tightly. It feels like holding one eye to a telescope while stirring a huge pot of porridge. By the evening, when I lie down in the gym, my crash mat seems to sway as wildly as a hammock, rocking me to sleep.

On trawlers, where huge quantities of pollock pour from the nets and the newer fishermen struggle to gut the fish quickly enough, the older hands tell them they will be fine once they have had The Dream, refusing to elaborate beyond saying, 'You'll know when you've had it.' After spending every day at sea for more than two weeks, I wake one morning from a dream in which I was following shearwaters smoothly through the long lens, responding so automatically to the boat moving beneath me that I found it easy to keep the camera to my eye. I have had The Dream. Afterwards the sea's constant motion becomes so normal that it is hard to imagine life without it.

Close to the horizon a wave breaks but this one is not made of water. Thousands of dark splinters rise in an arc. At the top they tilt and stream downwind, shearing the sea, to repeat the movement on the face of the next wave. During the Second World War, short-tailed shearwaters gathered in flocks so huge that they showed up on radar and the US Navy shelled them, believing they were Japanese warships.

Unfortunately they do not show up on Jimmer's modern equipment, or our job would be easier.

Until quite recently the most unusual thing about the shearwaters' lives was unknown: while nearly every migrating bird flies north to nest, these do the opposite. They nest in the southern hemisphere, around Australia, during the northern winter and spend their off-season here, feasting alongside the whales. The only animals able to attend this banquet are those few who can cling on through the Aleutian winter, or cope with the immense journeys to and fro. Surviving the voyage has always been a problem for human explorers too. Bering's exploration of the Aleutians ended in 1741, when he died trying to go home.

After three weeks of trial and error, constrained by fog and tide, by the wind and rough seas, we are beginning to understand some of the shearwaters' own constraints: how the wind's strength and direction affect their flight, how the upwellings, which feed the krill swarms and push them within diving range of the birds, are determined by the tides. The shearwaters and the whales seek out places where these upwellings are most likely: the shallow banks offshore and narrow channels between the islands, where rising tides flow the fastest. But the islands' complex shapes mean the tides are fickle: there might be three flood tides some days, and no ebb.

We are still unsure where to go next when a friend of Jimmer's comes on the radio. He is fishing for halibut in a channel where the current is particularly fierce and he says he's surrounded by feeding birds. He is several hours away from us and even if we set off now the peak tide would be long passed before we arrived, but Jimmer says the tides will build over the next few days, so we can attempt that channel tomorrow. We try not to be too excited because similar hopes have been raised before, only to evaporate: our highs and lows pass by as quickly as waves on the unquiet sea.

f

Puffins paddle-steam ahead of us, but they're unlike the puffins I know from home. They have all-black bodies, with white faces and orange feet and bills. Wild lemon-coloured plumes fly from their heads. They're tufted puffins. Porpoises streak across our bow, snatching breaths as they go, like gasping black and white torpedoes. To reach

the halibut fisherman's spot, *Miss Alyssa* first has to contend with the tide-race close to Akutan. This morning the water is flowing with us and we shoot through at fifteen knots, although the boat's top speed is only nine. Around us whirlpools twist beside oily upwellings, which bulge and spill from their centres. We enter a clear patch and then it is instantly rough again, with white breaking heads of waves. The fog makes it eerie: we can't see where we are going and all the time the sea grows rougher. There are great holes in the water, not wave troughs but cavities. We are all holding on, looking ahead and wondering what is there. Perhaps this is how it was for Bering, approaching these unknown shores. Jimmer, thankfully, is using his radar.

Since Bering's day many people have left their names on these islands, and sometimes more than that. Headlands and bays are named for the ships wrecked there. So far we've passed four rusting reminders to take care and Jimmer has shown us one fishing boat which was steered onto the rocks by its youngest crewman, right beside a stumpy lighthouse. He had been told to aim for the light while the others slept. Today we pass yet another wreck; even Jimmer didn't know it was there.

'I guess they didn't make that turn,' he says. A name is just visible on the stern: *Lisa Jo*, a wife or girlfriend – older now. I hope her fisherman came home from the sea.

ƒ

The fog clears and for the first time in weeks we see the blue sky. Shearwaters take off all around the boat, so many at once that their feet sound like a river running over stones. Lines of them fly alongside us and a whale surfaces. For once we are all going in the same direction. Ahead dark smoke seems to hang over the water. A huge flock is gathering: birds swarming like bees. The tide has turned and Jimmer accelerates. We must get there fast. On the sea below that swirling mass, the shearwaters are so densely packed they look like currants in a pudding. They must have found vast quantities of krill. Some are already too full to take off and a surfacing whale scatters them like an explosion of grey ash. Its tail, powering a feeding lunge, hurls some shearwaters out of the way while others, flying, swerve around the explosion of its breath. For an instant the dark birds are reflected in the whale's wet sides and as they stream past we smell their musty scent.

'What the hell?' says Jess, standing by to help me choose which way to film.

The flock is building all the time. Whales shoot their breath skywards, as if cannonballs were striking the sea, and squadrons of shearwaters fold their wings and dive among them. Head-on, their bodies are perfect circles, their wings as slim as blades, but they break their aerodynamic forms and shiver their wings to spill the wind, jack-knifing into the water. Wave after wave, thousands of them, vanishing in showers of spray. There are now four huge dark patches of feeding birds and still more come streaming in. One patch breaks up and another forms: the birds switch between them as new krill swarms are pushed up by the herring. Behind us the lower part of the sky is black, the horizon blotted out. When the shearwater flocks turn they spiral like dust lifted into the air by a tornado. The biggest groups are still ahead but we are now making slower progress against the tide. The back of a whale passes close by, blowing vapour as if it were a submerged train. There are whales everywhere, almost porpoising to feed. There must be so much food.

'More shearwaters, going in right behind you!' This time they are all diving in one place, calling as they go: so many of them that it doesn't seem natural. I had imagined this frenzy might last five minutes but when I check with Jess she says it has been going on, at the same intensity, for two hours. The boat's wild motion, the twists and turns of the tripod, have not registered at all in my need to make the most of our only chance. Then the helicopter appears overhead with Dave's stabilised camera swivelling, revealing the patterns of the flocks from above and the dark ripples spreading through them, as whales surface in their hearts.

We are in the eye of a hurricane of birds: hundreds of thousands in the air at once, mirroring all the life below, in this fizzing sea full of krill. For this much food it is worth travelling halfway round the world.

'Fortune favours the bold,' they say, at least the ones who survive do, and it has never been more true than in the Aleutians. Plunging back towards Akutan's volcano, I understand a bit more now about these inhospitable islands and their fabulously productive sea, where only the boldest can survive: tremendous explorers all of them, whether they are birds, or whales or people.

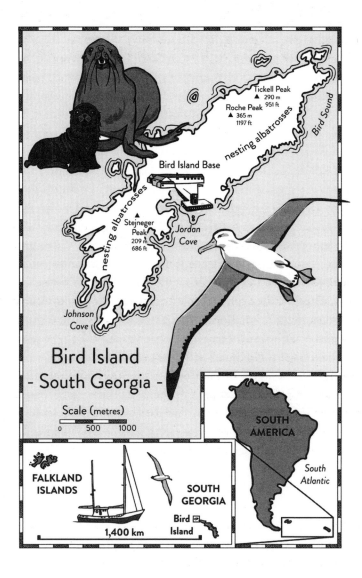

Tickell Peak
▲ 290 m
951 ft

Roche Peak
▲ 365 m
1197 ft

nesting albatrosses

Bird Sound

Bird Island Base

nesting albatrosses

▲
Stejneger
Peak
209 m
686 ft

Jordan
Cove

Johnson
Cove

Bird Island
- South Georgia -

Scale (metres)

0 500 1000

SOUTH
AMERICA

South
Atlantic

FALKLAND
ISLANDS

SOUTH
GEORGIA

Bird ⌷
Island

1,400 km

ANCIENT MARINERS
AND SAVAGE SEALS

The sub-Antarctic island of South Georgia is at the other end of the world from the Aleutians but the cold sea around it also swarms with krill, which feed vast numbers of animals. Antarctic fur seals breed on its beaches, in the world's greatest gathering of marine mammals. It is hard to imagine that 100 years ago they were close to extinction. Their extraordinary recovery has happened almost unseen, thanks to the remoteness of their home. South Georgia's smaller neighbour, Bird Island, now has so many of these aggressive seals that they affect everything you do there, which makes them hard to live with. As you might gather from its name, the island is also home to some curious birds, which I am looking forward to meeting more than the seals. To film them both I'm heading south, on one of the longest journeys of my life.

f

Before setting out I visit my grandmother, who has not been well. As we sit with our cups of tea I play down the eighteen-hour flight to the Falkland Islands and the 1,400km (870-mile) crossing in a yacht: five days on the world's stormiest seas. She does not share my urge to travel and has been abroad just twice. Even the thought of flying terrifies her – the legacy perhaps of being bombed during the Blitz and of seeing a Zeppelin looming over her home when she was very young. The enormous airship is one of her earliest memories. It had flown from

Germany to attack London. In 1918 that was an almost unimaginably long flight across the sea, but flights over many thousands of miles of ocean had been happening long before my grandma was born. They were among the world's greatest journeys and they were made by the birds I am going to film: wandering albatrosses.

She asks me why it is worth travelling so far to film them and I tell her about the albatrosses' graceful courtship dances and the long partnerships they forge to raise their chicks. I describe the young birds' exceptional wingspan, the world's largest at over three metres. My job will be to film them learning to fly. Our cups of tea chill as we imagine these giants leaving their island for the first time and skimming away across the waves.

Sometimes, as we talk, her eyes lose focus. We sit quietly then and I hold her hand, tracing the veins under her translucent skin as I wait, thinking how close we've always been, my grandma and I. Then she stirs and repeats her question and we start again.

She has always taken pleasure in noticing small details, pointing out the beautiful shape of a leaf, remembering the subtle colours of flowers. She notices people's feelings too and experience has made her wise.

'Will you miss your family, while the children are young and changing so fast?' she asks, remembering how my grandad had felt, after a year and a half of war, coming home to find his young daughter didn't recognise him. My grandma's memories of that homecoming and the long-vanished Zeppelin are as fresh as ever, but several times she asks me where she lives. Her recent past has almost completely gone.

'It's no fun getting old, dear,' she says, as I leave to start my journey.

When I reach Bird Island a week later, I am still thinking about the respect we owe to those with age and experience, and about family and memory and loss, because these things also matter in nature: they help to define the albatross.

𝒇

Driving snow buffets the windows of the base, flexing the glass as I look out at Jordan Cove. The beach is slick and grey. It is like November at home but this is the summer in the South Atlantic. Beyond the mouth of the bay, where waves explode on rock, there is an angular white hole on the horizon. It's an iceberg.

Bird Island lies just west of South Georgia and although it is a Holy Grail for wildlife filmmakers they certainly don't come here for the weather. Even in summer, when it's light for seventeen hours a day, the temperature hovers around 2°C (36°F) and the island is almost always wrapped in cloud. A million seabirds build their nests here and, with a bird or mammal in every one and a half square metres, the island is one of the richest places for wildlife anywhere in the world. A handful of scientists from the British Antarctic Survey (BAS) make up the entire human population and they have been kind enough to invite two visitors to stay: Matt and me.

I am up at dawn because it is my turn to be on start-up. I already have my list of duties on a clipboard so I set off towards the generator shed. There are many thousands of fur seals on the beach. Some are sleeping but plenty of others are awake and wailing like the damned. The gantry leading to the shed and pier is also carpeted with seals. The loo at the end of the pier used to be the only one on Bird Island. There are toilets inside now too but the scientists sometimes visit the old one anyway. They seem to enjoy the challenge of urgently running the gauntlet.

Some of the seals snort and lunge at my legs as I dodge between them. It's a relief to open the shed door and duck inside. It seems bizarre to go from a world-class wildlife spectacle to this industrial building, with its two generators the size of tractors and its red fire pumps, but this is what the British Antarctic Survey needs to operate its scientific base. I start to work my way through the checklist: first I have to dip a finger in the radiators to check they are full, then look for leaks, take down readings from dials on the fire pumps ... and all the time above my head I can hear footsteps: seabirds called sheathbills are up there, pecking at the metal roof. It sounds like messages from inmates being tapped out on the pipes in a prison. I am in a hurry to start filming this morning but the list continues over the page: ... dip the oil, open the air vents, select 'auto' on the generator and turn the key. It starts noisily. Next I turn on the power in the base. Beeps follow, lots of them, and I wonder whether this is normal.

Leaving the shed, I check behind the door in case it's hiding a seal, and as usual it is, and as usual he tries to bite me. If I can get past him I can go back inside and make some coffee. On Bird Island whoever is doing start-up gets up before the others, but when I enter the base all

the scientists are awake and clustered in the corridor in their under-pants, trying to turn off a very loud alarm I have set off inadvertently.

We all take turns doing each of the jobs because the base is self-sufficient and there are only seven of us here, so the others have little choice but to trust an incompetent like me with such important things as the generators. The scientists are very good at start-up but they have had more practice. Some of them will spend two and a half years on the island and they receive special training, in dentistry for instance, so they can drill each other's teeth in the depths of winter, when the popu-lation of the base is down to four or five. In the past only three people over-wintered and they knew a thing or two about missing home. For company they used to play darts matches with other Antarctic bases, by radio. It was years before the others realised that Bird Island had never had a dartboard.

f

It is a relief to know that we are going to start by filming the wander-ing albatrosses, rather than the seals. Their colony on Bird Island is one of the largest anywhere but the nesting birds will not be easy to reach, even though the island is just a few miles long. Albatrosses need strong winds to take off, so they build their nests high up: Matt and I have a climb ahead of us and first we must pass the thousands of fur seals who sincerely believe the beach is theirs. We shoulder our packs and pick up the tripod then Matt opens the door, blinking in the cold air, and immediately slams it shut. A male fur seal is sprawled exactly where he was about to step. Belatedly he opens a shutter in the door, as if he were checking for flames outside a plane, and we are relieved to see the seal flumping away down the steps, leaving a perfect image of himself on the walkway: a pointed snout, thick neck then a tapering body and two pairs of long, elegant flippers, outlined by the snow that fell as he slept. Fur seals are related more closely to sea lions than to the seals we have in Britain: the males are pugnacious, they weigh more than I do and they can move very quickly.

Yesterday I found a tray full of their yellow canine teeth in the lab. They were long, curved and very sharp. I would have guessed they came from a leopard if I hadn't read the label. By grinding their upper and lower canines together, the seals sharpen their edges. As I tested

them gingerly against my finger Matt told me that seals bite three-quar-
ters of the island's visitors. There was a broom beside the lab door. On
the head someone had written *Sweeping*, but on the handle it said *Fight-
ing*: someone else has been thinking about the fur seals' teeth.

Bird Island is remote, even by wildlife filming standards: if there
is an emergency we are far beyond the range of helicopters from the
Falklands and in the whole of South Georgia there is nowhere to land
a plane. As we leave the base Matt and I each pull a broom handle from
a box on the walkway. These two pieces of wood do not seem much to
have between us and the seals.

'What do we do if we get bitten, Matt?'

'Clean out the wound as much as you can with a scrubbing brush
and disinfect it,' he says, 'and hope it's not anywhere important. If it is
you might have to stay in bed for a month or more. If it's really bad we'd
have to radio for a ship to come and get you, but that could take weeks.
To get picked up from Bird Island you'd pretty much have to have an
ingrowing tooth, or be pregnant.'

Then he adds cheerfully, 'I've asked for loads of wound wash.'

⅄

Our boots splash among the rocks and the seals on either side raise their
heads. Some bare their teeth and snort, which in the cold air shoots
clouds of vapour and seal snot two metres in our direction. Others give
rumbling growls deep enough to do credit to a lion, making their long
whiskers vibrate, but they spoil the effect immediately by adding a
high-pitched whine: '*Oof choof, oof choof.*' This is so much the sound
of life around the base that the scientists even say it to each other when
they hear something racy, with extra emphasis – *Oof CHOOF!*

The male seals arch their backs and point their muzzles at the sky,
as if they are doing something difficult in yoga, but the most striking
thing about them is their smell. It's pure testosterone and they reek like
a room full of unwashed rugby kit. They are waiting for the females to
return from the sea, to pup and then to mate, and if anything else comes
into their territory it is something to bite. I imagine them grinding their
teeth to give them an edge. We need to cross the beach none the less, so we
point our broom handles outwards and, with Matt watching our left side
and me watching our right, we move briskly between the snarling seals.

Some make mock charges at us but perhaps our determination is more impressive than we realise because they let us through unbitten and their '*oof choofs*' fade as we reach a stream spreading over the stones. Female seals will not pup in running water so the streams are a no-man's-land and the best way to move around unmolested. We climb away from the shore, walking in the water and banging our broom handles on the rocks of the streambed. It winds between mounds of tussock grass, a plant like the marram on coastal dunes at home, which here grows far up the slopes of the hills in clumps almost as tall as a man. The wind blowing through its coarse stems makes a constant whispering: it's the universal sound of Bird Island away from the seal beaches. Matt leads me through a maze of smaller streams where tussocks loom over us, blocking the view.

'I'm starting to wonder if I'll find my way back, Matt.'

'There's always an antsy seal on this corner,' he points out, by way of a landmark.

'What happens if he moves?'

In the streambed yellow objects shift and clack under our boots, sounding more like plastic than pebbles. I look more closely and realise they are bones: hundreds of curved ribs and flat shoulder blades, with tough ridges for anchoring muscles. My foot rests on a jawbone and one of those sharply curved teeth. I shall know this place again at least: it's where the males who have lost their fights on the beach come to die.

We climb higher and the fog eddies about us, sometimes opening to show parts of the bay spread out below, with the small base surrounded by some of the island's 65,000 fur seals. As Matt and I turn away from the sea, the mist parts and there they are: enormous white birds scattered across a meadow and the valley beyond: a hundred wandering albatrosses.

f

People have known for centuries that the great albatrosses existed. The first Europeans to sail beyond 30°S could hardly have missed them, given the birds' habit of following ships. As early as 1593 Sir Richard Hawkins wrote that 'certain great fowles as big as swannes soared about us ... from the point of one wing to the point of the other, both stretched out, was about two fathoms'. The sailors caught and ate them

as a welcome break from salted meat, but some also believed the birds were the souls of their lost shipmates and it was this supernatural aspect that Samuel Taylor Coleridge made famous in *The Rime of the Ancient Mariner*. The unfortunate mariner killed an albatross and for ever bore the consequences, becoming first becalmed, then driven half mad by thirst, when 'slimy things did crawl with legs upon the slimy sea'. The rest of his crew cursed him and hung the dead albatross around his neck before they died. Some say the *Rime* was inspired by Captain James Cook's second voyage of discovery because, as a boy, Coleridge had been taught by William Wales, Cook's astronomer. Wales would have seen albatrosses at sea but he would also have encountered them in South Georgia, which was one of the many islands discovered on that expedition. Cook named it after King George III and he also gave Bird Island its name, perhaps for its most obvious birds: the great albatrosses. Coleridge's Mariner was spared the fate of his crew because he came to appreciate the beauty and the worth of 'all things, both great and small' and he spent the rest of his days making amends by spreading that message, even when his listeners were desperate to get away. Much has been discovered about albatrosses since Coleridge's time and, thanks to research done on Bird Island, we now know that his fateful albatross could have been more ancient than the Mariner himself.

The first bird flies so low over our heads that the long whoosh of air across its wings sounds like a passing glider. It is impossible not to gasp at its size. The albatross's wings are narrow and pointed and each one is almost as long as I am tall. Its feet are tucked invisibly into its belly feathers and all its body contours are aerodynamic shapes, smooth and rounded. It turns over the valley and comes back without a flap, holding its great wings almost perfectly flat. This is more like being at an air display than watching a bird. Wanderers are so efficient that they can glide twenty times further than the height they lose doing so, and in flight they use little more energy than they do on the ground, but even the best gliders need lift and for them that comes from the wind. Although some types of albatross live in the tropics, like the black-footed ones I filmed being attacked by tiger sharks, all the really large species fly around the Southern Ocean, which is the most consistently

windy place on the planet. Having such a remote and inaccessible home is why it took people so long to find out much about their lives.

On 24 November 1958, exactly fifty years before Matt and I gaze up at our first low-flying wanderer and it gazes back at us, an appropriately named ship, the MV *Albatross*, steamed into Jordan Cove and landed four men, who promptly put up two tents and a small shed. The scientists of that first Bird Island base included Lance Tickell, who had come here to learn everything he could about wandering albatrosses. There was a great deal to discover. Even their scientific name, *Diomedea exulans*, suggests they have secrets. *Exulans* means homeless, and although Tickell knew that Bird Island was one of the few places the wanderers did call home, he had no idea where they went while at sea: in fact no one did. Clearly, the birds did more than just wander about locally, searching for squid, but at the time the best guess was that they travelled only a few hundred miles.

Shortly after Matt and I arrived in the modern buildings that have replaced the original shed, the current albatross scientist, Derren Fox, showed us a film Lance Tickell made about his work.

'I'm just going up to see the men,' Tickell said, before setting off on his daily round of the nests and young birds. In forthright fifties fashion he deftly grabbed each albatross chick by the beak and bundled it under his arm, before weighing it and attaching a numbered ring to its leg. Some of the methods he employed, such as spray-painting a few adults red, now seem rather harsh, but this was pioneering stuff and in the days before GPS and satellite tags there was a point to it. Tickell's idea was to ask the Royal Navy and merchant seamen to look out for his painted birds and to report their positions. His plan paid off spectacularly when the first red albatross turned up half the world away, off the coast of Tasmania. It was the first inkling of what later studies on Bird Island and elsewhere have shown in great detail: that albatrosses are among the most widely travelled animals of all. They circle the globe repeatedly and in a lifetime might fly a million miles.

The work started by Lance Tickell continues today, although Derren now uses electronic tags instead of paint to track the birds. Some tags are as small as electrical fuses, recording just the time and day length, the minimum he needs to work out a rough position. Others can sense when an albatross has settled on the sea to feed. Some house GPS transmitters and send hourly reports to a satellite. The results are

emailed to Derren while the bird is still in flight. The maps they produce would have delighted Lance Tickell. Each line plots the path of a single albatross, tracked from its nest on Bird Island. It is clear that for them the ocean is far from featureless. One bird's path could have been drawn with a ruler. For hours her positions were about 65km (40 miles) apart, as evenly spaced as beads on a wire, then they became bunched. Derren explains that she had settled on the water. We check the time on the map – it was night – and we wonder whether she slept there, drifting slowly eastwards on the restless sea. In the morning her track resumed on the same bearing, north-west, towards South America. No one knows how albatrosses find their way but perhaps they combine senses we can barely imagine with their memories and long experience.

The scientists' methods have changed since Lance Tickell's time but Derren still goes out every day 'to see the men' and above all to check which chicks are ready to fly. Matt and I need to know that too.

f

In the viewfinder an adult is flying straight towards me, lining up for his final approach, lowering his feet and at the same time raising his neck. Feathers lift and flutter along the top of his wings, pulled away by the lower air pressure. He holds himself there, flying as slowly as he can, a whisker away from crashing. How pilots must wish they could feel the edge of a stall the way this bird does, but few would envy how he lands. Despite a strong headwind he is still doing twenty knots when he hits the ground hard, throwing his wings up and forward to protect them from the impact. Apparently this is quite usual because he soon stands up and shakes himself, unharmed. He furls his immense wings, transforming himself from a flier to a walker. On the ground he seems even more enormous than in the air. His plumage is almost completely white, telling us that he is a male. His robust beak does the same. It is pink and about six inches long, hooked at the end for dismembering squid. A few feathers on his neck have fine grey marks, like lines drawn with a hard pencil, and in common with most large birds, the tips of his wings are black, strengthened against wear and tear by the pigment melanin. His webbed, lilac-coloured feet are larger than my hands. I imagine him standing beside a mute swan, the largest bird at home. His body is wider than a swan's and he stands taller, despite his shorter

neck. His head is bigger and more rounded too, with black unfathomable eyes under jutting brows.

He lowers his head, points his bill forward and marches towards us, his feet slapping the ground and his head swinging from side to side with each step. He stops a few feet away and calmly looks me in the eye. It is impossible not to smile. Wandering albatrosses nest on a handful of the world's most remote islands, so they see very few people and he is curious about us, rather than afraid.

Another bird leaves a mound of plant stems and runs towards the male with an excited whinny. It's a grey-brown version of himself, the culmination of a whole year's work by both its parents: taking turns for ninety days to incubate the egg, then nine months caring for the chick. If they have fed it well, the young albatross might weigh more than its father. At first one of its parents would have stayed behind to keep it warm through the storms of the southern autumn but later they both ranged far from Bird Island to find food, sometimes returning to find their chick sitting up to its neck in snow. Wheedling and begging, the young wanderer taps its bill against its father's, asking to be fed. His throat works, he lowers his head and opens his bill slightly and the chick slips its own inside. A grey slurry shoots into its mouth, as if it's being pumped through a hose. It does not spill a drop. Bringing their youngster this far has cost its parents so much effort that before starting another family the pair will take a year off. One chick every two years is as slow as reproduction gets in birds. It's something Lance Tickell was the first to notice.

This all leads to a vital rite of passage shared by almost every bird: their first flight. The chick's life and all its parents' effort will depend on that first crucial leap into the air and young wandering albatrosses have a harder time of it than most. On their own they must work out how to use the world's largest wings without breaking their fragile bones. It's a time of intense concentration and risk, which, of course, should make it perfect for television, but we may not have many chances to film it. The number of white adults on the island is deceptive. Half of them are courting pairs and they will not have chicks until next year, so there are far fewer young birds about to fledge. Those we can see seem more interested in being fed than in taking off. Filming one flying for the first time is going to be a real challenge.

f

I have been forgiven for waking everyone earlier; or at least they are all kind enough not to mention it. Kindness, in such a small group of people, is as important as the roof over our heads. An instance of this is when we each take our turn to cook. On Bird Island's fiftieth anniversary as a scientific base it falls to me. The preparations fill much of the day, as there is also tomorrow's bread to bake and cakes too, if it's film night on a Saturday or a birthday like Bird Island's. I spend some time running through the things the others like or dislike, just as they do when it's their turn to cook, imagining what each person will want to eat after spending a cold day measuring albatrosses on the hill or counting seal pups on the shore. My niece's recipe for syrup pudding seems the perfect thing, as it's full of eggs, butter and sugar, so I triple the quantities and get mixing. On the base there is an unwritten but iron rule: after all this effort it is absolutely not allowed to come in late, grab some toast and eat it in your room. The meal, which has been carefully planned (though sometimes a little charred) is always shared and appreciated with laughter, conversation and thanks, so every day we all notice the care that one of us has taken on everyone's behalf.

Filming wildlife is a bit like this too. It is vital to put myself in the place of the animals I'm watching, to try to see things as they see them. It helps me predict what they are going to do next, and when you share others' experiences like this you usually grow fond of them. This has happened with the albatrosses but not so far (at least in my case) with Bird Island's fur seals.

The syrup pudding goes down a storm and I hope it makes up for the early morning alarm. After eating it and the birthday cake, we dress as 1950s scientists, in garish, BAS-issued check shirts and woolly hats, which takes me no time as I'm dressed like that already, and gather on the jetty. At the end there is a flagpole and the outdoor toilet, with a bird painted on the door: it's a wandering albatross, of course. Standing there, surrounded by disgruntled seals, we raise our glasses to Lance Tickell and his discoveries.

In the current batch of biologists there's a Canadian called Glenn Cross who tells me he has met one of the birds Tickell ringed as a chick in 1959: a grey-headed albatross, a smaller relative of the wanderer. I imagine this happened many years earlier but Glenn says he found her

just last week. Lance Tickell retired long ago but at least one of his original albatrosses is still going strong. She is now among the world's oldest known birds. At first sight, Glenn says, there is no sign that she is older than the others, all sitting on their cylindrical mud nests, which look like squat chimneys. Like them she has moulted her plumage for the breeding season and looks gorgeous in her new feathers. Her bill, like theirs, has a bright yellow stripe, set off handsomely by its black surround. Only her feet give away her great age. Their skin is thin and almost transparent.

'They're covered with lines like the patterns clay makes when it dries,' Glenn says, 'like the thin skin I remember on my grandmother's hands when she was sewing, when I was a boy. Her hands were how I could tell she was old.'

Even though the albatross is almost fifty, she is incubating an egg. Counting the generations we reckon that, at most, nine could have passed since she came out of her own egg, so somewhere on Bird Island her great-great-great-great-great-great-great-granddaughters and grandsons might soon be hatching. There is no mutual care in albatrosses, apart from when they feed their chicks and some gentle preening between mates, so great (x7) grandmother or not, she must still go to sea to feed. Glenn talks with respect about how hard it must be to survive for so many years in the Southern Ocean, and how much she must know about icebergs and whales and winter storms. We imagine the sights she has seen in her million air miles, travelling solely by the power of the wind.

Research done on Bird Island shows that age and experience have their price for albatrosses, just as they do for us. Older birds fly further and take longer to find food. I wonder how Glenn's albatross manages when she is out there on her own. Perhaps her navigational senses have dulled or, like my grandma, maybe sometimes she just can't remember where she lives.

f

A week after Bird Island's birthday it is my turn and I stand by a window in the base to call my parents. As we talk I watch the fur seals outside, feinting and glaring at each other. Making the call is absurdly easy, via the internet and a satellite link, as though it is nothing to be living

on a storm-wracked island so far away. I tell my mother about the cards I've opened this morning, which the children gave me before I left home. Freya has drawn a snowy scene where a small house stands by a jetty, with warm yellow light spilling from its windows and a horseshoe above the door, the right way up for catching luck. On the shore a lone figure points his camera at the sky, where two brown albatrosses soar against the mountains – they are fledgling wanderers. This is how she thinks of me, on my own in some faraway place. Mine is a lovely job, we both know that, but I have missed more than half her birthdays.

As always my grandma was right: time does pass very quickly when your children are young. When I call home they sing to me and the last thing I hear is my youngest, Kirsty, blowing kisses down the phone. Tomorrow is her birthday and I will miss that too.

So far we have had no luck filming a young wanderer taking its first flight and the pressure to film the fur seals is mounting. The beaches are becoming more crowded each day and fights between males are increasingly common.

In Lance Tickell's film he mentioned that, although he had watched the albatrosses every day for four years, he had never seen a young bird fly away.

'That's incredible, Derren, isn't it – he never saw it happen?'

'No he didn't and neither have I.'

It's quite a bombshell: we are halfway through our month on Bird Island, obliged to switch to filming the seals for a while, and now our chances of filming a wanderer's first flight seem more remote than ever.

The stream running down behind the base is our drinking supply, so any contamination from the fur seals that sometimes die in it must be filtered out before we can drink the water. Dirt from our boots seems trivial by comparison and walking in the streambed remains the safest way to move around. Everywhere else the seals hem in the buildings and the pier, the males making conical islands in a sea of slimmer, otter-shaped females. The beach is now so full that it's all but impossible to cross.

I have filmed other animals fighting ferociously, red deer stags for instance, but I have never seen anything like this beach. It looks like the Somme. There is mud and blood everywhere, with roaring, snarling enemies tearing at each other's throats: flesh is gouged and blood pumps from veins. Watching them fight is an assortment of birds: sheathbills, skuas and giant petrels, even gentle-faced pintail ducks, grown minute in their isolation and with a quite un-ducky taste for meat. They are all waiting for a seal to die, or at least to lie still enough to be eaten. It is an intimidating scene but not completely anarchic. Many of the females cluster around the largest and most successful bulls, unharassed by others, providing they stay close. If some were not at sea feeding there would be 9,000 seals on this part of the beach: three in every square metre. There is plenty to film – but where to start?

Some of the females in front of me are certain to give birth today and the closest male will want to keep them to himself, so this could be a good place to film a fight. I walk partway into the battleground and crouch by the camera but it is hard to stay focused on the filming, despite having two broom handles close at hand, because every snarl makes me twitch. Something bangs into my foot and I jump back. It is only an inquisitive pup: small, black and purring for its mother. When it looks up from my boot its purrs turn to growls. Even the pups want me to leave, and watching for incoming males is so distracting that I hardly have time to look through the lens. There must be a better way.

f

Our boat has come back to pick up Matt, who is needed elsewhere, and to drop off his replacement, the same Fredi I filmed peregrines with in New York, as well as Ted, the cameraman who was with me in Svalbard. Ted is going to concentrate on slow motion while I film at normal speed, looking out especially for what happens to the pups. As a parting gift Matt has welded some old fuel drums into a full metal jacket, or at least a full metal kilt. Once we are inside its walls the fighting seals ignore us and it even has handles, so we can lift it up and walk around. We are ready to film in the heart of the colony.

More females are arriving all the time and I film one from the safety of the portable fort, as she sets out from the shallows with her wet coat reflecting the sky. She is only two-thirds as tall as the males and less

than a quarter of their weight but her urge to give birth exactly where she was born is irresistible and she weaves and ducks between them. Two males block her way, closing in on each other with their heads up and eyes rolling, baring their teeth. One lunges and grabs the thick ruff of fur at the other's neck, worrying it like a dog with a rag. The other male lashes out and carves a gash in his forehead. They charge back and forth across the border between their territories, scattering pups and mothers. One pup is bowled over and trampled under their flippers but it scuttles off, apparently unhurt. The males trade bite for bite, ripping at each other's heads and necks, then lean together like exhausted boxers, with their sides heaving. One shakes himself, so close that salt spray covers the lens. The female takes her chance to join the group nearest me. The males can hardly raise their heads as she slips past. Every year she will breed with whoever is strong enough to hold this piece of beach, but for the males it's all or nothing. Only those who can defend a good patch have any chance of mating, which for them justifies the risks they take in battle.

Despite the violence I am warming to the seals at last. The newly arrived female is gorgeous as well as daring. Her wet fur is spiky but where it parts it reveals a soft inner pile. This was once the hottest commodity in China and its valuable trade was why most of South Georgia's earliest visitors came here to kill seals. By the time the hunting stopped, around the start of the twentieth century, there were just a few hundred left. What has happened since then is an extraordinary success story. The seals were protected in 1908 and left alone for 100 years. There may now be as many as 4 million of them.

Two weeks later, purrs have largely replaced the males' snarls and there is more new life than death on the beach. I watch one female who seems restless, arching her back beyond the vertical, while the others lie like sleek torpedoes beside their pups. She sways from side to side and her flanks twitch: her baby is kicking. This is so vital a time, such an elemental act. I am fascinated by it: the only births I have seen first-hand were my own children's. As her waters break, the nearest male leans towards her until his muzzle gently touches hers. The pup's flippers come first, folded together like grey kid gloves. It slithers quickly

out, with a membrane caul covering its head: proof against drowning, people used to say, when a human child was born like this. The female calls, keening directly into her pup's ears and it wriggles, wet and black, then opens its eyes and bleats back, like a toy.

I remember the calm time after my own first child was born. Time spent just cradling her in my hands, gazing at her face, at her wide, blue eyes and her fingers with nails the size of lentils. She barely filled my two palms. I was feeling her touch, learning her smell, and I could almost feel my mind rewiring itself, promising to look after her, come what may. These fur seals are the same: the new mum and her pup, wide-eyed and nose-to-nose, sniffing and calling into each other's faces, learning each other. How else would they ever stay together in all this chaos? Tucked in to suckle, the pup sighs and shuts its eyes and I can't help but smile.

f

It is time to go back to filming the albatrosses and I show Fredi the route along the streambed, turning at the corner where there's always an antsy seal. After Derren's bombshell it is hard to be positive about our chances but another unlikely event cheers us up as we climb: for the first time in months the fog lifts and the sun shines on Bird Island. From the ridge above the base the buildings look tiny, surrounded by the dark tide of seals that has filled the beach right to their walls. The bay is quite sheltered but, as usual, there's a wind blowing up here.

Derren knows of an albatross colony on the far side of the island where there are more young birds and a spectacular view of South Georgia. To reach it we must climb high around the flank of the largest hill. The wind grabs loose slabs of rock, lifting and dropping them with alarming bangs, and clouds spin from the peak as if they have been speeded up in the camera, turning the sun on and off. For some time we concentrate on placing our feet carefully, glad again of the broom handles, and when I lift my eyes the wind and the view take my breath away. Three icebergs, speedwell blue, are grounded below the cliffs of South Georgia and above them climbs an almost sheer range of mountains in grey, red and green. The more distant peaks are jagged and corniced with snow. It is as if the Alps have been flooded by the sea. In between there is a wild piece of water called Bird Sound. Kelp bruises its surface,

purple and brown, and in the deeper channel there are lines of white splashes, the Morse code of fur seals porpoising home. Below us adult albatrosses are scattered like sheep across the hillside, with perhaps forty fledglings among them, many flexing their new wings or preening out their last bits of down. Some are weaving through the tussock, heading uphill. We must quickly work out which of them is most likely to fly.

One of the most active youngsters leads us to the top of a steep slope above the sea. It seems a good place to practise taking off. The albatross ignores me as I crouch to set up the camera. On the upper surface of its wings the new feathers are arranged in long rows, as neatly as slates on a roof. Its pointed primary feathers are crinkled, as if they have just been unwrapped. A squall races up the tussock slope towards us and I wonder whether this youngster has any clue about how to use its wings. It opens them to the breeze, feeling a new sensation that we call lift. It's the start of a relationship with the wind that will last a lifetime. It tenses its wings, straightens them, and the wind raises the bird teetering into the air. For a moment it hangs there with its feet trailing, then instability takes over and the long drop below becomes real. The albatross is dumped in the grass halfway down the slope. Fredi and I watch anxiously as it prises itself from a hollow, with its beak caked in mud, and struggles up through the tussock to try again. I film it making several more flights, trying to control its wings and move forward through the air. After each crash it climbs laboriously back up.

Snow starts to fall. The albatross and I are both cold and disheartened and it has had enough. It folds its wings, settles into the tussock with its bill tucked into its feathers and shuts its eyes. Snowflakes land on its forehead and rest there without melting.

On the way back through the colony a glint of steel catches my eye. It's a fish hook as long as my thumb, lying by an empty nest. In the lab Derren shows me a pile of others, all recovered from nests on Bird Island and all potentially lethal. These are just the ones the birds have brought back and regurgitated, along with food for their chicks. They meet many more hooks at sea. Derren has just received an email with some bad news about this: *A wandering albatross with leg ring 5216188 was found dead at location 35°55′ South, 51°56′ West.*

'That's off the coast of Uruguay,' he says. 'It's a very popular place for our birds to forage and also to be caught.'

The BAS database shows that the ring was given to a young female from Bird Island. She has died nearly 1,300km (800 miles) away. She fledged eight years ago from a nest on the ridge above the base and was not seen here again until she reappeared five years later, in a group of awkward adolescents visiting the colony to meet other young birds and practise their displays. In time she found a mate and Derren came to know them well. He has been photographing their first chick every week since it hatched. It is sitting out there now, almost ready to fly and waiting for its parents to return. On his computer Derren shows us a small dot on the map next to the date its mother died. It is surrounded by many dozens of other dots.

'Those are just a tiny fraction of the birds who die, the ones whose rings are recovered on boats fishing for tuna. A hundred thousand albatrosses of all kinds die like this every year.'

They might be the masters of the world's wildest oceans but nothing in their long experience has taught albatrosses not to swallow hooks hidden in floating fish. Some boats use lines 130km (80 miles) long, set with 10,000 baited hooks. Since the long-line fishery began off Uruguay and Brazil in the 1990s, the wandering albatrosses of South Georgia have declined at about 4 per cent a year. These birds, raising only one chick every two years, simply cannot take the loss.

The albatrosses live and die where hardly anyone ever sees them. For them this is almost as great a problem as swallowing fish hooks because, for the people who could help, seeing *is* believing. That's where films can make a difference. Photography is a young medium and television is younger still, but moving pictures can be more compelling than even first-hand descriptions of such dramatic events as my grandma's Zeppelin, and unlike human memories, films last. That's one reason wildlife films matter: they're a set of permanent memories we can all share, making real those things we have not seen for ourselves, such as the plight of the albatrosses. In time perhaps this will make us wiser about protecting what we still have, by making it harder for anyone to say, 'I didn't know.'

I hope our filming on Bird Island helps the albatrosses. It would be tragic if films become the only way to watch a female wanderer banking low over her colony, while male after male throw back their heads to call her down from the sky.

f

A few days after its mother died off Uruguay the orphaned chick took to the air and flew away. None of us saw it go and three weeks on I am still struggling to film a young albatross taking off, but this morning the wind has risen to a full gale and there is a different feeling among the birds. They are scattered all over the hillside and many are facing the wind, exercising their wings. One seems especially promising: it is heading purposefully for the steepest part of the ridge. Whenever it stops it half-opens its wings to test the air. Fredi and I close the distance as quickly as we can, stumbling through the tussock with the camera equipment. The bird has reached a perfect spot where the wind blows straight up the slope with a long drop below. Even better, there is a view of the sea beyond, so if it does fly from here the shot will be wonderful. I cannot afford to miss the moment and I run through the grass mounds and bogs, with the camera bouncing on my shoulder. The young albatross is already on the lip of the slope, opening its wings to feel the updraughts.

'Please don't go,' I say under my breath. 'Not now, please.'

Wrestling to set up the tripod, I have stuck one of its legs deep in the tussock. The bird gives a few shallow flaps, looking intently out to sea, and then tilts into the attitude it will take in flight. I wrench the tripod free and plonk it down, levelling the camera with one hand and turning it on with the other. The bird lifts onto its toes in a gust, its wingtips quivering. At last the camera is running and framed and focused and my plea changes: 'Please go. Go now!' and as though it has been flying all its life, the albatross lifts from the ground and sails away. In seconds it has crossed the coast, gaining height and already it is further from its nest than it has ever been before. Soon it is just a dark shape, flying strongly across the face of a distant iceberg. It is the most enormous relief – for us both. For the next few years and perhaps as many as five or six, it will circle the world, then somehow find its way back to Bird Island, to look for a mate within yards of its nest, and learn how to dance. Soon I will be leaving too, but my journey home doesn't feel so long any more.

On our last night the scientists throw a party. It's a barbecue, outside in the falling sleet. We stand close to the fire, warming our beers in gloved hands while seals call *'oof choof'* around us and albatrosses

circle overhead. It is so cold that we almost don't notice the smell. As a leaving present I have made Derren and the others another huge syrup pudding.

'You can stay!' they say, and I am touched as well as tempted.

When we weigh anchor before dawn the base is just a murky outline above the beach dark with seals, but the generator is already running and the kitchen light is on. As we slip away I wonder who is on start-up.

*

At home I find my grandmother has her leg in traction.

'You've broken your hip, Grandma. You've had a fall.'

'Have I, dear?' she says. 'Well, I suppose I must have because it does hurt. It really grips sometimes and then I have to say "five fives are twenty-five," but you mustn't give in to it, or if you do it's very hard to come back.'

I think of the young albatross climbing the hill after each crash-landing. Its determination to keep trying was so similar to hers: this quiet woman who has lived, without complaining, through losing her home to a wartime bomb, then the husband she loved and finally her memories too.

In my favourite photograph she is smooth-skinned and beautiful, shyly modelling a hairstyle for her first employer, a hairdresser. The memories that have stayed with her longest are all from that time: how she loved to dance the foxtrot with my grandad, their delight in growing plants together and their pride at counting more than 100 morning glories, blooming outside their door one summer's dawn.

I leave her with two pictures: one of my children smiling and a card from my sister, of some morning glories. Their blue petals are a shade paler than the nurses' uniforms but the exact colour of the sky through the window behind my grandma's bed: they are photographs being memories.

*

I am often away when my family needs me most. It is the biggest sacrifice of this way of life – so is it worthwhile? The shots I filmed during

that month among the fur seals and the albatrosses comprised just six minutes of the finished programme, but how much time a story lasts on screen matters less than how long it stays in our minds. Series like *Frozen Planet* reach a huge audience. Where once no one had seen a wanderer take its first flight, now more than 100 million people, all over the world, have shared the experience. Perhaps, when they face problems of their own, some might remember seeing a young albatross that never gave up and learned to fly.

AN UPDATE ON ALBATROSSES

*N*o albatrosses breed in the United Kingdom, but the remnants of empire extend to some of the remote islands in the South Atlantic that suit them so well, places like Bird Island in South Georgia. That's why the British Antarctic Survey and UK-based conservation organisations, such as the Royal Society for the Protection of Birds and BirdLife International, play important roles in helping them.

Since we filmed the wandering albatrosses on Bird Island their numbers have continued to fall – they have halved since the early 1960s – but there are some signs of hope, according to Dr Cleo Small who heads BirdLife International's Marine Programme. The Albatross Taskforce, set up in the late 1990s, has promoted simple ways to prevent birds swallowing baited hooks, including the use of streamers, weighted lines and fishing at night. Cleo hopes that by 2015/16 the numbers of birds dying in all fisheries will have fallen by 80 per cent. Recent changes in Uruguay and a new Brazilian law on mandatory boat inspections, make this seem possible for the first time.

Better still, recent albatross counts from Bird Island may be showing that at last the changes are working. Dr Richard Phillips, a seabird ecologist at the British Antarctic Survey, says that the count of breeding wanderers reached its lowest ever point in 2013/14, but in the next breeding season it climbed back to a level similar to 2008/9. He remains cautious, saying it is too soon to be sure the worst is over – 2015/16 will be the clincher.

Cleo Small says it should be possible to save albatrosses without adversely affecting people's livelihoods, which is unusual for a conservation problem. Even so, the campaign has taken a long time to make a difference. The large number of birds dying first came to global attention in the late 1990s, but for the next decade the wandering albatrosses on Bird Island

carried on declining. Without the regular counts started by Lance Tickell, their decline might have gone unnoticed for much longer.

'We have been waiting for this to happen for years,' Cleo says, 'but as the birds only breed every two years, any recovery will be slow.' Most encouraging, though, is that much of the Albatross Taskforce's work has been funded by donations. It seems that many of us do care about what happens to these birds, even though they live at the other end of the Earth, where most of us are unlikely ever to meet them in person.

Richard Phillips kindly checked the albatross records for me, to see whether the wanderer chick that was orphaned while we were on Bird Island in 2008 had survived to find its way home: 'Orange C50 has indeed been seen back at Bird Island. It first returned as a non-breeding bird in 2011/12 and has been seen (as a non breeder) every season since then.'

In 2012 Bird Island's second highest hill was named Tickell Peak in honour of the man who started the study of the island's albatrosses. Lance Tickell died two years later.

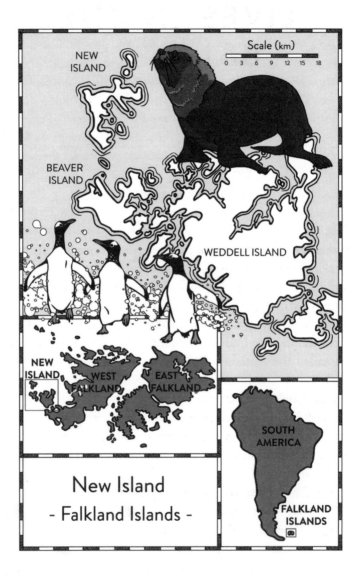

NEW ISLAND

BEAVER ISLAND

WEDDELL ISLAND

Scale (km)

0 3 6 9 12 15 18

NEW ISLAND

WEST FALKLAND

EAST FALKLAND

SOUTH AMERICA

FALKLAND ISLANDS

New Island
- Falkland Islands -

LIVES IN THE BALANCE

There are few beaches more beautiful than New Island's pale cres-
cents of sand. You could be in the tropics if the air were not so
brisk and there were no penguins waiting on the shore. These are gen-
too penguins, which also live on the frozen beaches of South Georgia
and further south, in Antarctica. Thanks to a quirk of the currents in
the South Atlantic, the Falkland Islands lie in the warmer waters north
of a line called the Antarctic Convergence, while at the same latitude
but on the other side of the line, the island of South Georgia is sur-
rounded by properly polar water. The seas around the Falklands are
just as full of food for penguins, so New Island's gentoos would have it
easy, compared with their South Georgian cousins, if it were not for one
thing – one animal, in fact – not even one species but a single individual:
a male sea lion.

The gentoos' nests are packed together in a smelly, noisy colony
above the beach. They are quite safe ashore because there are no land
mammals and providing the penguins keep their (albeit rather limited)
wits about them, they can see off the few predatory birds: particularly
striated caracaras. These are mischievous and known locally, without
much affection, as Johnny Rooks. What happens to the penguins in
the sea is another matter and it's why the three of us – Matt, Justin and
I – have bumped our way here in an ancient Land Rover belonging to
Tony Chater, the man who owns this half of the island. He brings us
to a halt on a ridge overlooking the beach. From this distance it looks

peaceful and it's impossible to know what dramas will be played out on its sands.

We have three weeks' food and water to unload, as well as our camera gear, then Tony shows us where we will be staying, in a tiny hut with bunks, chairs, a table and a gas cooker. Built onto the back there is a loo whose walls are filled with postcards from all over the world. Apart from our voices the only man-made sound will come from the generator we have brought to charge batteries. The view from the hut is superb: down over the nesting penguins to the sweep of sand and water, then out to two rugged islands with the open horizon beyond. Tony has shown us photographs of enormous waves pounding these beaches and cliffs. We are hoping to film penguins in waves like that. For them, coming ashore means taking the biggest gamble of their lives, and not just because of the wild sea.

The outermost parts of the Falklands are quiet and isolated. Living here is going to be something close to bliss and, better still, this is one of very few occasions when my family have been able to come too. It's a rare chance for my children to see what my job involves and why it takes me away from them so often. The hut above the beach is too small for all of us, so they are staying in a cabin a few miles away, sharing the tiny settlement with Tony and his family, the island's other owner and some visiting scientists.

Tony has been watching the gentoos on this beach for years. He explains that nothing much happens in the mornings, except that most of the adult penguins will walk down to the shore, stare at the sea for a while, then dive in for a day's fishing. They hunt small crustaceans called lobster krill, which gather between the islands. Reaching them involves a long swim and the birds will be away for most of the day. Their chicks are well grown and they pass their time doing little except preening their downy feathers and waiting for their parents to come back. Like them, Tony says, we will need to be ready in the late afternoon, when the adults return with their stomachs full of krill to feed the chicks. He wishes us luck and rattles away in the Land Rover.

f

Justin and I sort out the cameras and Matt starts baking bread. There are two thumps on the roof and an upside-down face appears at the

window. It belongs to a bird the size of a crow but with the hooked beak of a raptor: the Johnny Rooks have arrived. They stay on the roof when I go outside, looking down at me from just a few feet away, full of bright curiosity. The pair look alike, dark plumaged with rusty underparts and a ruff about their throats, lined with the striations that give them their name. They have sturdy yellow legs and clawed feet and they are far more inclined to walk than to fly. They investigate everything in case it's edible: a case in point are my knee pads, which I have been searching for inside the hut. The Johnny Rooks must have found them on the grass outside and they have been busy ripping them to pieces. The Falklands' sheep farmers are no fans of these birds, not just because they harm lambs, but because they often steal underwear from washing lines. Given this reputation for theft and breaking things, I should have paid more heed to the warning of my shredded knee pads.

A gale is forecast. Tony has pointed out that in a day or two the wind will be driving large waves onto this beach. We must be ready to make the most of filming the penguins among them, so on the first afternoon we sit above the shore to see what happens when the gentoos come back. The Johnny Rooks have followed us and as soon as we stop they run to our packs and start unzipping pockets, fiddling with straps and worrying loose threads.

Tony's description of what will happen next is spot on: the first penguins swim into the bay just as the dipping sun casts cliff-shadows onto the beach. They seem reluctant to come ashore and instead mill about beyond the breakers, sometimes raising their necks to look around. More birds join them, their wet backs rising and falling like a raft of floating tyres, almost hidden by the waves. We keep track of them by glimpsing the red of their raised bills and the white patches above their eyes. Still more penguins join the group. There is no sign of the hunter who frightens them so much.

The beach is long and the penguins swim back and forth, always staying outside the breakers. They have almost reached the far end when, abruptly, they decide it is safe to enter the surf. As they do, for an instant, we can see into the heart of a wave as it curls high before

breaking. Inside there is a dark shape, travelling fast in their direction. It is much larger than a penguin, expertly using the sea's energy and its long flippers to surf within the wave. The crest breaks in a white explosion and the sea lion is gone. In the bubbles and wave crashes the penguins will be swimming blind.

They hurl themselves through the foam, scrambling upright in the shallows and running up the sand in a tight-bunched line. The sea lion has missed his chance but already a second group of penguins is gathering offshore. We glimpse him, craning his neck to peer at the birds across the wave tops and ducking under before he's spotted. Most of the time he cannot see them and they can't see him either, but both players know the other is there and they move like people playing battleships: second-guessing each other and forced to take shots in the dark.

This time the sea lion positions himself well. The penguins know he is hiding somewhere in the shallows but their hungry chicks have lined up on the shore and they cannot wait for ever. When the group at sea reaches about 200, each bird judges that the risk of being caught is balanced by its need to be ashore and they turn towards the beach. Not one of them stays behind. There is an awful inevitability about the risk they must run every afternoon in order to keep their chicks alive. One chance of dying in a few hundred – they're the best odds available and the penguins have no choice but to take them.

The group swims into the shallows almost exactly where we last saw the sea lion. He's skilled at ambushing them and he waits until it is too late for them to turn back before making his move. Then he surfs in on a wave, flattening his body to plane across the sand behind the gentoos on a thin skim of water. Most of the penguins have their backs to him, standing with their flippers raised for balance, slowed by the backwash against their short legs. As the first ones reach dry sand they run uphill with short quick strides. The last to leave the sea are directly in the sea lion's path. He pulls his hind flippers under him and lumbers in pursuit, a determined muscular animal. The penguins panic, falling forward and beating the beach with their feet and flippers as if it was water, desperately scrambling away. The lurching sea lion is hardly more graceful but he is gaining ground. Halfway up the beach, pursuer and pursued are tiring fast. Both animals are insulated by layers of fat that now threaten to overheat them. The sea lion is close to his limit but

with a last lunge his head enters my camera's frame and his jaws close around one penguin's body.

He is now so hot that he lies flat on the sand to recover, still holding on to the penguin, which is very much alive. It bends its neck and tries to peck him. The sea lion's teeth are suited to gripping rather than slicing and on the beach he has no easy way to deal with his prey. He will need to thrash the bird to pieces in the water, using his flippers for leverage. When he gathers himself and starts back towards the sea I dread filming what is about to happen, but then he stops, sets the penguin down on the sand and lets it go. The bird picks itself up, races into the waves and swims fast offshore. Matt, Justin and I look at each other, perplexed. Why did he release it after all that effort? Perhaps catching penguins is easier than it looks and he doesn't need to eat them all, but over the next hour the mystery deepens as we watch him chase and catch several more birds in the shallows, then destroy them offshore, under a cloud of seabirds scavenging for scraps. At dusk we are still discussing the puzzle as we walk back to the hut, passing the penguin colony where well-fed chicks are settling down for the night beside their parents, except for those few who wait in vain.

f

Tony's storm arrives as forecast, a real hooley from the north, hammering the beach with rollers much higher than our heads, filling the bay with spume and a deep roar. Scenes like this are meat and drink to slow-motion cameras, so we lug the heavy equipment and its large battery to the water's edge. The battery rests on the sand, connected to the camera by a cable. Blowing sand blurs the boundary between land and water and I drape a bag over the camera to protect it as much as possible. We cover our heads and breathe through scarves, facing the oncoming waves, which the wind is steepening spectacularly; and out of those waves come the gentoos, masses of them, as if the flying water is condensing into penguins. The sea lion has no hope of finding them in the maelstrom but instead they are threatened by the sheer power of the sea. Some strike the waves awkwardly and are flung upwards, spinning out of control. One punches through the top of a wave and emerges four or five metres above the beach, still going up, before crashing back into the smothering foam. Others fly upright, as if they were leaping

through a door, with the entire frame behind them filled by a wall of spray, but penguins are tough birds and no matter how hard they hit the beach they are up and running in seconds, escaping the danger zone in the surf.

When it is too dark to film I look down and discover the battery has been completely buried. Its cable rises from the sand, as though the camera is taking power directly from the beach. In those few wild hours we have filmed the first of the many penguins that will appear on screen in the *Frozen Planet* series, materialising magically from the South Atlantic's life-giving, life-threatening waves. Piecing together the rest of the sequence over the next few weeks reveals something new and fascinating about how the sea lion hunts penguins and why, after such strenuous chases, he sometimes lets them go.

f

When I was Kirsty's age maths homework was not my favourite thing, but then I never did it in a small cabin, with sand swishing against the floorboards under my bare feet and the smell of the sea coming through an open window. That's the scene I find after waking at dawn and walking to the settlement to visit my family. Being certain that everything you need to film happens only in the afternoon is an undreamed-of luxury. It means there's time to share breakfast (pancakes) and hear what they have been up to. Yesterday, the children tell me, they watched rockhopper penguins coming ashore by hurling themselves from the highest waves, then gripping tightly with their claws to bounce away from the water. By waiting quietly beside their path, they spent the afternoon eye to eye with the climbing birds, still wet from the sea and heavy with food. On the way back they met a sea lion. Freya shows me her drawing of it growling at them and Rowan photographed it for me, before they fled through the tussock grass. They have been using the tussock to make dens with Tony's children, half-buried ones in the sand, thatched with stems. Tony's wife Kim bakes brownies with them when they come home, happy and with sand in their hair. They tell me they've started to build a more elaborate den from driftwood. They make me promise to visit it with them when it's finished, in a few mornings' time. This afternoon they are coming to the penguins' beach to watch us filming.

We walk back together along the path past Tony's vegetable garden: a small walled-in patch, nowhere near his house. The wall keeps out the Magellanic penguins, which dig deep burrows and wreak havoc with his lettuces, and a scarecrow made from fishing buoys is supposed to deter the Johnny Rooks, but they use it as a perch instead. To our left, the island rises steeply towards cliffs, while on the right it dips gently into the sea. Falkland steamer ducks rest near the beach and drift a little offshore as we pass. Their wings are too small for flight and instead they use them to 'paddle-steam' across the surface.

We find Matt and Justin checking yesterday's shots and deciding how to divide up the beach. Justin takes one camera to cover the section below the cliffs while the rest of us tuck ourselves in with the slow-motion camera at the other end, hoping the sea lion will not notice us. The Johnny Rooks have sharp eyes and they turn up immediately. One of them jumps onto the camera while I am rooting in my pack for a battery. Its feet slide on the smooth metal and it moves towards the back to find a grip. I have not locked the tripod and it starts to tilt under the weight of the bird, slowly raising the long lens. The Johnny Rook realises what is happening and clambers to the other end, perching on the lens hood. The camera starts to tilt the other way, so it scrambles back to where it started. Matt and I have been splitting our sides and wishing we'd had the foresight to film this slow-motion seesaw. We should have been thinking about what might happen next: with a flurry the Johnny Rook grips the viewfinder and pushes down hard, to take off. The camera and lens fall sideways onto the rocks, with the heavy tripod on top. When I pick them up the viewfinder is dangling by a cable, its metal bracket snapped clean through. Luckily almost anything can be fixed, at least temporarily, with camera tape, cable ties and driftwood, so we are back in business before the sea lion starts chasing the gentoos.

Groups of penguins gather as before and rush through the surf. The sea lion catches some and again he lets one or two go. Others he takes offshore and shakes to pieces. It happens too far out to see clearly with the naked eye, which I am glad about for the children's sake, but by watching the recordings we can see that when he catches a penguin he eats almost none of it, then carefully picks up the spilled lobster krill, intended for its chicks. Catching and releasing some of the birds makes sense after all: if they don't feel heavy enough to have a full stomach,

the sea lion knows he will gain nothing by killing them and that he is better off starting again. When he picks them up, the penguins' lives are literally in the balance.

New Island is a valuable place for making discoveries about the natural world. Scientists come here from many countries and a friendly Dutch researcher takes the children with her on her rounds of the nocturnal seabirds called prions, which nest in burrows among the tussock grass. The kids are delighted that each burrow is marked with a stone bearing a painted number, like a front door. They take turns to hold the fluffy chicks before they are weighed and returned to their dark homes, each having made its small contributions to our understanding of how the world works.

Afterwards the four of us crawl into their driftwood den on the shore, completed after hours of work and filled with imagination, laughter and the reflected light of the sea. On a makeshift table stands a cup holding a cluster of flowers.

The helicopter rises, taking us away, and we look down at Tony, Kim and their children, holding their arms high in farewell despite the blowing sand. When you live as far from the mainstream as they do, new friendships are rare and partings feel absolute. The helicopter's shadow passes across the driftwood den and is cast onto the turquoise sea.

There are certain times and places I will look back on with happiness, down the tunnel of the years. Among them are these days spent with my family, good friends and the penguins on those southern beaches.

AN UPDATE ON NEW ISLAND

*O*ur *filming almost coincided with the end of Tony and Kim's time on New Island. They sold their section of the island to the conservation trust that already owned the other half and moved away. Their lives seem to be no less wild as a result: Kim now posts pictures of their children on horseback, galloping across the back-country of Montana.*

The whole island is a national nature reserve and it has an impressive thirty-year history as a research site, which befits a place with such important seabird colonies – the thin-billed prions that my children met number two million pairs: it's the world's largest gathering of these birds. Imagine if every one of their nests had its own hand-painted front door stone.

The Falkland Islands are also home to the world's largest breeding population of gentoo penguins. Their fortunes vary and the number of penguins had fallen dramatically a few years before our filming, probably because of a bloom of toxic algae. Gentoos can have several chicks, as long as there's plenty of food, so they recovered quickly from this disaster and by 2008 they had reached a record high of around 120,000 breeding pairs, spread across eighty-five sites.

In 2010 oil was discovered during exploratory drilling around the Falklands, raising the spectre of what an oil spill would do to these world-class seabird colonies. Commercial quantities of oil are expected to start flowing in 2017. Meanwhile gentoo penguins are spreading southwards and colonising new areas in the Antarctic, sometimes replacing Adélies, as the sea ice coverage falls.

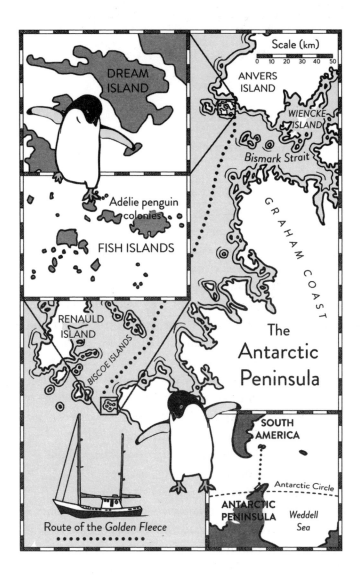

DREAM
ISLAND

Scale (km)

0 10 20 30 40 50

ANVERS
ISLAND

WIENCKE
ISLAND

Bismark Strait

Adélie penguin
colonies

FISH ISLANDS

G R A H A M C O A S T

RENAULD
ISLAND

BISCOE ISLANDS

The
Antarctic
Peninsula

SOUTH
AMERICA

Antarctic Circle

ANTARCTIC
PENINSULA

Weddell
Sea

Route of the *Golden Fleece*

PENGUINS TAKING THE PLUNGE

It is hard enough to evade a determined hunter if you are an adult penguin, but what if you are a chick? Young penguins have a rite of passage every bit as dangerous as taking to the air for the first time with the enormous wings of a wandering albatross: they have to learn to swim, despite the predators waiting for them in the sea.

Dream Island is remote, uninhabited and due south of Argentina: it sounds so romantic but in fact the island is cold and as hard as stone. It lies near the Antarctic peninsula and apart from a few tough lichens, little else lives here. Frost has shattered the rocks, leaving them stacked like tiles grouted with moss. I can pull them apart with my hands. The stones are angular and sharp except where a narrow path climbs away from the sea. It is made of pebbles polished by feet walking over them, perhaps for thousands of years, to judge by their near-perfect smoothness. They could have been tumbled in a stream.

On the beach flatulent elephant seals lie side by side. They are short-haired, sandy or ginger, and all of them are female. They are half as long again as me and very fat, although still much smaller than the three-ton males, which are the world's largest seals. These are among the deepest diving of all mammals. Their large eyes have seen bioluminescent glimmers in the darkness, 2km (1¼ miles) down, where giant squid and others pass their unknown lives. The seals have come ashore to sleep and they wake reluctantly, bleary-eyed, craning their necks to watch me pass, as the stones of the beach clink under my boots. They respond with snorts,

sneezes and gargling grunts like outboard motors, as well as the world's loudest raspberries, which would have a five-year-old in stitches. On an Antarctic beach, when not much else is going on, elephant seals are good company – they never fail to make you laugh – but we have come here to film a different type of seal. One of the world's most efficient predators also visits Dream Island: the leopard seal, but they seem to be in short supply.

A dumpy bird is coming down the path towards the sea, sometimes walking, sometimes jumping. It passes close by without a glance. It's a dapper Adélie penguin, no taller than my wellington boots. It is gleaming white on the front and black behind, simple in the extreme, with just its pink feet and another dash of pink on its beak adding some colour. Its eyes seem unusually expressive because each is ringed in white. As it blinks the rings become curves like crescent moons. The penguin holds its streamlined flippers at its sides. They serve in place of wings because, of course, these birds swim rather than fly. To film Adélie penguins swimming is the other reason we are here.

f

'Penguin' may have come originally from the Welsh, Breton or Cornish name for another black and white flightless bird, the now extinct great auk, which lived in the North Atlantic. Sailors carried the name south and applied it to the similar-looking birds they found there. The logbook of Sir Francis Drake's *Golden Hind* refers to 'a foule which the Welsh men name *pengwin*', seen as they passed through the Straits of Magellan in the 1570s. The French still reserve *pinguin* for the great auk and call penguins *manchot* instead.

In 1840 a French naval officer, Jules Sébastien César Dumont d'Urville, discovered these most southerly of all penguins and named them after his wife Adele. His voyages to explore the Pacific, the Southern Ocean and the Antarctic took him away from his family for even longer than a wildlife filmmaker. Instead of immortalising her as a penguin, Adele d'Urville would perhaps have preferred her husband to have spent more time at home. He named part of the Antarctic continent after her as well. His third expedition was the last to travel anywhere on behalf of France entirely by sail. It seems appropriate that we should have come here with another celebrated French sailor.

Climbing the smooth path gives me a view across the island.

Anchored in the inlet is the *Golden Fleece*, a 19.5-metre (65ft) motor-sailing ketch, which belongs to Jérôme Poncet. Jérôme has spent most of his adult life exploring the Antarctic and his knowledge is second to none. His son Dion helps him run the *Golden Fleece*, with Cathy and Céline making up the rest of the crew. I joined them yesterday from a passenger ship, with Liz, a series researcher. We have switched places with two whale scientists who have spent the last month helping to film an incredible sequence of hunting orcas. The collaboration has been a great success and the director, Kathryn, and cameramen Doug Allan and Doug Anderson, are still buzzing with excitement at how the whales made waves with their bodies and used them to wash seals from ice floes. This behaviour has never been filmed in detail before and it's a real coup for the series, as well as yielding new scientific observations.

The two Dougs are both outstanding cameramen who do much of their filming underwater. My role, in this second half of the shoot, is to bring a long lens and a slow-motion camera to bear when the leopard seals and penguins meet. Doug Allan has been here before, about fifteen years ago, for the BBC series *Life in the Freezer*. He says they found thousands of penguin chicks in the colony and when the young birds reached the water's edge several leopard seals were waiting for them. He filmed the youngsters struggling through broken ice while the seals hunted them down. The sequence was memorable and traumatic to watch. The largest seals are more than 3 metres (10ft) long and they can open their mouths astonishingly wide. It took some nerve to dive with them. Doug filmed one as it grazed its large teeth across the lens port of his underwater camera housing. There were so many penguins going into the water, and so many opportunities for the seals to hunt them, that he saw a dozen or more being caught every day. Doug had imagined we would have no trouble filming this again, but we can see that something is wrong. The Adélies' noisy colony should cover much of the island, yet from the hill we can see large areas of smoothed pebbles where there used to be nests. Their remaining colony is only a fifth of the size it was when Doug was last here. The penguins have almost literally melted away. It seems the leopard seals have gone as well: perhaps this year's small group of chicks are just not worth waiting for.

Kathryn and Jérôme make a difficult decision: rather than staying, in the hope that a seal will show up, we are going further south. Jérôme knows some other islands we might try but no boats have visited them

this year, so we may find they have fewer penguins too. The journey will take a couple of days and time is precious: we are gambling that by doing this we will find a healthy colony before its young birds leave. At least further south it should be colder, so their breeding season will be less advanced. More than any other bird, besides emperor penguins, cold is one thing Adélies do not mind. They are true ice-birds.

f

Jérôme and Doug Allan are old friends who have shared many Antarctic journeys. In the wheelhouse of the *Golden Fleece*, where potted plants are scattered among the navigational instruments, they reminisce about some of their hairier moments, or at least Doug does – Jérôme tends to dismiss near-death experiences with a Gallic shrug. Doug describes one occasion when a massive gust laid the boat on her beam-ends. Amidst the chaos of flying books, equipment and people, he says Jérôme kept hold of the wheel and calmly walked up the wall, still steering the boat and allowing her to right herself.

Even this pales in comparison with Jérôme's pioneering Antarctic sailing in a much smaller boat, the 10-metre (33ft) sloop *Damien*, with his friend Gérard Janichon. In 1971 they visited the island of South Georgia, uninhabited except for some small settlements in a few bays on its north coast, marked as whaling stations on Jérôme's chart. In a storm, south of the island, they were overtaken by monstrous seas. Jérôme describes the *Damien* tipping forward on the face of a wave taller than she was long, until for a moment the boat was vertical, then somersaulting – pitchpoling rather than capsizing – and landing upside down. She stayed there because the mast had become an effective keel. The two men were trapped inside the hull. Green underwater light came in through the portholes. The stove had strewn hot coal and ash everywhere. The hatches were battened down but water was pouring in anyway, siphoned through pipes never designed to operate the wrong way up. No one knew where they were and they were too far from the nearest inhabited land to be found, let alone rescued. Standing on the ceiling of the boat that had been their home for the last four years, Jérôme and Gérard shook hands and said goodbye. Then another enormous wave rolled them upright. They spent the next six hours bailing, chilled to the bone. They had just finished when the *Damien* capsized. This time

they spent less time upside down because the mast snapped off. Again they bailed until they could do no more, collapsing like dead people onto soaking bunks where they slept, beyond caring. He says they hardly noticed when the boat turned turtle again and rolled right back over.

With a stumpy mast rigged from a spinnaker pole, it took them almost a week to tack to and fro along the south coast of the island and round to Grytviken on the north side, where they were towed to the old whaling station, by then occupied by the British Antarctic Survey.

After a less eventful journey, we anchor by an island even smaller than Dream, and Dion takes us ashore in the inflatable. There are penguins here, but rather than Adélies they are a group of young chinstraps, and they're in a bad way. Penguin colonies are never the cleanest places but these birds are filthy, with mud plastered all over their downy feathers. Like the Adélies, these are southern birds, suited to life around snow and ice, where the chicks' down is good insulation against the cold. On this island all the snow has melted, leaving a dangerous, glutinous mixture of mud and penguin droppings, coloured red by digested krill. This part of the Antarctic peninsula has recently become warm enough for it to rain, compounding the penguins' problems because waterlogged chicks can die of exposure. The warming is affecting the sea here as well, which makes the greatest difference to those extreme ice-birds, the Adélies.

Alarmed by the quagmire in the chinstrap colony, we press on further south and drop anchor among the Fish Islands, a scattering of low bare rocks in a bay ringed with glaciers. The GPS says we are virtually on the Antarctic Circle, but still some way north of where Jérôme and his wife once spent the winter on their boat.

At midnight I stand on deck as the sun dips briefly behind a mountain. Distant icebergs glow apricot, like the sky. The air is very cold and perfectly still but the floes move anyway, propelled by the tide, their dark shapes gliding across the sky's reflection as if the sea is breathing. One grinds along the side of the *Golden Fleece* and white lights flicker on its rough surface. I watch them as it passes and turn, wondering, to find the newly risen moon lighting the floes and glaciers, blue and silver. The sea reflects unfamiliar southern stars. Among them I recognise only my old friend Orion, who stands upside down in the sky

and is restored when he's reflected in the sea. I could spend all night out here but in four hours we will start filming, so I go to my bunk and fall asleep to the sound of ice scraping along the hull. It's something I never imagined I would be pleased to hear, but the ice means there should be Adélies.

f

In the morning we go ashore and find hundreds of them, spread across several islands. Some of the adults are in pairs, displaying to each other. They point their beaks at the sky and slowly flap their flippers while they trumpet, their breasts pulsating with the effort. Others lie on the snow to cool down. To our great relief the largest island alone has more than 100 chicks, so we are not too late to film them going. In fact, most are still moulting their last tufts of down: it lingers on top of their heads and many still wear fluffy brown caps. Their backs are the smoky blue of exhaust fumes and their fronts are completely white. They lack the adults' eye rings. When the chicks crouch and fluff up their feathers they become something like a pot, short and squat, to conserve heat, but when they slick them down again and stretch their necks, they are long and skinny. One group of youngsters seems almost ready to go to sea. They flap, but their flippers don't work in the air and they buzz about like clockwork toys. Even so, it is safer to practise on the land: this is a dangerous place to learn to swim.

An adult hops up the path from the sea and five chicks immediately pound towards it, demanding food. Only one of them might be its own, so the adult turns and runs as fast as it can. The chicks follow, tripping and falling over each other until just one is left in pursuit. The adult seems to know that this is the right one, or perhaps it has just had enough of running on a full stomach, and it regurgitates a mush of krill into the chick's mouth. The tiny crustaceans are the Adélies' staple food. Antarctic krill breed in the shelter of the ice and feed on the algae growing underneath, which is why having an ice-covered sea really matters to these penguins.

While we have been counting the chicks, Jérôme has taken the *Golden Fleece* around the islands, looking for seals. He calls on the radio to say that according to his chart plotter he is now far inside the glacier. There are new islands there too, unsurveyed and unnamed, revealed by the retreating ice front. Leopard seals are no longer the

Adélies' most pressing problem – the Antarctic peninsula is feeling the heat more than almost anywhere else on Earth. Of course, there can be abnormally warm years anywhere, but this is a real change: just thirty years ago the sea here would have been frozen for almost three months longer than it is now, which is why the penguins are suffering. Even this southern colony was several times larger when Jérôme saw it last.

In order to travel as fast as possible, penguins snatch breaths while leaping out of the water in smooth curves. Groups porpoising like this look spectacular. Just offshore from the busiest island there is a low rock, which seems perfect for filming them. It is just large enough for the tripod and me, so Dion drops me off. Landing small boats on icy shores comes to him as naturally as breathing. He was born aboard his parents' yacht after the winter they had spent down here, delivered in South Georgia by Jérôme, who had looked up how to do it in a book.

Soon a group of adult penguins hops down to the water opposite my rock, followed by a rabble of chicks. The adults are wary and they look all around before committing themselves. Nothing breaks the surface and there is no sound but the distant colony and the lap of waves. One wets its feet then takes a header into the sea. It goes off like a torpedo and the rest splash in after it. As they pass my rock they start to porpoise, making it as hard as they can for a seal to intercept them. The young birds crowd to the water's edge but they stop on the brink and watch the adults go.

There is a crash like thunder: the face of a glacier has collapsed into the sea. The sound rumbles on and on. The fallen section is enormous and through my lens I can see the white water at the glacier's foot, the blue scar left in the ice and the spray still hanging in the air. The waves might be enormous too and they will be heading this way.

'Dion! There's a really big bit of ice fallen in, can you bring the boat?'
Choosing such a low rock was not such a good idea after all.

We are conscious of each passing day, so Kathryn splits the team in three: she and Doug Allan will stake out part of the penguin colony, while Doug Anderson and Liz prepare to film an iceberg underwater.

Jérôme and I set out in his inflatable boat, looking for leopard seals. We scout the bays melted into a huge grounded iceberg and find a female, floating in one of its cold blue grottoes. Her body is sleek and lithe, her head rounded and reptilian. She brings her enormous mouth close to the inflated tube of our rubber boat and Jérôme watches her closely, holding an oar. He has had his boats punctured by leopard seals before. The idea of finding ourselves in the water with her alarms me and I can't help imagining what she would do to a bird the size of my forearm, which has never swum before.

Later I see exactly what she does, when I film her flaying a penguin; gripping its head and whipping it out of the water in a long fast arc. Without hands to hold it while she eats she has little choice, but in slow motion the effect is too horrible to watch and I am sure the shots will never be included in the programme. Predators must hunt but there are limits to how red in tooth and claw we want our nature films to be. Wilson's storm petrels come pattering across the water like black butterflies, to pick up scraps of the penguin as she feeds.

When Dion spots another seal, with a penguin it has just caught, Doug Anderson is ready to dive. Doug Allan and I film from above, as the seal rolls and turns around him. His bubbles and the waves make it hard to tell what is happening but the dead penguin seems to pass between the two of them while Doug dives deeper, then ascends.

When he climbs out he describes something extraordinary. The seal swam around him with the dead penguin in her mouth, more curious than aggressive. She came close, then dropped the penguin. It sank and Doug swam down to retrieve it. When he held it out she took it gently from his hand and gave it back: he was being courted by a leopard seal.

Through moments like these we are coming to know the seals better, although most of their lives are still hidden. Clearly they hunt around the ice, using it to rest on and to hide. There are at least four seals working these islands. They often haul themselves out on the floes to sleep but they each seem to patrol their own area of shore. Knowing this has not helped us yet: we still have no film of a seal trying to catch a young penguin and the islands are emptier now. The youngsters slip away in small groups and so far we have missed them going.

f

Fifteen chicks are teetering towards the shore. When they jump they hold their flippers back, to counterbalance their heads. Their soft feet land silently unless the stones tap against each other. They are fat, rather clumsy, and they seem unsure about where to go, but they will follow anybody, so when one bird starts the others fall in behind. Several take the sensible route on a penguin path, but three go the wrong way to the top of a small cliff and become stuck on a ledge with a two-metre drop to the shore. They look uneasy up there, with only their claws holding on. They want to be with the other penguins but they don't know how to get down. One leans far out and then falls, feet first, landing on the rocks with a thump. It scrambles up unharmed. Falling must be inevitable if you are a penguin and they seem to expect it. They buzz their flippers as if they are trying to take off, straining upward on their toes. Several walk over and stand close enough to touch, staring at the sea. Occasionally one cocks its head sideways and looks up at me. They are gentle company. These birds have never swum before and now they are lined up, wondering what's in the water. They seem impossibly unlikely to survive. I try to imagine how they will cope with the dwindling ice, how much longer Adélie penguins will nest on these islands.

I sometimes wonder whether any of the animals I film will become extinct, leaving these images as part of the record of their time on Earth. I have filmed rarer birds than these Adélies, but when I look at the young penguins, preening and pottering about my feet, I can't help thinking it would have been like this to sit beside a group of dodos. Adélies could move further south to find more ice but eventually the Antarctic continent will block their way and that will be the beginning of the end, because penguins must always have access to the sea. Their species may become one of the earliest casualties of climate change.

More young birds are coming down to the shore and as they pass I speak to each of them: 'Good luck. Good luck. Good luck.'

The bay looks different every day, not just because the light changes but the ice moves as well, so the whole landscape rearranges itself. The weather is changing too. A storm is coming from the north, bringing snow. Our world shrinks to just the closest rocks and icebergs. The wind moans in the rigging. It gathers brash ice and presses it against the *Golden*

Fleece, forcing her anchor to drag. Jérôme moves her into the shelter of an island. It's a risky strategy when there is ice around, because the wind might change direction and leave us without a way out, but there is little choice.

In two days we will start the long journey back to the Falklands. We have not filmed a leopard seal catching a penguin. It is disappointing, of course, to come so far and not to do what we had hoped, but this is the Antarctic: unpredictable and quick to change. In the distance a seal surfaces with a penguin carcass, thrashing it while petrels flutter downwind. With the weather like this it is beyond our reach.

By the time the wind drops there are many young penguins waiting on the beaches. They have been held back by the storm and they are ready for their first swim, but their way into the sea is blocked. The wind has piled broken ice against the islands in a creaking mass, stretching far offshore.

We each take a radio and spread out, to give ourselves the best chance of seeing the penguins leave and the seals trying to intercept them. Kathryn spots the first group to go but they are hidden from where I am, on the largest island. The ice here is becoming patchy as the tide changes. Behind me a single adult comes down the path, followed by a group of youngsters. They scramble closer to the water, peering in, and this time I really think they'll go. The adult decides the coast is clear and dives into a small gap. The first three or four young birds tumble after it, trying to stay together. One falls in backwards and panics as it hits the water, splashing spray everywhere. Another goes offshore but it is uneasy on its own and it comes straight back. This seems to give the others confidence and they all go in at once, paddling through the ice with their heads up, more like nervous ducks than penguins, propelled by short strokes of their flippers. Reaching the open water, they put their heads under, feeling the urge to dive, and down they go. Their dives are short to start with and they snatch breaths in between. In their brief lives they have never been alone and they call loudly to each other to stay close, but now is not the time to attract attention.

Liz comes on the radio: 'John, there's a seal swimming around the coast towards you. It's going to come into your bay.'

Looking into the sun, with the ice as shiny as a broken mirror, the seal's head stands out black when it rises between the floes and slips back under. The young penguins have noticed nothing. The first one tries to

porpoise, shooting out of the water and landing upside down. Another flies out and falls sideways but they are learning incredibly quickly, gaining in speed and confidence. It is only minutes since they left the shore. A big piece of ice falls from an iceberg and smacks into the sea. All the penguins leap: they must have heard the impact underwater.

The group divides. Seven or eight choose to stay among the floating ice. The more confident swimmers head out to sea and, miraculously, the seal passes inshore of them. It's a close shave but with every metre they put between themselves and the islands, the safer they become. They may have made the better choice.

Voices come over the radio, adding to the picture and confusing it: 'Doug, have you seen anything there?'

'He's spy-hopping by the triangular bay where they started off.'

There seem to be several seals, aware that more penguins than usual are leaving. To make progress among the floes the young penguins either have to dive under them, or scramble across their surface. Either way they can't tell where the leopard seals are.

A seal appears, patrolling the shore closer to them. It has not yet seen or heard the penguins but it can't be long now. It dives and I cannot predict where it will come up next. One of the youngsters has fallen behind and is stuck in a crack, calling for the others. I see the seal's dark head rise again. It sees or hears the penguin and slips under to close the gap. Cats and mice have nothing on this. The worst thing the bird could do now is to go back into the water. Liz has seen it too: 'John, you may be on it already but the single Adélie chick has just dived in. It's heading your way through the brash.'

The barest hint of a sleek head comes up, the seal breathes and disappears. The bird surfaces, yelling and flailing at the water, struggling to catch up with the others. Still it has not noticed the seal following, the long neck rising like a periscope. A small iceberg blocks their way. The other penguins have already climbed its sides and the lone youngster claws at the smooth ice, slapping its flippers to gain purchase, and then it's up and high enough to be safe, for the moment.

The berg is moving, drifting slowly away with its penguin passengers. There is no doubt that Adélies need ice. This piece has already saved several of them. I wish I could be sure that the young penguins will find enough of it to keep them safe and fed for the rest of their lives.

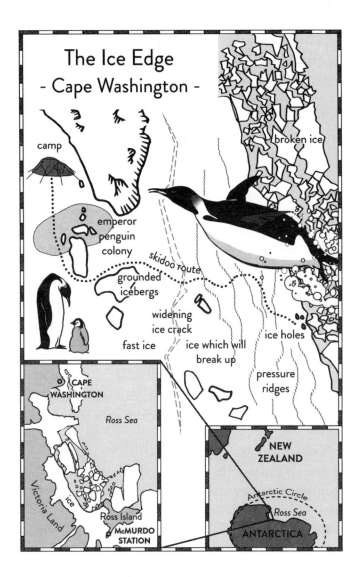

AN AUDIENCE
WITH EMPERORS

O nly one bird depends on ice more than the Adélie: the emperor penguin is so wedded to frozen water that it needs never set foot on land. Visiting them was a highlight of the twenty years I have spent filming and part of the adventure was the journey to one of their colonies, on the other side of the world.

f

Mount Erebus drifts by the window, snow-covered and steaming. At almost 4,000 metres (more than 12,000ft), the volcano's summit is well above the aeroplane. It's a week now since I arrived in the Antarctic from New Zealand. On the way we passed a lonely spot, somewhere in the Southern Ocean, which lies exactly opposite my home in Scotland. The week has passed in an intense burst of training and preparation for the time ahead and now I am squeezed into the back of a Twin Otter with a jumble of sledges, filming and diving equipment, and Didier, a French underwater cameraman who used to work for Jacques Cousteau. The other three people in our team have flown out ahead of us, with all the food and camping equipment. When the plane took off, in front of the US Antarctic Program's Station at McMurdo, there was no sense that we were racing over the frozen sea. The ice runway there is several metres thick and at this time of year, in the southern spring, it barely flexes, even under the weight of the large transport jets from

New Zealand. An icebreaker visits once a year to smash a channel to the pier, allowing a fuel tanker and cargo ship to resupply the base. Further out in the Ross Sea the ice is less stable and we have a vested interest in how long it will last. For much of the ninety-minute flight I stare down at angular pieces of ice, making patterns that never quite repeat, like shards of glass in a shattered window.

*

'We are twenty miles back, estimated overhead Cape Washington in seven minutes.' The pilot, Lexie, is Canadian and well used to flying in the cold, despite being startlingly young. From the cockpit she can see where we'll need to go to film the penguins and it's not looking good.

'The ice is moving through. You can see where you're going to hit rotten ice leading up to the water. I don't think I'd want to go on it but you guys may know more about that.'

I'm not sure I do, but I know we are in good hands.

Lexie circles to give us our bearings and Didier and I press our faces to the windows, looking for tracks, but the pilot spots them first.

'There, lots of lines. Those are penguin trails.' She turns the plane to show us. 'That's a line of penguins, all the way back to the colony.'

'It's a long way, isn't it?'

'Yes. You are going to run into pressure ridges. You don't really know how big they are until you are up against them. You'll find those tough to get through.'

I can see the ridges she means, wavy lines of ice forced up where large floes have been pushed together by the wind or tide. They are like walls, blocking the penguins' way. Antarctic pilots' lives depend on judging the roughness and the strength of ice and soon our lives will too.

'Do you think that grey ice would be strong enough to take a ski-doo, Lexie?'

'I wouldn't trust it but that would be something you'd have to go up and see, I guess.'

Didier shouts from his side of the plane, 'See those holes, they are all swimming in there!' The holes come into view, three mirrored pools, close together and a little way back from the ice edge.

'They're jumping out. This is where we go diving!'

'Trouble is, getting there,' says the pilot and she circles again so we can photograph the holes and the trails leading to them, then turns back towards the dark mass of the cape and a group of large icebergs frozen in nearby. I have seen these icebergs before, in a satellite image, but in that picture an expanse of dark water separated the last berg from the ice further out, the ice we have just flown over. Out there, where today the penguins are walking on a solid surface, it had shattered into thousands of loose floes. The picture was taken in early December last year. It's November now and we are going to spend the next three weeks on the ice. There is no question that sometime soon it will break up, perhaps starting beside the same iceberg as last year: the question is when?

A discoloured area of snow passes below us, covered in dots. 'That's the colony,' says Lexie, 'and this is the camp coming up now.' She banks the plane and a cluster of yellow tents swings into view on our wingtip, with another group of dark dots nearby. 'We'll be landing on the northbound runway,' she jokes. 'You guys might get lucky and not have any wind.' On the previous flight the plane was shunted sideways at the last moment by an unexpected gust.

The stall warning squeals as the speed comes off but we are not blown sideways and with a crunch the skis touch down on the snow – on the sea, I remind myself. We taxi towards the tents where our three friends and fifty emperor penguins are waiting for us. Even Lexie climbs out to photograph them.

Emperors are the world's largest penguins and if you kneel in front of them they are tall enough to look you in the eye. Penguins' eyes are not like ours: instead of being curved on the outside, theirs are flat, to produce sharp images underwater and at least passable ones in air. It's one of the many adaptations to help them live at the extreme limit of what's possible for any animal. The emperors crane forward and peer at us closely. They have probably never seen a person before and they are not at all shy. More are walking and sliding across from the colony. It seems they will travel quite a way to investigate an upright shape. It's the first time any of us has been mistaken for a penguin.

The nearest one turns its back, raises its feathers to shake and sleeks them down again until they look like tiny smooth scales. The

bird's head is black and velvety. The dark feathers on its back have frosty grey tips, while the white ones in front gleam as brightly as the snow. Black lines run from its neck to the base of each flipper: a lovely extra finesse, as if a calligrapher had made the strokes with a fat brush, their edges blurring slightly where the ink has spread. It has just three patches of colour: slips of pink on the sides of its bill and a sunset of orange and yellow behind its eyes and below its chin. The emperor stands as upright as a skittle, balanced improbably on the tripod of its feet and stiff tail. It starts to contort its body to scratch its head: a comic performance that entails standing on one foot while raising the other as far as its very short leg will allow, over one flipper, while extending its neck sideways and downwards. Its head and claws only just meet but it seems to enjoy the result. If everything about these penguins looks awkward it's because they are optimised for life in the sea.

f

'Welcome to Cape Washington!' The can-do Australian, Chadden, is in charge of this shoot, as he was in the Aleutians. Steve, an American diver from the base, is here to work with Didier, while Leah has come with us to run the camp. Hers seems to be the hardest job of all. The first two flights brought a mountain of gear but she already has it neatly stowed and the tents are set up. The emperors watch us unload the plane, then stand beside us as it takes off in a burst of blown snow. In ten days one more flight will bring some extra food and Steve's and Leah's replacements. Until that plane comes, the nearest people will be the Italians at a base 130km (80 miles) away. It is so quiet that, unless a penguin calls, the loudest sound I can hear is the blood rushing through my ears.

By the time we have sorted out our camera kit and put our bags in our sleeping tents Leah has melted a huge pan of snow, made coffee and a hot meal. As we eat in the mess tent Chadden outlines his plans. He has seen last year's satellite photo too and the pressure ridges from the plane. Tomorrow four of us will travel light, taking two skidoos but no cameras, and we'll try to find a way to the ice holes. We will stay in touch with Leah at camp using walkie-talkies. She seems to be ready for all eventualities, and has tuned the short-wave radio to McMurdo's frequency in case there's an emergency. With a flourish she produces

pina coladas to toast the expedition, mixed with a handful of tooth-tingling Antarctic snow. Outside the tent the grounded icebergs are tall blue shapes in a white plain. Cape Washington looms behind us, an ice-covered headland ending in a dark bluff of rock, and inland there are row after row of mountains, as inaccessible as the moon.

On the first day of November, ninety-eight years before we arrived, a group of British men set out on foot from a hut near McMurdo, hoping to be the first people ever to reach the South Pole, 1,360km (845 miles) away. Their Terra Nova expedition had spent months ferrying depots of food and fuel onto the ice to supply the first part of this journey and to await their return. By early in January they had climbed the enormous Beardmore glacier onto the Antarctic plateau and passed their final depot. The last of their support team turned back and the five men of the polar party continued south, each hauling more than his own weight of supplies on sledges. The group comprised Captain Robert Scott, Dr Edward Wilson, Lieutenant Henry 'Birdie' Bowers, Captain Lawrence 'Titus' Oates and Petty Officer Edgar 'Taffy' Evans.

As I look at the mountains inland from our camp I think about those five men. Unpacking a thick sleeping bag in the shelter of my modern dome tent, I wonder how cold their nights were, under canvas in their reindeer-skin bags, and I'm still with them the next morning, when Steve shows me the skidoos that will pull our camera gear across the ice. This is the most inhospitable place I have ever been: humans are not well suited to living here, but what Scott's polar party managed to do a century ago puts our hardships in perspective. They were brave men. None survived.

After breakfast we pack the sledges and head out to sea, past the emperor penguins' colony; currently a shifting mass of adults and chicks, moving slowly from one side of the icebergs to the other. They do not build nests or hold territories, so they have no reason to stay in one place. Midsummer is still some weeks away but the emperors started breeding in the southern winter, so they already have quite large chicks. In

May or June the females each laid a single egg, which they transferred onto their mates' feet to be incubated. The males then huddled together through the darkness and blizzards of midwinter, while the females returned to sea to feed. More than 100 days later, during which time their eggs had hatched and the males had lived entirely off their own fat, the females trekked for many miles, back across the ice, to relieve them and to see their chicks for the first time. These chicks are surely the most attractive young birds you could find anywhere in the world. They are slender at the top with enormously fat bottoms: pear-shaped soft toy penguins, dressed in grey onesies with black hoods and white faces. Having no fixed nest is a disadvantage when it comes to finding each other, so they call to their parents with a carolling sound, like song-birds, wiggling from side to side or tipping their heads up and down. It's a serious business, even though it makes them look ridiculously cute, but we are not here to film the chicks because that has been done already for this series and instead we follow the lines of adults walking away through the icebergs, on their way to the sea.

A narrow gap leads us between two bergs with an ice cliff on either side, one of them indented with a vividly blue cave. The sides of the last iceberg are festooned with icicles many metres long. They're a spectacular sign that the ice on top has been melting, allowing water to drip down the walls and refreeze. We park the skidoos at the end of this iceberg. In last year's satellite picture this is where the fast ice ended.

Ahead of us is a scene of absolute chaos. The ice has been shunted into ridges taller than I am. There's an open area beyond but then another long ridge snakes across the ice, with more in the distance. Black and white figures wobble between them on a meandering path. The snow is trodden flat where the penguins have walked, dimpled by their heels and toes. Wherever the ice is flat enough they save energy by lying down and pushing with their feet. They must climb each ridge, laboriously using their bills for grip as well as their claws, then slide down the far side, unable to stop and often thumping into each other on the way. On the skidoos we cannot climb like a penguin, or fit through such narrow gaps, but we must find some kind of route, so we set out after them on foot. We know from yesterday's aerial view that the ice ends a few kilometres further out. It's a long walk if your legs are as short as a penguin's but nothing compared to the females' march in the winter, when much more of the sea was frozen.

We step over wide cracks filled with drifted snow and pass domes of ice, pushed up by pressure from below. On a calm day like this the ice is probably stable but that could change quickly if the wind starts to blow from inland, so we have brought a satellite phone for emergencies as well as the walkie-talkies. Even so the nearest helicopter able to lift us from a drifting ice floe is very far away and it's unlikely to fly out here in bad weather. As we hurry on behind the penguins I feel the wind picking up. Didier points out a group of emperors coming the other way:

'They shine, they are wet!' The birds look like varnished Russian dolls. More wet penguins are standing nearby, trumpeting.

Didier finds the first hole. It's no larger than a kitchen table. The others are close by: insignificant-looking pools we have come so far to find. A penguin surfaces in one of them and gasps air. We walk cautiously to the edge. Although, seen from the side, you could take it for a pond in a snow-covered field, looking directly down it is a door into a different world. Through the clearest seawater on Earth we look into an abyss so deep that light rays seems to converge at a point infinitely far away. As the water surface moves the rays spin like spokes in a pinwheel of light. It is impossible not to lean forward, pulled by vertigo.

Chadden, Didier and Steve hope to dive in these holes and film the penguins in the unearthly space under the ice. To do that we will need to bring the skidoos here through the ridges. Didier waves his very large hands: 'We must build a road!'

f

Before setting off the next day, Chadden checks the time and calls McMurdo exactly on schedule.

'Hello, this is Cape Washington. Please could we have a weather update?'

'Where did you say?'

'Cape Washington.'

'Oh, OK. What's the weather like there at the moment?'

'There are two-eighths cloud cover at about ten thousand feet, the wind is light from the north-west and the temperature's about minus twenty-five degrees Centigrade.'

'OK, standby … Here's your forecast: cloud cover: two-eighths,

height: ten thousand feet, wind: light north-westerly, temperature: minus twenty-five degrees Centigrade. Have a good day.'

'Ah ... yeah, thanks for that. Out.'

Unsure whether to be reassured by this forecast, we load the sledges with shovels, a big pick, an iron bar and a bundle of small red flags on wire stems. Leah has already used two of these in camp, to mark the only places we are allowed to pee and to pour washing-up water. As we make all our water by collecting and melting snow it is best not to lose track of whatever else we've put there, in case we start recycling it by accident. Her flags have quickly become tattered and I had put this down to the wind until I realised how much they fascinate the penguins. This morning a line of them is waiting to peck at the fluttering plastic.

Even in a place as alien as this we have already started making the unfamiliar familiar, by naming the landmarks along our route. We drive past the Dirty Iceberg, the V-shaped One and the Last Iceberg With the Icicles, but in a place made entirely of frozen water these landmarks could change quickly, so we plan to use the red flags to mark our way through the pressure ridges. We may need to make the journey back in a hurry or in a blizzard and I hope the penguins will leave these flags alone.

Hacking our way through the first ridge is warm work and we soon shed our heavy coats. Levelling the ice takes time but at least it's possible. I walk on ahead to mark the next part of the route while the others shovel snow into the remaining holes. A startling noise, like a wave breaking, makes me spin round, only to find a single penguin sliding by on its stomach. They need the smoothest path too and by following the penguins' route we make steady progress until we come to a really large obstacle. I can hear the skidoos catching me up but the next ridge is very tall and I haven't yet found a way through. The penguin goes to the right, struggles to its feet and squeezes through a narrow gap, almost jamming its body. Didier points left: 'That looks better. So far so good, uh?'

By mid afternoon there are fewer penguins ahead and a long line of them behind. Instead of leading the way, our guides are now following us: our ice road must have become the easiest route to the sea.

Hours later we break through the final ridge and drive slowly up to the pools where a group of penguins stands. Their bellies are distended

by the fish they have caught during a week at sea. In the water another group is rolling upside down, washing themselves. Two weeks after leaving home we have found a way to bring the cameras and the dive gear to the edge of the ice and at last we can start filming.

⟊

Gingerly as a cat, I set up the tripod and camera on the thin ice beside one of the holes, to film the penguins leaping out, while Didier and Steve prepare for their first dive. When they are suited up and sitting on the edge Chadden passes Didier his camera in its heavy housing.

'What's your plan if you meet a leopard seal under the ice?' he asks. Leopard seals hunt emperor penguins much as they do the Adélies, by ambushing them as they enter and leave the sea. If one turns up here it is unlikely to be pleased to find Didier waiting by the holes.

'There is no plan,' Didier says, 'I film it!' and in a roil of bubbles he and Steve are gone. The ice between my feet starts to fizz. It's the divers' air escaping through tiny cracks; a reminder of how close they are below. Any illusion that this is solid ground is growing weaker by the minute. The water below is about 300 metres (1,000ft) deep. The emperors can easily reach the seabed and stay there, fishing, for almost twenty minutes at a time. Unlike the penguins, Didier and Steve must stay close to the holes, which are their only way back.

I look down through the spinning rays and in the far distance a group of penguins rises towards me like water beetles, streaming silver bubbles as they come. They surface, tight-packed in one of the holes, rolling forward to snatch air, then making way for others to breathe. They dive again and erupt from the nearest hole, right in front of me: twenty very heavy penguins hurtling out in explosions of water and bubbles, leaping well clear in case there is a seal waiting for them. Most of them do this with ease and land on their bellies with loud slaps, but so many penguins have been using the same exit, and splashing freezing water about, that a wall of ice has grown on one side of the hole. It must be invisible from below because some of the penguins smash into it at full speed. I can hear the impact of their immensely strong breastbones before they fall back into the water. Others, rocketing up, swerve in a split second to avoid a collision and dive deep to try again. One bird smacks into the wall head-on, driving its bill into the ice while its neck

whiplashes. It slides back and disappears. Waves lap the ice and the fizz of tiny bubbles bursting continues for some time. Out of the water the penguins flail their feet and flippers, hurrying away from the hole, then lever themselves upright and look back at us with slight interest. Like the ice wall, we were not here when they left, but we are less important than their chicks waiting in the colony, so they turn and walk away.

Didier and Steve surface and we lift out the camera, their tanks and weight belts. They are excited by what they have seen, mumbling through half-frozen lips about filming groups of penguins converging on the holes like fireworks, leaving twisting trails of bubbles hanging in the water. The sea temperature is −1.8°C (28°F) and only the salt is preventing it freezing. Didier has torn one of his gloves and it's leaking. After half an hour he can hardly move his fingers. He thinks he will be able to improvise something in time to dive again tomorrow, but before we reach the camp a blizzard is blowing.

f

Everyone arriving for the first time at McMurdo Station has to take a course on what to do if they are stranded on the ice with minimal equipment. Without this training you are likely to die before being found. The course is known as Happy Camper.

On the sea ice, where we were dropped out of sight of the base, there was a panoramic view of the Royal Society Range, on the other side of McMurdo Sound. Our instructor, Dylan, pointed out glaciers which were named after Scott's companions. White Island rose from the ice sheet nearer to us. Scott's party had marched past it on their way to the pole. At the beginning they had used inefficient ponies and tractors to pull some of their heavy gear. Two weeks earlier a group of Norwegians, led by Roald Amundsen, had left their base further east, travelling light with dog sleds and skis. The quest to reach the South Pole had become a race.

Dylan explained that if we found ourselves in trouble, our first priority should be to make shelter. We practised putting up a pyramidal canvas tent of the same design that Scott took to the pole. They are still used today when weight is not an issue. We also made a kind of igloo called a quinzhee, by laying a groundsheet over our piled-up rucksacks and shovelling snow on top, then tamping it down. The snow

quickly froze into its new shape and after a couple of hours the roof was strong enough to stand on. We dragged the bags out through a hole and crawled inside. There was space for five or six people to escape the wind. Lying in the soft turquoise glow of the crazed ceiling, their bodies would soon warm the air. I opted to dig a snow hole to sleep in. The trick, Dylan said, was to start by digging a narrow trench and then broaden it out from below. Snow is a good building material and it was easy to carve a raised sleeping platform into one wall of my cave, so the cold air would settle lower down. There was just enough headroom to lie on an air mat, with an upside-down sledge as the roof. We built a wall of snow blocks too, to shelter the cooking area, and learned that it takes a long time to melt enough snow to make hot drinks and a meal. The effort involved was extraordinary and Dylan drove home the point that survival depends as much on staying positive as on what you decide to do.

In the snow cave that night, my breath froze into frost crystals. They hung from the ceiling like a thin coating of fur. Occasionally flakes floated down and tickled the tiny part of my face not covered by the sleeping bag. I thought about how we had unwound the antenna of the short-wave radio and adjusted its length for different frequencies. Voices had crackled to us from Korean fishing boats in the South Pacific. We had re-tuned and taken turns to call the US base at the South Pole. Scott's expedition carried no portable radios on their march because none existed at the time. They could not transmit the news that at the pole they had found a Norwegian flag, nor could they call for help when they were pinned down by bad weather on their return journey, just 17km (less than 11 miles) short of their final depot. Dylan talked to us about this too, about what to do when conditions deteriorate: whether to turn back, or wait, or press on and, if you do decide to continue, how to reduce the risk by spending as little time exposed to it as possible.

Scott's failure was in part because he had decided not to use dogs to pull the sledges, so his journey took much longer than Amundsen's and his party had to drag more food and fuel behind them. Their bodies were not found until the next spring, frozen in their pyramidal tent out there on the ice. They are still there. Their comrades folded the tent over them and left it to be buried by the snow. Long ago they were incorporated into the Ross Ice Shelf, which is moving slowly towards

the sea. In about 270 years they will reach the edge and then perhaps float away, entombed in an iceberg.

*

At Cape Washington we each have our own sleeping tents and we share three larger ones: the mess tent and one each to store the camera equipment and the dive gear. These three have gas heaters so, apart from when we sleep, they are the only places warm enough to take off our huge red coats. There is a drawback to heating tents that have a frozen floor: after a week they have all subsided, but moving them will be time-consuming because the guy ropes are not held down by pegs, which would easily pull out in a storm. Instead they are looped around horizontal lengths of bamboo, called 'dead men', buried deep in the snow. While the wind is still blowing, moving the tents will have to wait, so we put up with the sloping floors and when pools appear on the groundsheets we make snowballs and dip them in the puddles to absorb the water. We use the time to review the shots we have taken so far and to maintain the cameras. Didier mends his torn glove. The resupply flight was supposed to come today but we can't see the sky and with such a strong wind blowing it has been postponed.

During Happy Camper we did an exercise to prove how dangerous a blizzard like this can be. We were told to search for someone who had gone outside and failed to return. Eight of us took part, wearing large white buckets over our heads to simulate what it's like in a whiteout: we could see nothing but our own feet. We knew we must not risk losing anyone else so we paid out a rope from a fixed point and spaced ourselves evenly along it, then tried to walk to and fro in an arc, extending the rope each time a sweep found nothing, conscious that the clock was ticking. The lost person had not taken her coat – it was just a short walk to the toilet tent. Eventually someone tripped over her, lying in the snow. Dylan told us that most groups fail even to do that.

I have this in mind when I visit our own toilet tent at Cape Washington. We have marked the way with more of our little flags and I am glad of them today because after just a few strides the world ahead contains nothing but a small red triangle on a wire. There is no ground and no sky. It's not dark, just maddeningly, uniformly white in every direction. Without shadows to give them depth, I trip over snowdrifts

and stumble into pits, with that jarring feeling of coming downstairs in the dark and miscounting the steps. It's hard even to stand upright, as though gravity has lurched sideways. Reaching the loo is a relief in more ways than one.

For three days the snow has fallen continuously, in flakes half the size of my thumb, and it now lies waist-deep around the tents. There has not been so much snowfall here in twenty years: the air is usually too cold to carry enough moisture. We dig paths between the tents and shake them so they will not be buried. Of course, there is no possibility of going to the ice edge while it's like this and even the penguins have left the camp. They cannot walk or slide through the drifts. The waiting is using up our precious filming time but there is one bonus of being stuck on the frozen sea: when I lie down in my tent, unearthly sounds filter up through the ice: a reminder that there is something underneath and it isn't land. Straining to hear them is like tuning the radio and finding alien signals there among the static: electronic-sounding chirps and tones, smoothly rising and falling, long notes held and sustained. They are sounds from another world: the songs of Weddell seals. These are the only seals to swim so far under the ice. They keep their breathing holes open by rasping the sides with their teeth. The males defend them against others because the holes are not just precious for access to the air: female seals will also climb through them to give birth, after which they'll mate. The songs I can hear are made by males declaring their presence to each other and keeping their rivals away, trilling in their odd dark world as they pass below us like submarines.

At last the wind has dropped and quiet returns. Every footstep is transmitted through the hardening snow and into my tent. Creak, creak, creak: the penguins are coming back. Creak, creak ... twang (they have no concept of guy ropes).

We have missed their company. When we are inside the tents the emperors stand beside the most penguin-like objects they can find, the divers' white air tanks. They are gentle birds and good company but you wouldn't want one in your tent: their farts are terrible. Outside they go everywhere with us: they watch us brushing our teeth, they trudge with us to the loo tent and wait there, beside the drums labelled *Human Waste*.

Early expeditions dug pits in the snow, as dumping places. It's said that in those less enlightened times, when the US South Pole Station needed a deeper trash pit, a bulldozer was brought by air all the way from New Zealand. There was too little fuel for the aircraft to land and take off again, so it was pushed out as the plane flew by, to parachute down. As the chutes were too small to work unaided, retro-rockets were supposed to fire at the last minute and slow its descent, but they didn't go off and the bulldozer smashed into the ice, at once excavating a new pit and becoming its first piece of junk.

Since those days an international treaty has put strict limits on what can be brought here and left behind, so when we leave Cape Washington we will take everything back with us to McMurdo, including the waste drums. At the end of the season they will go onward by ship to San Diego, with all the other rubbish from the base. There will be plenty of it because McMurdo Station is the size of a small town. It has a hospital, a library and even a fire truck. Its inhabitants have formed several bands, one of which has the curious name of Porn Spill, to commemorate something that happened when the annual resupply ship was being unloaded in the US. That year an amnesty had been declared, to purge McMurdo of any pornographic magazines that had accumulated there. They filled a large container and it was duly taken to California. As it was being swung ashore a cable broke and several tons of porn spilled spectacularly onto the dock.

f

Next morning the storm has passed, the sky is blue to the horizon and everything is covered in fresh snow. The view inland is spectacular. On every surface tiny ice crystals splinter the light, each beaming a fraction of the sun's spectrum. When I move my head they blink in different colours. During the blizzard it felt as though the beauty of this place would be broken, but instead the wind has sculpted the snow into crescent-shaped dunes with intricate patterns on their surfaces. Warmth is the only thing capable of destroying what is here, including the sea ice. While we have been sheltering in our tents the days have grown slightly longer and a little less cold.

We stand with the penguins, listening for the plane. It is six days late now but we know it has taken off, bringing Dylan to take Steve's

place and Martha to replace Leah. There will be some extra food as well as the camera equipment I need to film the penguins in extreme slow motion. Didier and I have already been slowing them down but the best we can manage with our cameras is 150 frames a second, which plays back six times slower than normal. The new camera was designed for filming artillery shells leaving gun barrels and seat-belt tests in dummy car crashes, and it has another great advantage for filming leaping penguins: it stores every frame in a memory cache, endlessly looping, so it has an 'end trigger': jargon meaning that I don't need to press the record button until *after* the action has happened, although I will still need to predict where to frame and focus the lens. This camera was never meant to be used outside or at such low temperatures and we are not certain it will work here at all.

On Dylan's first journey to the ice edge we push a bamboo pole into the growing crack by the last iceberg. It is now about two feet wide. The pole goes straight into the sea. There's a breeze blowing from inland and he suggests that we should pause to discuss whether to go on. We all need to be happy with the decision. Chadden mentions the principle used by cave divers, who agree in advance that any member of the team can say at any time that they want to go back, without giving a reason.

Didier interrupts: 'I tell you about us cave diving,' he says. 'I was diving in a cave, we are hundreds of metres underground, in water as clear as glass, and then what happens? Earthquake! Suddenly the visibility is zero. There is just our one little line to guide us back.' He holds up his thumb and forefinger, almost touching, to show us the thin thread on which their lives depended. 'If it breaks we all are dead. It was every man for himself.'

There is silence while we digest this. Maybe the cave diving model isn't the best one after all.

Dylan reminds us that we can limit the risk by reducing how long we spend out there. As we climb back onto the skidoos and set out to find our ice road, I think about how long it would take me to pack away the slow-motion camera if we have to leave in a hurry.

All our flags have been buried but we can remember the twists and turns and it seems the penguins can too. Reassuringly, we pass quite a

few in the half hour it takes us to reach the holes. They would be the first to tell us that the ice has broken: if they could jump into the sea beside the last iceberg we would soon find ourselves alone.

Dylan spins the drill. At McMurdo he taught us how to test the thickness of the ice, using an electric drill with the longest bit I have ever seen. It towered over us and took several minutes to reach liquid water, two metres down. We have brought a hand augur to save weight but it's all we need to show that the ice by the penguins' holes is only as thick as the width of my palm. It's enough to support a person and perhaps even a skidoo, because its weight would be spread across its large track, but we know it would be foolish for all of us to stand in one place with a pile of heavy equipment. And then there's the effect of the wind and the sun on the ice.

'If we got more wind from any direction it would break that up real quick,' says Dylan. 'While it's been cloudy the ice will have been getting much warmer. Long-wave radiation comes in through clouds and the ice absorbs it. Short-wave radiation gets reflected back, but it can't escape the clouds, so that warms things up too. There's way more heat going into the ice when it's cloudy than when it's sunny … If it feels slushy where it felt crunchy the other day, that's something to bear in mind.'

I have spread the parts of the slow-motion camera kit around me on the ice and I'm connecting it together with cables. It's like setting up a computer outdoors, while curious penguins look over my shoulder: 'System Set – Select,' *beep*, 'Segment Size – 100,' *beep*, 'Knee – On,' *beep*, 'Luminance – Normal,' *beep*: on and on through the menus until the most important one: 'Frame Rate – 750.' Seven hundred and fifty frames a second – that's thirty times slowed down. At last it's time to point the camera at something moving fast.

Before long a group of penguins surfaces in the furthest hole, gasping for breath just as they did before. I have focused on the closest hole, where I think they might leap out. The camera is primed and I remind myself that I must not press the trigger as soon as I see them, but afterwards, which goes against every instinct. They dive and almost immediately shoot out of the water in front of me, slamming down on the ice and skidding in all directions. I am so close to the hole that one penguin slides between the tripod legs and others drag the camera's cables with them. The birds are gone in a blink and I jab the button to save the

recording. At such a high frame rate there's only a moment to do this and it's impossible to know whether I have recorded anything worthwhile.

Playback takes some time and when the shot first appears it shows nothing but a calm patch of water reflecting some ice. The reflected image deforms a little. Something is coming: a sharp bill rises to pierce the surface, like Excalibur leaving the lake, followed by the crown of the emperor's head and then its eye. A film of water clings to its body, flowing smoothly down half its length as if it were a gleaming second skin, perfectly reflecting the sun. When its flippers meet this water-skin they shatter it to atoms. The whole penguin passes through the frame and leaves, trailing water. It is breathtaking to watch. Over the next few hours I frame the penguins from many angles as they leap and crash-land. My favourite shot shows one flying clear of the ice as high as my head, scattering drops like sprays of diamonds in the intense light.

Didier is delighted with the shots from his diving too and, now he is out and getting dry, Chadden decides to take a risk that would not have worked while Didier was filming close to the holes. The slow-motion camera has an underwater housing. It was designed for a single use in the tropics and, apart from one dunk in a bath to test its seals, it has not been used since. It has never been tried in the cold. If it works, the pictures could be extraordinary, but if it doesn't, and the camera floods with salt water, there will be nothing we can do to fix it. Once it's in the housing it becomes even more troublesome to use. There is no way to attach a viewfinder so we have to lower the camera into the water on a pole and look at the picture on a screen, huddled under a coat to avoid the glare. To set the focus and exposure we have to haul the pole back up, unbolt the housing and dry it meticulously, before taking the camera out to make the adjustments, and then repeat the process in reverse. We do this several times until it is set correctly. Finally, the camera is underwater and facing almost directly downwards, where the light rays dance, but now the weather is deteriorating. The wind is still blowing directly offshore and it's strengthening. A pure white snow petrel glides across the expanding area of grey sea. Antarctic sailors say these birds are a sign of an impending storm. Ice is blowing away from the edge and we must leave. I am about to pull the camera out when a penguin shoots through the frame. It is gone in a flash but I press the button anyway. We haul the camera up and pack it as quickly as we can. As we reach the last iceberg, Cape Washington disappears into the lowering cloud.

Back at the camp there are shots to download and cameras and dive gear to clean, so it's not until late in the evening that we have a chance to watch the underwater slow-motion shot, just a rough version of it for now: the master is still waiting to be saved from its memory card. We gather round the laptop in the mess tent.

On the screen there is nothing but dark water. The penguin enters at the bottom of the frame with its back to us and slowly rises through the exact centre of the picture, holding its flippers stiffly on either side. It is perfectly symmetrical. Decompressing air pours from the feathers on its back and its nape in a silver torrent, which swirls in the slipstream and does not diminish until long after the penguin has gone.

Didier breaks the silence: 'We must do more of this, no?'

He knows it will mean sacrificing his remaining chances to dive with the penguins, but none of us realise that this second storm will keep us in camp until our last day, or that I will use the time to make a terrible mistake.

Downloading the camera's memory cards is a slow process. I do it methodically by sorting the cards into two piles: those still to be downloaded to the hard drive and those I have already copied, which it's safe to erase and use again. I have already processed the shot of the penguin rising like a cross on a silver chain, in order to watch the rough version, so I put that card in the 'done' pile and erase it with the others, forgetting that I have not downloaded the master file first. The rough copy is not good enough to use in the series and although we try every means of recovering the lost data, the unique shot is gone for ever.

The plane is due tomorrow and by the time it arrives the whole camp must be packed, but the storm blows on, taking with it our chance to go back to the holes for a last try. Martha kindly says that if the wind drops overnight she will take all the tents down on her own, so we spend the evening packing as much as we can. When we go to bed the wind is still shaking the tents.

Chadden wakes us at four in the morning. It is perfectly calm. We throw everything onto the sledges and drive as far as the last iceberg.

The ice beyond has not yet disappeared, so we press on to the holes. I put the camera together as quickly as I can, only to discover that in the rush I have left the monitor screen in camp. Without it I cannot frame or expose the picture. Without a word of blame Chadden goes back for it, faster on a skidoo without a sledge, but even more of our precious time has gone.

He returns within the hour and reports that lines of penguins are making their way towards us. I wait for them with my head under the coat and an underwater view of the ice edge on the screen. I can hear them lining up beside me, a group of perhaps fifty birds, calling and getting ready to take the plunge. In a rush their feet and flippers slap the ice. They hurl themselves into the water and through the camera's frame. I press the trigger as the last ones stream by. On the playback screen we watch them slowed down: shambling penguins becoming beautiful underwater fliers, diving away from us into the blue, going where we can never follow and dappled there by the spinning shafts of light.

On that thin ice, half a world away from home, I have rarely been so happy.

f

On my last day at McMurdo I climb Observation Hill, overlooking the base, with its workshops, its laboratories and its housing for more than 1,000 people. In the distance is one of the huts used by Scott's Terra Nova Expedition. On top of the hill stands the large wooden cross they left behind. From beside it you can look south towards the pole and the Ross Ice Shelf, where Scott's party died in 1912. Carved on the cross, below their names, is this line from Tennyson's poem, 'Ulysses':

To strive, to seek, to find, and not to yield.

If it were possible to have heroes in the natural world, as well as in ours, mine would be the emperor penguins and that would be their motto too.

CONCLUSION:
MOVING PICTURES

I spend more time away than most dads, but sometimes I have longer spells at home. During one of these my son, Rowan, and I head off in the morning to look for otters. He is keen to take photographs but we both know how wary otters can be. We have never been close enough before. I would like to show him that taking time to look properly is among the most important things I have ever learned, whether you come home with any pictures or not.

Today is a perfect morning for spotting otters: there is no wind and we can see the silver wakes of a mother and cub fishing offshore. The sound of them munching their catch carries clearly across the still water. In time they swim towards us and climb onto a weed-covered rock, to rest and groom each other. We watch as they curl up together to sleep. This is Rowan's chance to go closer. He spends fifteen minutes creeping forward, crouching silently when the otters stir, then he lies in the water to wait. Both otters are fast asleep but their legs and whiskers twitch: they are dreaming. Although the water is cold Rowan doesn't stir until the rising tide rouses the cub, which wakes its mother by lying on her head. As they look around and stretch, Rowan photographs them, but despite the cold he doesn't wade back to me, beaming, until they have swum away, and I am most proud of him for that.

This is why the natural world matters: if not for the joy and the responsibility learned by sharing a moment in the lives of two otters, then for the fascination of watching birds in a park or a butterfly

sipping nectar from a flower. Wildlife films should inspire us to experience nature for ourselves, but when that's impossible, when animals live far away or even when they've died before we were born, their images can merge with our memories and make us feel that we've met them.

f

In 2014 I went to the Smithsonian Institution in Washington DC, to see a pigeon named Martha. She had been dead for exactly 100 years. She was the last of her kind, the passenger pigeon, which was once the most abundant bird in North America and perhaps in the world. Meeting her was a profound moment: I would love to have filmed the pigeons' immense flocks darkening America's skies, or one of their colonies where billions nested, but extinction is for ever and during my travels I have seen it looming for more and more animals.

I missed the chance to film passenger pigeons by a few generations: my grandmother was born just before Martha died, which shrinks the century for me. There were not many photographers in 1914, so only a handful of images show the last passenger pigeon alive, and there are no moving pictures of her at all, yet looking at those grainy black and white photographs is more poignant than seeing her preserved remains.

Photography has come a long way since it recorded Martha's last days. The images we can produce now are more vivid and detailed than ever before but the greatest change is very recent and has less to do with cameras than with the technology for putting new pictures in front of us every day. Masses of them now compete for our attention and the ones we notice are those telling the most engaging stories.

That is what wildlife films must do if they are going to make a difference, if they are going to help the next passenger pigeon. Stories told well through moving pictures can bring to life animals we've never met, including those in trouble, such as wandering albatrosses or Adélie penguins, and those with inspiring stories of recovery, like the peregrine falcon and Antarctic fur seal. As long as your children and mine watch them and feel lucky to live in such a fascinating world, they are on the path towards protecting wild animals and their homes. Compelling films can make us care that we stand to lose, not just the

most attractive and appealing species, but the whole complex, beautiful spectacle of nature.

In the most important sense of the word, *moving* is exactly what our pictures ought to be, and if they are, perhaps more of us will choose to be on nature's side.

ACKNOWLEDGEMENTS

People sometimes ask whether wildlife or photography came to me first and the answer is that they arrived together. I owe my interest in wild animals to my mother, who often took my sister and me on nature walks, after which we would make things from whatever we had found in the woods and fields, as she had as a child. My father, an engineer, loves cameras. He built my first one from a biscuit tin and showed me how to process the pictures. I am very grateful to them both for their unfailing patience as they ferried me between nature reserves, and for the help they gave me when the pennies I'd saved in a jam jar didn't quite stretch to the price of my first binoculars. Combining these interests became a reality thanks to Martin Baggs, a family friend who let me tag along when he went out photographing birds and looked at my first efforts with a sympathetic eye. My biology teacher Nik Knight encouraged me too.

In common with almost every wildlife filmmaker, it was the incomparable David Attenborough who made me realise there might be a career in this, when I watched him on television one day, lifting a leaf to reveal the existence of white tent-making bats. With animals like that in the world who could dream of doing anything other than filming them?

The late Jeffery Boswell gave me my first job in the RSPB Film Unit and encouraged me to write, as well as to make films, as did Derek Niemann. Richard Brock did the same at the BBC, followed by Peter Jones, and John Sparks, Neil Nightingale and Mike Gunton, while they

were editors of the *Natural World* series. Sarah Blunt, an outstanding radio producer in the BBC's Natural History Unit, turned some of my filming stories into programmes for Radio 4 and has done more than anyone to keep me writing. Thank you, Sarah.

Wildlife films are made by teams of people, some of whom have appeared in these pages. I have shared filming trips with many more and feel enormously privileged to have done so. They are the most interesting, motivated and generous people around.

In no particular order, but connected to the filming trips described in this book, I am especially grateful to: Alastair Fothergill, Vanessa Berlowitz, Miles Barton, Adam Chapman, Andrew Murray, Mark Linfield, Huw Cordey, Mark Brownlow, Fredi Devas, Matt Swarbrick, Chadden Hunter, Jeff Wilson, Jason Roberts, Steinar Aksnes, Captain Bjørne Kvernmo and the crew of the *Havsel*, Ted Giffords, Mateo Willis, Jérôme and Dion Poncet, Cathy, Céline and the rest of the crew of the *Golden Fleece*, Ian McCarthy, Mark van de Weg of the yacht *Jonathan*, who lost his dinghy to the walrus, Doug Anderson, Doug Allan, Chris Watson, Kathryn Jeffs, Elizabeth White, Justin Maquire, Nathan Budd, Kathy Kasic, Bob Landis, John Shier, Tony and Kim Chater, Georgina Strange of the New Island Conservation Trust, Didier Noirot, Richard Wollocombe, Doug Perrine, Ellen Husain, Mandi Stark, Phil Chapman, Hannah Boot, Echo and the team in China, Digpal Singh, Ramjas Gupta, Toby Sinclair, Emily Winks, Andrew Yarme, Louis the eider farmer, Lance Goodwin, Peter and Thomas Joe, Paul Thompson, Matt Wilson, David Baillie, Jess Farrer, Steve Lewis, Tom Crowley, Jimmer and Alyssa McDonald.

Behind the scenes there are the production managers, production coordinators and researchers who organise filming trips for lucky people like me. They rarely go to exciting locations and they are often overlooked. Thank you all. Neither the filming nor this book would have been possible without you.

Thanks too to Linda Bakken, who allowed me to quote from her blog about Svalbard, Christopher Milensky in the Birds Division of the Smithsonian Institution, who showed me Martha, to Rick McIntyre and Laurie Lyman, who revealed the lives of Yellowstone's wolves, and Christopher Nadareski of the NYC Department of Environmental Protection, who works so tirelessly to help the city's peregrines, as does Barbara Saunders of the NY State Department of Environmental

Acknowledgements

Conservation, who updated me on the fledglings' stories. Jim Harris and Sara Gavney Moore of the International Crane Foundation, Richard Phillips and Andy Wood of the British Antarctic Survey and Cleo Small of BirdLife International, all kindly provided information for the updates.

Among the many organisations that made the filming possible, the British Antarctic Survey was outstanding, with its scientists on Bird Island including Derren Fox and Ewan Edwards, who made our stay in the sub-Antarctic such a pleasure. The National Science Foundation and the US Antarctic Program were also excellent, as were their personnel, including Dylan, Steve, Leah, Martha and Lexie, who kept us safe on the sea ice at Cape Washington. Thanks too to the US National Park Service, the US Fish and Wildlife Service, New York City's MTA, the governor of Svalbard, Jiangxi Forestry Department in China and the Ministry of Environment and Forests in India, which all gave permission to film in the special places they look after.

Jane Smith, Dinah Mackay, Jon Close and my wife, Mary-Lou, all kindly read my early drafts and contributed many helpful suggestions, as did my excellent agent, Alex Christofi, and skilful copy-editor, Trevor Horwood, later on. Ailish Heneberry, Julian Hector, Albert DePetrillo and Jane Hamlin all helped make it possible to include the stories in this book. I am grateful to the many friends who have allowed me to use their photographs and to my daughter Freya, whose artwork graces the maps.

As a novice book writer I have been very fortunate to have John Davey as my editor. Not only did he ask me to write the book in the first place, but he has guided me through the process with great kindness and humour. Any errors in the text are my own.

Penny Daniel and the lovely team at Profile have all been excellent.

When I was starting out, wildlife cameraman Hugh Miles was a great inspiration, not only with his beautiful films but also for his sensitive approach towards animals. So were the many conservationists, such as Aldo Leopold and Tom Cade, who have ensured that there are still wild animals left to film and wild places for them to call home.

None of my work would be possible without the love and support of my children and especially Mary-Lou, who makes films too and understands more than most why it is so important to go and how much I wish I could stay.

Films can spark an interest, but the real work is done by the many individuals and conservation organisations dedicated to protecting wild places and wild animals. Here is how to contact a few of them; they all do great work and deserve our support:

The Royal Society for the Protection of Birds (RSPB) – www.rspb.org.uk
BirdLife International – www.birdlife.org
The UK's Wildlife Trusts – www.wildlifetrusts.org
The World Land Trust – www.worldlandtrust.org
The National Audubon Society – www.audubon.org
The Sierra Club – www.sierraclub.org
The World Wildlife Fund (WWF) – www.worldwildlife.org
The Peregrine Fund – www.peregrinefund.org
Panthera – www.panthera.org

LIST OF
ILLUSTRATIONS

20. Improvised metal hide (metal fort), Bird Island, South Atlantic (photo: Miles Barton)
21. The pier in seal season, Bird Island, South Atlantic (photo: Miles Barton)
22. Wandering albatross courting display, Bird Island, South Atlantic
23. Peregrine falcon, New York, USA (photo: Paul Thompson)
24. Booby on camera, French Frigate Shoals, Pacific Ocean
25. Otters, Argyll, Scotland (photo: Rowan Aitchison)

All photographs author's own unless otherwise stated.

INDEX

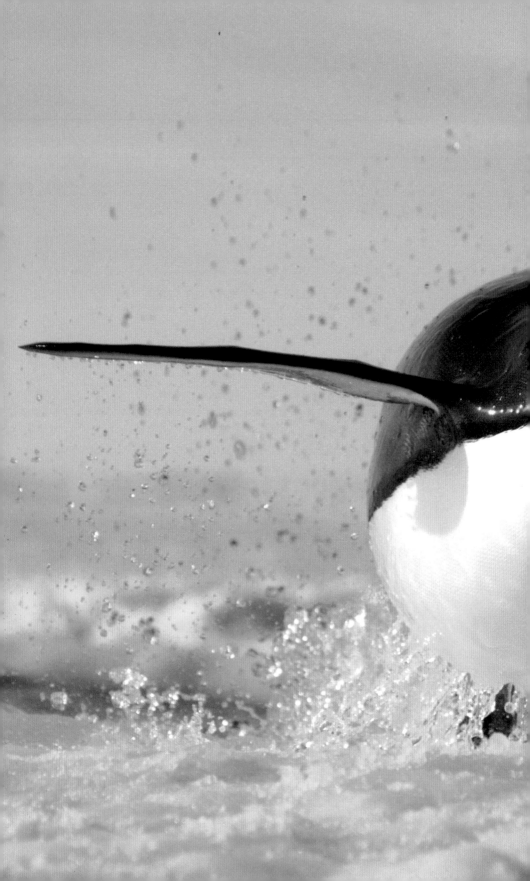